Word into Art
Artists of the Modern Middle East

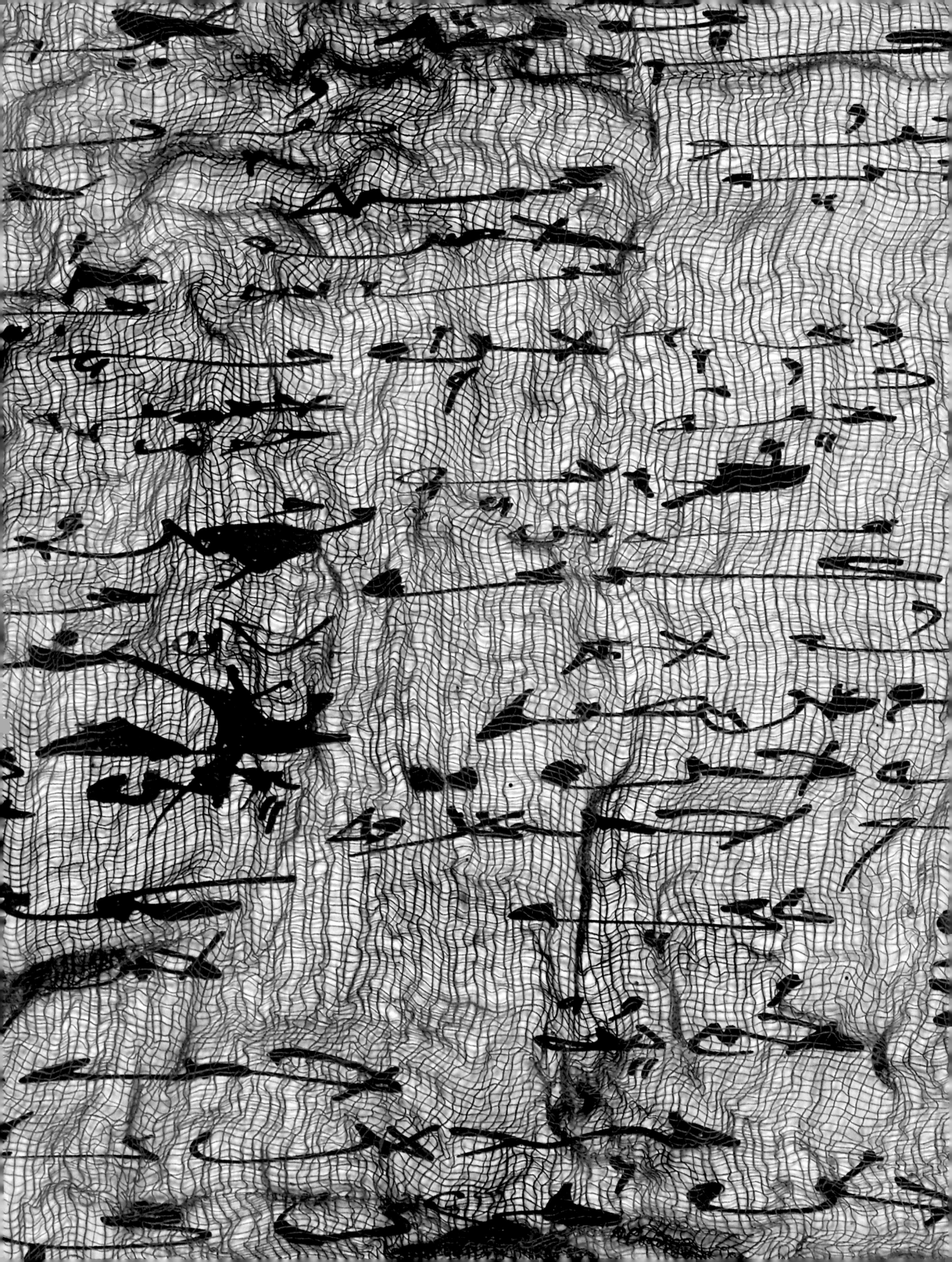

Venetia Porter

with contributions by Isabelle Caussé

Foreword by Saeb Eigner

Word into Art
Artists of the Modern Middle East

THE BRITISH MUSEUM PRESS

In memory of my mother, Thea Porter,
who introduced me to the contemporary art
of the Middle East

For Charles, Emily and Rhiannon

© 2006 The Trustees of the British Museum

Venetia Porter has asserted the right
to be identified as the author of this work

First published in 2006 by The British Museum Press
A division of The British Museum Company Ltd
38 Russell Square, London WC1B 3QQ

www.britishmuseum.co.uk

A catalogue record for this book
is available from the British Library

Cased edition:
ISBN-13: 978-0-7141-1163-6
ISBN-10: 0-7141-1163-5

Paperback edition:
ISBN-13: 978-0-7141-1164-3
ISBN-10: 0-7141-1164-3

Designed by Harry Green
Printed in Spain by Grafos SA, Barcelona

Dubai Holding is proud to support the exhibition *Word into Art*, which represents the first time that such a wide range of art, by over seventy-five artists from the Middle East, has been exhibited in one location. It shows the strong influence that Arabic, one of the most beautiful calligraphic languages in the world, continues to exert over artists of the modern generation and how it has inspired modern art in the region in so many different ways.

This exhibition provides a singular opportunity to experience the impact of the rich literary traditions of Arabic on art today. Therefore, I am delighted that such a rich repository of art as the British Museum is putting on this exhibition. I certainly hope you enjoy it.

H.E. Mohammad Al Gergawi
Executive Chairman, Dubai Holding

Contents

Preface

The Middle East is not normally associated with modern art. However, I'm glad to say that times are changing. With the benefits of improved education and economic prosperity, there is now a greater understanding and appreciation of art. In the United Arab Emirates, we have been working to boost this trend. We hope that our efforts, even if relatively small in global terms, will help artists to further develop as well as encourage other patrons to support them.

The government of the United Arab Emirates is now sustaining and assisting both institutions and individuals to develop and create the right environment for this movement to prosper. This momentum is not confined to the public sector alone. There are, for example, thriving art galleries and exhibitions in Dubai, fuelled by a strong interest in Middle Eastern art from a vastly multicultural population.

With this exposure to the rest of the world, contemporary art in the Middle East has encouraged a global audience to become enchanted by the artistic qualities of Islamic calligraphy. Modern art has found its place in our growing and developing environment because artists from the region have tapped the potential of Arabic as an art form. As this exhibition demonstrates, its potential has yet to find its limits.

The primary value of Arabic to art is, most importantly, as a form of identity to the region. Arabic has transcended borders to become the international symbol of its people. As such, it is a potent tool for artists looking to transmit their messages about the issues, themes and trends that pervade the modern Arab world today.

Obviously Arabic text is not only an identifying symbol: it has been actively used across the Middle East to communicate and teach. As well as being the language of the Holy Qur'an and poetry, it has been used to tabulate mathematical advances and scientific research. From its inception as a structured method of written communication over 1,300 years ago, Arabic script has recorded history. Since then, it has evolved as one of the most beautiful scripts in the world to inspire art through the many calligraphic styles and forms found in use today throughout Arab intellectualism.

This is why the Arabic language is such a powerful concept in our modern-day understanding of art in the Middle East. Where pictographic and abstract art forms are still very much in evidence, the qualities of the text evoke far more in the minds of the many people who live in this region. Within Middle Eastern art, the concept of a picture telling a thousand words is turned on its head. It begs a new question: how many images can a single word reveal?

I hope this excellent exhibition by the British Museum helps you to find the answer.

H.E. MOHAMMAD AL GERGAWI
EXECUTIVE CHAIRMAN
DUBAI HOLDING

Preface

As a follower of Middle Eastern art in its many forms, contemporary and calligraphic, I am pleased to be involved in the British Museum's Middle East Season and its exhibition, *Word into Art*. I am particularly thrilled that this event will be coming to Dubai, which is slowly emerging as an Arab art arena.

The exhibition brings together Middle Eastern artists from all corners of the globe, commonly united by the written word, its sublime beauty portrayed in various and creative ways, whether in the traditional format of calligraphy or contemporary media such as photography and installation.

The number of artists involved and the variety of their works, all unified by a common, unobtrusive theme, make this a very interesting exhibition. It is also a celebration of the art and the artists of our region, and an important step in showing the new Middle East and its art.

The art world is moving forward at a rather interesting pace, and the direction is perhaps more universal than ever. Our region, sadly, is not an active participant in this development. However, recent trends, including greater openness and deeper awareness, coupled with a new-found sense of self-confidence, appear to be bringing about positive change. Dubai in many ways is at the forefront of this modernizing trend in the Arab world; and that it should play an important part in this exhibition is in itself proof that art needs patrons and supporters. I am particularly proud that we have chosen to play that role.

This is an important exhibition brought together by passion, determination and foresight: positive values that are well known to us in the United Arab Emirates. We look forward to welcoming this exhibition to Dubai, and are confident that it will bring greater awareness and recognition of the energy and creativity of Middle Eastern art.

H.E. DR ANWAR GARGASH
DUBAI, UNITED ARAB EMIRATES

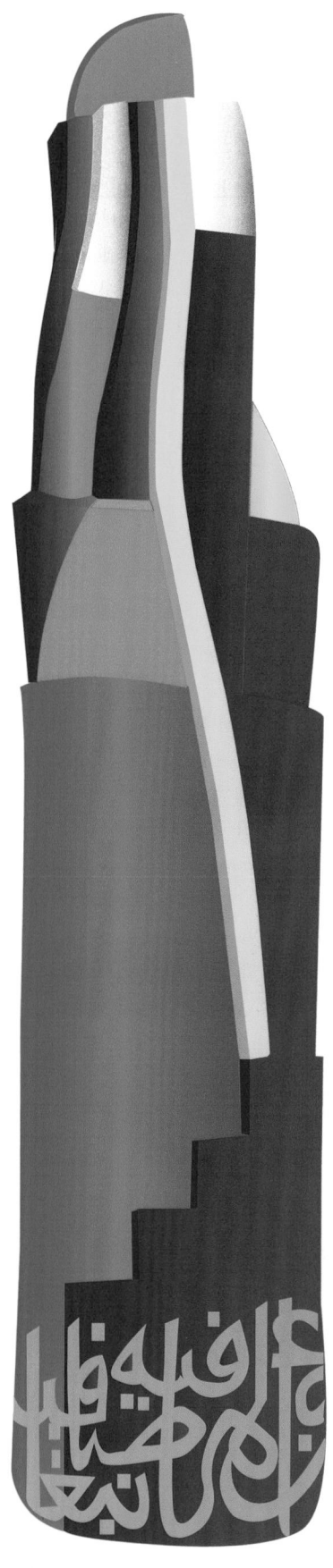

Dia al-Azzawi
Blessed Tigris

COMPUTER-GENERATED IMAGE OF THE DESIGN
FOR THE SCULPTURE
H 6.0 m, D 1.2 m (approx.)
PRIVATE COLLECTION

Specially created for the exhibition *Word into Art*,
the sculpture, made from fibre glass, has inscribed
upon it a poem by the celebrated Iraqi poet,
journalist and political activist Muhammad Mahdi
al-Jawahiri (d. 1997). This poem, written in 1962,
is 'O blessed Tigris':

'I greet you from afar, O greet me back,
O blessed Tigris, river of gardens green.
I greet your banks, seeking to quench my thirst,
Like doves between water and clay aflutter seen.
O blessed Tigris, oft have I been forced to leave
To drink from springs which didn't my thirst relieve.
O blessed Tigris, what inflames your heart
Inflames me and what grieves you makes me grieve.
O wanderer, play with a gentle touch;
Caress the lute softly and sing again,
That you may soothe a volcano seething with rage
And pacify a heart burning with pain.'

(Translated Hussein Hadawi)

Preface

When Parliament set up the British Museum in 1753 it had one overarching purpose in view: to enable citizens to think about the world they live in. This exhibition addresses one part of the world we now inhabit, and about which citizens are currently doing a great deal of thinking – the Middle East.

Word into Art puts on show for the first time the British Museum's collection of contemporary art from the Middle East, built up over the last twenty-five years. It focuses, like much of the Museum's earlier collections from the same area, on the transformation of the written word into expressive free-flowing form. But this modern calligraphy also embraces graffiti, and the wall-words of street politics now take their place alongside verses from holy scripture and quotations from the great poets and philosophers. *Word into Art* includes work by artists from virtually all countries from Morocco to Iran, some of them now working in Europe or America, but all addressing through the word issues of profound importance for the region – questions of belief and tradition, social order and personal integrity, and conflict of all sorts, cultural, religious and political.

This is not a new departure for the British Museum. Among the objects in our founding collection were amulets and seals delicately inscribed with Qur'anic and other religious verses, narratives of Jewish history as well as pious souvenirs of Christian Jerusalem. Enlightenment Europe was fascinated by the Levant. It studied its antiquities. It admired and envied its prodigious commercial success. But above all, the politicians and philosophers of eighteenth-century Europe wondered at the exemplary religious tolerance of the Middle East under the Sultan. Nowhere in Europe could Christian, Muslim and Jew live together in harmony as they could in Constantinople, Cairo or Baghdad, and the political thinkers of Germany, Britain and France could see that this was the model for the future.

If anything has distinguished the monumental and artistic cultures of the Middle East from the third millennium BC onwards, it is the significance accorded to words. As visitors to the Assyrian galleries in the British Museum can readily observe, the cuneiform inscriptions of ancient Mesopotamia march straight across carved reliefs of men and of gods, as if proclaiming the superiority of word over image. From those, through the Islamic collections' wealth of calligraphy to the remarkable sculpture by Dia al-Azzawi (opposite), there is in the Museum's collection enduring evidence of a sustained meditation by the peoples of the Middle East on the mighty power of the carved, written, and painted word to prolong memory, effect change, and communicate truth.

The truths that need communicating to the world about the Middle East now are not one but many, and would require much more than one art show. I believe, however, that this exhibition can make a contribution. It is the first of its kind, certainly in Europe. It could not have been achieved without the help and support of Dubai Holding, our sponsor, and Saeb Eigner, special adviser for the Modern Middle East Season 2006. To them the Museum owes its warmest thanks.

NEIL MACGREGOR
DIRECTOR, BRITISH MUSEUM

Acknowledgements

The exhibition *Word into Art* and this book are the result of a wonderful collaboration between a number of enthusiasts of contemporary Middle Eastern art, and the energy and engagement of my colleagues at the British Museum. First and foremost I would like to thank Saeb Eigner, the British Museum's special adviser on the Middle East Season 2006, without whom this would not have happened at all and who has been a constant source of advice and practical assistance on many levels. Furthermore I would like to thank him for introducing us to our generous sponsors Dubai Holding, whose executive chairman is H.E. Mohammad Al Gergawi, and to H.E. Dr Anwar Gargash, patron and supporter of the arts.

The book could not have been written without Isabelle Caussé, who with unfailing good humour and initiative took on the enormous task of the artists' biographies and has helped with much else besides. Laura Lappin, our editor at British Museum Press, worked with us consistently and with seemingly limitless patience. I am profoundly grateful to them both.

For their constant kindness, encouragement and guidance throughout the process of creating the exhibition I would like particularly to thank Dia al-Azzawi, Rose Issa, Samar Damluji and Frances Carey. For the Arabic alphabet I would like to thank Mustafa Ja'far and for the table of Arabic scripts Nassar Mansour. For assistance with the biographies of artists and much else I am extremely grateful to Marie-Geneviève Guesdon, Maysaloun Faraj, Nada Shabout who kindly let me study her thesis, as well as Mona Atassi, Saleh Barakat and Stephen Stapleton. In addition, I would like to thank Manijeh Mir-Emadi; Hala Kittani; the Museum of Contemporary Art, Tehran; Farhad Hakimzade, Michael Baumgartner, Ali Ansari, Peter Saunders; Brahim Alaoui and Eric Delpont from the Institut du Monde Arabe, Paris; Elizabeth Lalloucheck and Chilli Hawes of the October Gallery; Claude Lemand of the Claude Lemand Gallery; Haldun Dostoğlu of Galeri Nev; Paola Potena of Lia Rumna Gallery; the Zamalek Gallery; the Lisson Gallery; the Anthony Reynolds Gallery; Sunny Rahbar of Third Line gallery; the Kashya Hildebrand Gallery; Carolyn Ramo at the Nicole Klagsbrun Gallery; Saqi Books and Mai Ghoussoub; Isabel Carlisle; Lisa Ellis and Katie Brook from Lonworld UK; and Malek Inja and Jonathan Howell-Jones from Dubai Holding. For help with some of the translations of the Arabic and Persian texts I would like to thank Julia Bray, Rana Kabbani, Shahrokh Razmjou and Vesta Curtis. For reading various drafts I am grateful to Charles Tripp, Sheila Blair, Jonathan Williams and Dinneke Huizenga.

The majority of the works included in the book and exhibition are from the British Museum's collection, largely bought with the help of the Brooke Sewell Permanent Fund. Acquiring these works has been a fascinating journey and the result of an enjoyable process of discovery and learning over a number of years. I have shared this task with Robert Knox, Keeper of the department of Asia, who has supported and encouraged the development of the collection. The exhibition has been enhanced by a number of loans and I am extremely grateful to the lenders Dr Anwar Gargash, Abdul

Rahman Al Owais, Rose Issa, Parviz Tanavoli, Samar Damluji, Dia al-Azzawi, Sabiha al Khemir, Ghada Amer and the Gagosian Gallery, Michal Rovner and the Pace Wildenstein Gallery. There are others who prefer to remain anonymous to whom I am also extremely grateful.

Among my colleagues at the British Museum my wholehearted thanks go to Kevin Lovelock and John Williams for beautifully photographing so many of the works and for their good humour throughout the process. For the design of the book I thank Harry Green, who sadly passed away before the book was completed, Peter Ward who subsequently took it on, and for the editing Jenny Knight. At British Museum Press thanks to Susan Walby and Sara Jackson for the production, and Andrew Thatcher and Rosemary Bradley for their enthusiasm and encouragement of the project from the beginning. Other colleagues have been supportive in many different ways. My thanks go to Julie Hudson, Chris Spring, Helen Wang, Sheila Canby, Richard Blurton, Sona Datta, John Curtis, Antony Griffiths, Mark Macdonald, Stephen Coppel, and to the following who were involved particularly with the exhibition and the Middle East Season: Xerxes Mazda, Jonathan Ould, Rebecca Richards, Jonathan Williams, Joanna Mackle, Margaret O'Brien and Anneke Rifkin, amongst others. Finally, I am extremely grateful to the Director Neil MacGregor and Deputy Director Andrew Burnett, who have both been a constant source of support and kindness throughout.

It is to the artists, however, that I owe the largest debt of gratitude, for it is their work – rich, varied and thought-provoking – that has provided the inspiration for *Word into Art*.

VENETIA PORTER

Foreword

I am fortunate to be living in an age in which art, in all its forms and from all periods, is the subject of impassioned discussion and debate. Artistic expression has, of course, always been central to the cultures of the Middle East although the rest of the world may have overlooked it at times. But this book is clear evidence that things are changing. There is currently a remarkable renaissance underway among artists, galleries, and collectors of contemporary Middle Eastern art within the region itself. Together they are creating a movement whose effects are beginning to be recognized throughout the world.

This new wave of interest began in 1977, with the opening of the Museum of Contemporary Art in Tehran where some of the world's best-known artists have been displayed. Iran is indeed today producing some of the region's greatest contemporary artists, many of whom are featured in this book. Most recently, the Istanbul Contemporary Art Museum opened in 1998.

Cultural activity does not always take place where the money is, and this is also the case in the Middle East. There is an interesting interplay developing between artists from economically less developed parts of the region, and governments and individuals from more prosperous countries. Art and artists have always needed benefactors and supporters and it is encouraging to see the beginnings of this in the Middle East, as collectors and governments seek ways to promote artists by acquiring their works and other kinds of public support. Galleries are emerging in some of the newest and most cosmopolitan centres of the region, and cities such as Dubai, Beirut, Cairo, and Istanbul are starting to examine how best to support their artistic communities. In some cases this is driven by individuals but in others it is led and inspired by open-minded and visionary governments.

Some of the greatest living Middle Eastern artists are from Iran, such as Shirin Neshat who now lives in New York. Others still live in Tehran, including the sculptor Parviz Tanavoli, the painter Khosrow Hassanzadeh, the film producer and photographer Abbas Kiarostami and the photographer Bahman Jalali. There is also a new generation of modern artists emerging, such as Farhad Moshiri and Shadi Ghadirian.

Lebanon has a long cultural history, producing some important artists as Guiragossian, a truly modernist movement painter who would have felt at home painting with Picasso or Matisse, or more traditional artists, namely Faroukh and Ounsi. Fortunately the Lebanon, notwithstanding its tragic civil wars and political woes, continues to produce talented forward-thinking artists.

Turning to North Africa, there is clearly competition between Egypt and its westerly neighbours, notably Morocco, Tunisia and Algeria. Some of the greatest North African artists come from Egypt, the bastion of the 1950s' Arab nationalist movement and recognized by many as the region's cultural hub. Much of their work is reproduced here, including Chant Avedessian's stencils, Ahmed Moustafa's calligraphic works, Sabah Naim's works featuring photos of everyday life in Cairo, which include the country's

well-known daily newspapers. Also shown are the hand-painted photographs of Youssef Nabil who now joins Shirin Neshat and Ghada Amer in New York, possibly the ultimate destination for many of this generation of young Middle Eastern artists whose impact will carry the influence of Middle Eastern artistic endeavour worldwide.

The culturally rich country of Iraq has, naturally, produced some of the area's best-known artists, such as Dia al-Azzawi and Ismail Fattah. The best known Libyan artist, now resident in London, is Ali Omar Ermes with his simple flowing Arabic letters that also feature extracts from some of the region's greatest poets. Many more countries in the Middle East, including Jordan and Syria, have produced some exceptionally talented artists.

This book is a tribute to the many artists of the region, who have kept alive an avant-garde culture in the arts. In many cases this has sadly required personal sacrifices, including emigration and persecution, but it is these artists' perseverance that has allowed a greater level of understanding of the cultural achievements of the contemporary Middle East at a time when such understanding is needed more than ever.

Middle Eastern art has in recent years not been high on the world's cultural agenda. But with some new enthused life and nurturing by the generosity and dedication of patrons and supporters, this will change. This is a region that in the past was a cultural centre of excellence; hopefully it will not be long before it regains such a reputation.

Until then many, like me, will remain passionate followers of the region's art, encouraged by the support, understanding and generosity of its people. I am privileged to have the trust, support and understanding of many of the region's business and government leaders, without whom this book and indeed the exhibition with which it coincides may not have been possible. I hope that they will continue to allow themselves to follow their instinct in a time increasingly dominated by bureaucracy and politics, neither of which have any place in supporting the arts.

A nation's art is after all its soul.

SAEB EIGNER

Introduction

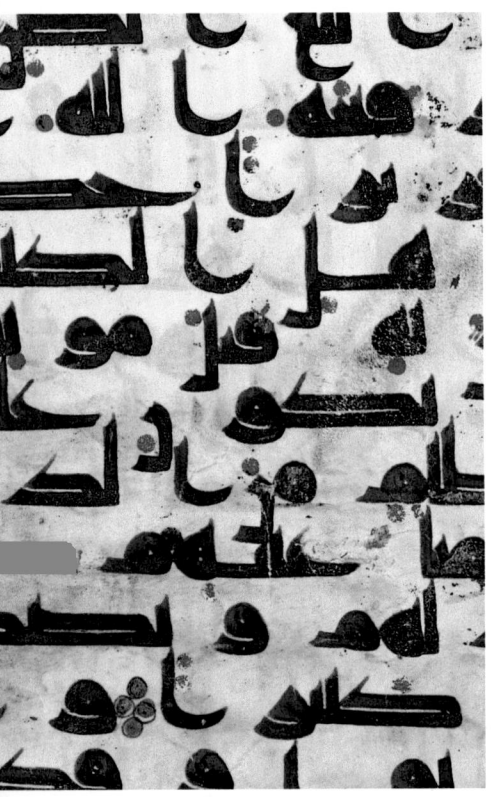

1 Qur'an page (detail), brownish-black ink on parchment, probably Iraq, ninth–tenth centuries
H 15.6 cm, W 23.40 cm
British Museum, 2001 6-5 1
The text, inscribed in the angular script known as *kufic*, is from Qur'an Chapter 4, 'Women' (*al-Nisa*), verses 157–61. The red dots were an early device for distinguishing between letters of the same shape; they were also used as an aid to vocalization.

Contemporary Middle Eastern art at the British Museum

In the mid-1980s the British Museum began acquiring contemporary Middle Eastern art (the Middle East in this context also includes North Africa). This was part of a broader initiative across the Museum to return to the guiding principles of its eighteenth-century founders and actively collect contemporary artefacts from around the world (Carey 1991: 6–10). The primary aim for the Middle Eastern collection was to acquire works on paper. This collection, mainly housed in the Department of Asia, now comprises the work of some hundred artists from across the region, from Iran to North Africa. An early decision was to choose work which somehow 'spoke' of the region and showed continuity with 'Islamic' art. Thus works which contained modern examples and interpretations of Arabic calligraphy were initially favoured over more global, generic forms of contemporary art. The emphasis today continues to be on work on paper, although there are also a few works in other media. The collection is constantly growing, the ultimate objective being to create a body of work that is representative, as far as possible, of the whole region. It is significant that a number of the artists whose work is included here no longer reside in their countries of origin, having left the region either temporarily or permanently. It is also striking that, whether inside or outside their homeland, the art they produce shows strong links with their own artistic heritage and history, powerfully demonstrating their reactions to conflict or exile.

Why Word into Art?

In trying to choose a suitable framework within which to exhibit some of the British Museum's collection of contemporary Middle Eastern art, the obvious focus was on works that use script in the broadest sense. This was not simply because the writing takes so many different and interesting forms, but because grouping the works together thematically, and looking at what is written within them, allows us to gain some insight into different aspects of the rich literary and artistic cultures of this region, as well as into the ways in which artists are affected by history and by the politics of the world of today.

In the exhibition the focus has been on Arabic script which, like Hebrew, is powerfully connected to the religions of the region. In addition to works from the British Museum's collection, the exhibition includes a number of objects that have been kindly lent for this purpose. The works are divided into four sections. 'Sacred Script' can be regarded as the starting point. It explains the relationship between the Arabic script and the religion of Islam (fig. 1), showing the enduring vitality of the Arabic calligraphic tradition today. It focuses on artists and calligraphers who use established styles of script (see pp. 20–21) but in contemporary formats, inspired by a belief in God and the holy texts. The powerful literary tradition of the Middle East, the enduring appeal of ancient and modern Arabic and Persian poetry, and the appeal of the work of Sufi writers is evoked in the second section, 'Literature and Art'. It shows how artists seek to find ever more inventive ways of writing these texts. The third section, 'Deconstructing the Word', focuses on the use of script in Middle Eastern abstract art from the mid-twentieth century to the present day. Here the

messages are more ambivalent and link with past or present identities in subtle ways, unlike those of the works in the other sections where texts tell specific stories. Letters and words are sometimes legible, but more often they are not, having been turned into beautiful abstract patterns or sometimes hinting at poetry or the magical tradition. The last section, 'Identity, History and Politics', looks at the ways in which the words embedded in these works, when combined with an image, or even books themselves, can provide us with real snapshots of history as well as revealing reactions to the region's devastating conflicts during the past few decades.

The modern art of the Middle East

Placing the work of artists now in a broader context, the end of the nineteenth century saw the beginnings of a profound divergence of approach and style in the art of the Middle East. On the one hand, throughout much of the region there were the continuing traditions of so-called 'Islamic' art: calligraphers, miniaturists, potters and metalworkers carried on using age-old techniques, sometimes deliberately harking back to former styles – as in Egypt with the nineteenth-century 'Mamluk revival'. On the other hand, a distinctive 'modern' art was emerging in the region. Its creators sometimes used elements of the stylistic vocabulary of 'Islamic' art, but they differed from its traditions in terms of materials, techniques and formats, using lithography or photography, for example. These are specifically associated with Western art traditions and were introduced into the region only from the mid-nineteenth century. As members of emerging national communities, these artists and intellectuals had a clear view of their own identities and increasingly sought to express subjective and political truths through a medium that they themselves had transformed. They created new genres that owed much to international artistic schools of the twentieth and twenty-first centuries, but were unmistakably informed by views of their own artistic traditions and heritage. They established schools and movements with clear manifestos and they responded powerfully to the politics of their own countries in particular and the region as a whole. This strongly evoked sense of identity, which continues to be evident in the work of many Middle Eastern artists today – as in, for example, the work of Yemeni artist Fu'ad al-Futaih (fig. 2) – is arguably the single most important theme of the art highlighted here and what lends it its extraordinary richness.

Hurufiyya: the development of an artistic movement

The focus of this exhibition on the use of script in Middle Eastern art is not simply an accident of the British Museum's collection. It captures a powerful thread in the art of the region as a whole, encompassing beautiful calligraphy with its ancient roots, and the random graffiti of other artists. So important is this trend that a special term has been coined for it: *hurufiyya*, after the Arabic word *harf*, meaning 'letter', and alluding to the medieval Islamic scientific study of the occult properties of letters. The Palestinian artist Kamal Boullata (cats 10, 23, 37) describes how he was haunted by the Word and developed a 'talismanic relationship with it', like so many other artists of the region (Boullata 1983).

Words, of course, appear in Western visual art and distinct parallels may be made with Western manifestations. A number of the early generation of Arab artists who studied in Paris would certainly have been exposed to these art forms. At the forefront was the Cubist painter Georges Braque, who placed painted letters within his well-known work

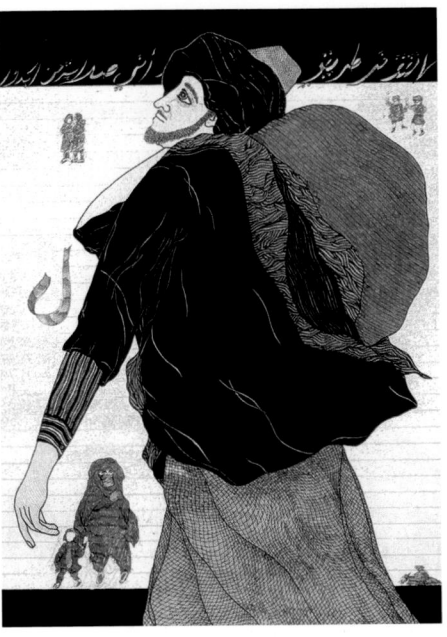

2 Fu'ad al-Futaih (b. 1948),
The Immigrant, **ink on board, 1975**
Collection of the artist
During the 1970s young Yemenis left their country, often for years at a time, to work in Saudi Arabia and the Gulf States; the remittances they sent back provided for their families. Fu'ad al-Futaih is one of Yemen's most prominent artists and in this work he captures the spirit of optimism of these young men. The Arabic script at the top are lines from a Yemeni poem declaiming that the protagonist will overcome any obstacles he finds on his journey. Of his work al-Futaih has said: 'I want to give Arab or Islamic art a modern face with a strong personality'.

3 Bruce Nauman (b. 1941), *Normal Desires*, lithograph (32/50), 1973
H 61.8 cm, W 89 cm
British Museum, 1979 10-6 22
Nauman was interested in the visual presence of words. Previously using neon signs, in 1973 and 1975 he published a series of lithographs in which statements such as 'Normal Desires' appears as though carved out of stone (Carey and Griffiths 1980: 50, Coppel 1989).

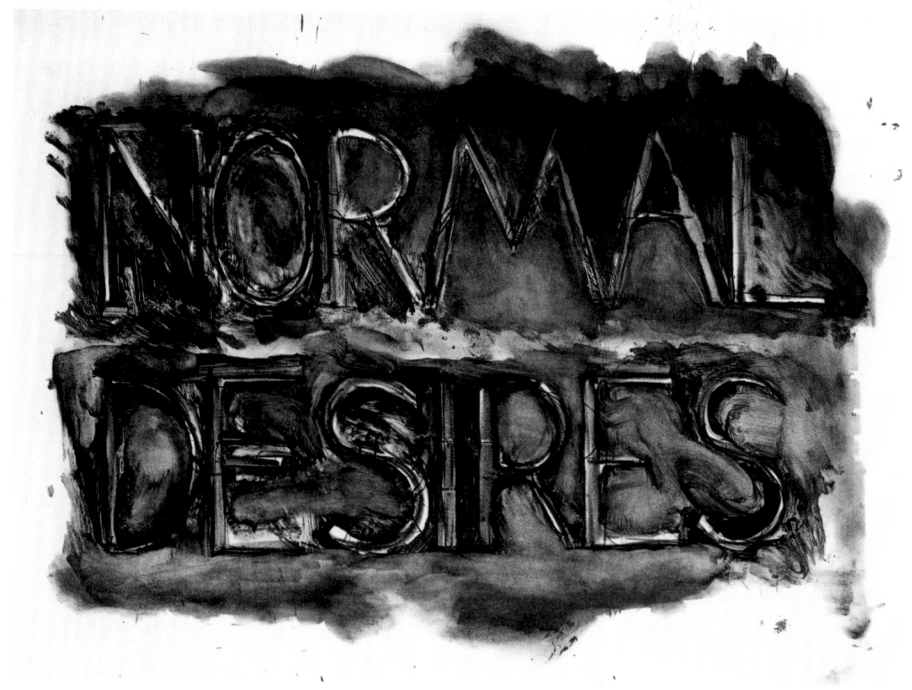

Le Portugais, painted in 1911. Many others, including Piet Mondrian, Max Ernst, Juan Miró, Antoni Tàpies – who was a powerful influence on Shakir Hassan al-Said – and contemporary American artist Bruce Nauman (fig. 3), continued to incorporate letters and words in one form or another into their work (Butor 1969, Legrand 1962, Adler and Ernst 1987). Another example is Paul Klee, who painted poems in Latin capital letters within coloured squares in 1917–18. In an interesting reversal, Klee, who visited Tunisia in 1914, was influenced by Arabic script in his work as well. This can be seen, for example, in his *Insula dulcamara*, painted in 1938, in the collection of the Zentrum Paul Klee, Berne.

Hurufiyya is a term that denotes works of art 'which deal with the Arabic language, letter or text, as a visual element of composing' (Daghir 1990: 11, Shabout 1999: 164). Some of the earliest uses of Arabic letter forms in Middle Eastern abstract art – arguably the true beginnings of *hurufiyya* – were deployed by Iraqi artists such as Madiha Omar (d. 2005), who was perhaps the first artist fully to incorporate Arabic letters in her abstract work (cat. 40). Shakir Hassan al-Said (d. 2004) did the same (cat. 41). In his case, this was his practical articulation of a specific philosophy: a brilliant artist and art theorist, and profoundly influenced by the Sufism of Husayn ibn Mansur al-Hallaj (*c.* 858–922), he was one of the towering figures of the modern Iraqi art scene. Drawing on a synthesis of Sufism and Western existentialist philosophy, his increasingly abstract works focused on the inclusion of letters and reflected his view that artistic expression is achieved by stages, similar to the stages that bring you closer to God, as articulated by the Sufi mystics. He believed that 'the Arabic script, in its different forms and schools, reflects and is a reflection of the history of the Arab individual and social reality, which remained stored in the intellectual unconsciousness of culture and society'. He also found that it contained 'the mythological consciousness of Mesopotamian societies and all others that followed. Thus, language and its written form are the means of revealing the hidden' (Shabout 1999: 244). Like other key Iraqi artists of this generation, such as Jawad Selim (d. 1961), his aim was to find ways to create a fusion with their heritage, or *turath*. Although not associated with

4 Issam el-Said (1938–1988), untitled, lithograph, (1980s)
H 78 cm, W 58 cm
Private Collection
Fascinated by the concept of geometric proportion in Islamic art, el-Said embarked on a series of studies based on the structure of Arabic letter shapes. In this triangular composition, in a style based on square *kufic*, he has inscribed the *shahada*, the phrase 'There is no God but God, Muhammad is the prophet of God'. His favourite maxim was apparently: 'As long as the proportions are right, then an object or design has beauty' (el-Said 1989: 47).

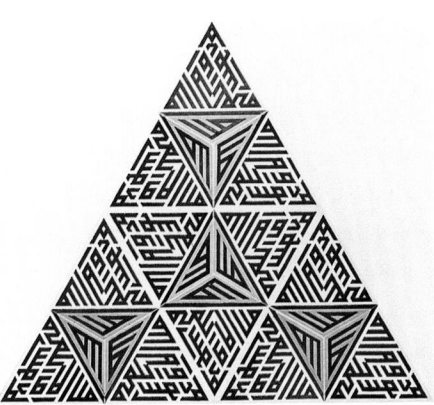

using script in his work, Selim – in his iconic monument that still stands in Baghdad today, *nasb al-huriyya* (the Freedom Monument, al-Khalil 1991: 81–93) – conceived his series of bronze figural reliefs as a story that had to be read like the Arabic script, from right to left. Another Iraqi artist, Issam el-Said (d. 1988), who trained at Cambridge as an architect and lived in self-imposed exile from Iraq, was the first artist to explore 'Islamic' design fully and within it the structural forms of the Arabic script (fig. 4; el-Said 1989). The Egyptian artist Ahmed Moustafa also took his inspiration from the structure of the script, going back to the tenth-century work of the calligrapher Ibn Muqla, who is said to have developed the system of proportion of the Arabic script (cats 7, 8). One of the first artists to turn the script into, in essence, word pictures was Moroccan artist Mehdi Qotbi (fig. 5; Guesdon and Nouri 2001: 184). Going beyond the word, Dia al-Azzawi stated, 'I believe in using visual elements in a painting as primary material: Arabic script could be part of it. I do not find that a painting becomes Arabic through the use of the Arabic script. The painting's identity comes from a group of elements, not script or ornaments alone' (Rotterdam 2002).

But can this now ubiquitous use of script be described as a movement? Are the reasons for including script always the same? To what extent does it still consciously connect with Arab/Iranian/Muslim identities, or in some cases with a rejection of Western representational art? A series of studies by Sylvia Naef (1992), Wijdan Ali (1997), Nada Shabout (1999) and others has looked in depth at this subject and only some of these broad questions can be touched upon here. It is interesting to look at the case of Turkey, for example, where the Arabic script was abandoned in favour of the Latin alphabet as part of a raft of modernizing reforms during the Ataturk era. Apart from a few traditional calligraphers continuing the age-old tradition of teaching the script, it rarely appears in abstract or other forms of modern art, reflecting perhaps the secular influences in the artistic life of modern

5 Mehdi Qotbi (b. 1951), *Ecriture*, gouache on paper, 1979
H 70 cm, W 51 cm
Ministère de la culture, FNAC, Inv. 33569
Moroccan artist Mehdi Qotbi has been living in Paris since the 1970s. He was one of the earliest artists to create abstract pictures out of words which have become devoid of meaning. He works with writers and poets creating *livres d'artistes* as well as paintings.

6 Erol Akyavaş (1932–99), *The glory of the kings*, oil on canvas, 1959
H 122 cm, W 214 cm
Museum of Modern Art, New York, Gift of Mr and Mrs L.M. Angeleski
Trained in Turkey and then Paris with Lhote and Léger during the 1950s, Akyavaş espoused European modernisn, later studying in America with architect Mies Van Der Rohe. This painting, in which he deconstructed Arabic words, was exhibited in 1961 at the Angeleski Gallery in New York where his work was widely acclaimed. The painting was acquired by the Museum of Modern Art in 1961.

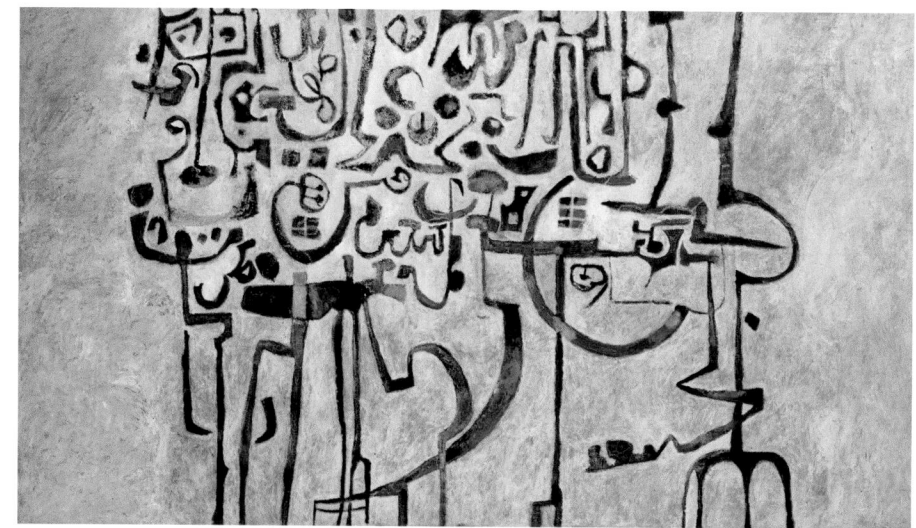

Turkey. One of the few Turkish artists to include Arabic script in his work is Erol Akyavaş (d. 1999) (fig. 6; Akyavaş 2000: 39–45), whose early works included Arabic letters in abstract compositions, but who was increasingly inspired by different aspects of the Islamic tradition. This is evident from his Mi'rajname (the night journey of the Prophet Muhammad). There is a clear intention to form a bridge with the past, a theme that recurs in works of other artists from the Middle East.

Certain Arab artists also use script to help express their engagement with current political issues: in particular, the growth of anti-colonial nationalist movements and a series of cataclysmic events that have affected the region in significant ways. In Egypt, for example, the regime of King Farouk was overthrown in 1952 by Jamal Abd al-Nasir, whose *Philosophy of the Revolution* (1959) stressed the ethnicity of the Egyptians, their role as Muslims and as Arabs, and the position of Egypt within Africa. This was to affect the course of modern Egyptian art: figural representation was abandoned in the art schools and nudes could no longer be exhibited; there was instead much concentration on geometry and on Arabic calligraphy – in effect, a self-conscious return to 'Islamic' themes.

An event that deeply affected the Middle East as a whole was the defeat of the Arab armies by Israel in the June war of 1967. This caused a major re-evaluation of the direction that the Arab world should take, in which artists and intellectuals participated. Poet and critic Buland al-Haidari, writing on the theme of 'Arabness', described artists after 1967 as 'vying with each other in trying to blaze a new trail which would give concrete expression to the longing for Arab unity, and end by giving the Arab world an art of its own' (al-Haidari 1981: 21–2). As a consequence, Arab artists, many of whom had trained in the West or had been exposed to Western art traditions, began to seek inspiration from aspects of their own indigenous culture. The increased use of script by some artists can certainly be seen in the light of this. Wijdan Ali, for example, describes her abandonment of figural representation and the focus on script in her *Kerbala* series as a direct result of the Gulf war of 1991 (Ali 1997: 163) (cat. 56).

In Iran, as perhaps elsewhere, the use of script in modern art was a response to the increasingly ferocious criticism of the abstract tendency among Western-trained artists. Writing in the journal *Sokhan* about the third Tehran Biennial in 1962, the critic Cyrus Zoka called for 'a visual language that would speak specifically to Iranians' (Daftari 2002: 67).

Saqqakhaneh was the result and is the term coined for the artistic movement that began in Iran in the 1960s which not only sought to integrate popular symbols of Shi'a culture in art, but also found new ways of using calligraphy and script – particularly the traditional Iranian styles of *nasta'liq* and *shekaste*. Literally meaning 'water fountain', *Saqqakhaneh* specifically refers to public fountains offering drinking water constructed in honour of Shi'a martyrs who were denied water at Kerbala and in this way alludes to the powerful traditions of Shi'a Islam. Among the key artists in this movement were Parviz Tanavoli (cat. 52) and Charles-Hossein Zenderoudi (cat. 2).

It is not only Arabic script that has been adopted as a medium of expression and turned into art in this region. Israeli artist Michal Rovner has become fascinated by 'notions of text, signal sign, the visual appearance of language; marks that people make, or leave behind' (Rovner 2005: 332). Some of her video installations take the form of books, in which the scripts, which could be Hebrew or Aramaic, are in fact lines of constantly moving people (cat. 61). El Hanani as a Moroccan Jew is inspired by his complex cultural background and is particularly drawn to the minute script used by medieval and later Muslim and Hebrew scribes to write their holy texts (cat. 57). Another interesting phenomenon is the use of Latin script by Middle Eastern artists such as Youssef Nabil occasionally in his photographs (cat. 89) and Ghada Amer in her complex embroidered works (fig. 7), powerfully fusing Western and Eastern traditions.

The works presented here all have many stories to tell. One can detect a deep love for Arabic calligraphy and the art of the book itself, which has a long tradition in the region and is now being dramatically transformed. Obvious, too, is the fascination with the structure of letters across the region; and the words themselves, which invite us to dig deep into the culture of the region. And finally, it is the potent messages contained in these works that cry out and haunt us.

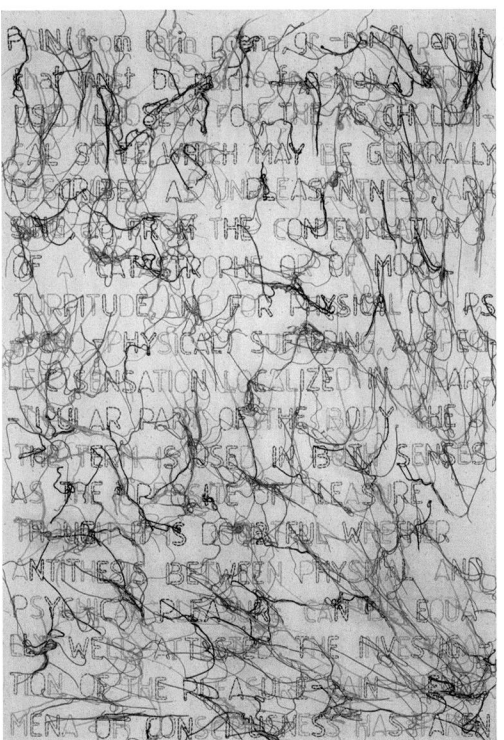

7 Ghada Amer (b. 1963), *Pain*, embroidery and gel medium on canvas, (2005)
H 66 cm, W 45.7 cm
Gagosian Gallery
Egyptian-born Ghada Amer lives and works in New York. Her work is characterized by an examination of stereotypical notions of feminity. Embroidery, stitching, and sewing, traditionally identified as 'female' techniques, are the hallmarks of her work. This work is part of a recent series in which Amer has embroidered definitions of 'desire', 'pain', 'torment', 'longing' and 'absence' from a variety of sources, with one word presented on each canvas. Using a commercial machine and stencilled font, Amer embroiders the text directly onto canvas. The loose threads hang from individual words and create an abstract quality to the work.

The Arabic Script

THE ORIGIN AND DEVELOPMENT OF THE ARABIC SCRIPT

Before the coming of Islam, Arabic was a spoken language only; its script was based on a form of Aramaic used by the Nabateans (100 BC–AD 100), now best known for the remains of their remarkable city at Petra in Jordan. These early writings are rare and found on a handful of examples in the deserts of Syria, Jordan and Iraq. It was the revelation of Islam to the prophet Muhammad in the early seventh century in Arabia that was to dramatically change the role of the Arabic script. For there was now a pressing need to write down the holy text of the Qur'an which had been revealed by God through the Archangel Gabriel in the Arabic language. The establishment of Arabic as the language and script of the administration of the Muslim empire coincided with the belief that in order to copy the Qur'an the writing must be as beautiful as possible. Over the centuries, a series of remarkable scripts were developed by master calligraphers, principally used to copy the holy text, but which were soon employed in all manner of other contexts, including official documents, coins, gravestones, and the façades of religious and secular buildings. The script became therefore not simply a vehicle for communication but – in a culture in which figural representation was discouraged – a major outlet of creativity and a characteristic feature of the art of the Islamic lands.

ARABIC SCRIPT STYLES
Written by Nassar Mansour

A verse from the Qur'an (68:1), 'By the pen and what they inscribe', is written to the right in a selection of Arabic scripts that will be recognized in the works presented in this catalogue.

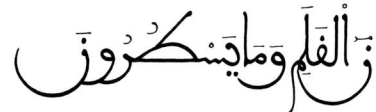

Kufic script developed around the end of the seventh century. Its origin has been associated with Kufa, Iraq, and other centres. Characterized by angular letters forms it gradually became more elaborate and was widely used until about the twelfth century. It was superseded for copying the Qur'an by the cursive script *naskh*.

Maghribi script evolved in North Africa and Spain in the tenth century. Forms of this script are still used in North Africa today.

Square kufic appears from the thirteenth century on coins, tilework and elsewhere in the lands of the Mongols and their successors.

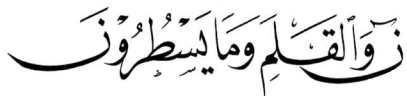

Naskh is the copyists' hand, mainly used from the twelfth century for writing government documents in addition to copying the Qur'an.

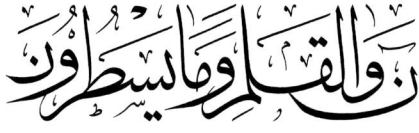

Thuluth started to develop in the ninth century and is a favoured script for ornamental inscriptions. A variant is *jali thuluth*.

Nasta'liq, the 'hanging script'. According to legend it was perfected by the fifteenth-century calligrapher Mir 'Ali al-Tabrizi after dreaming of flying geese. It was popular in Iran and Mughal India from the sixteenth century.

Diwani was developed by Ottoman Turkish calligraphers during the fifteenth century and often used on official documents such as firmans.

THE ARABIC ALPHABET IN NASKH SCRIPT
Written by Mustafa Ja'far

The Arabic alphabet is written from right to left (shown vertically here with Latin equivalents) and consists of twenty-eight letters created from seventeen different letter shapes. In modern Arabic dots above and below help to distinguish letters from each other. In early Arabic these dots were frequently omitted. Many of the letters change their shape depending on where they are situated within a word. These variations are shown here alongside the individual letters. The letters that are underlined are pronounced emphatically. The Arabic alphabet has been employed and developed to write a variety of other languages. One of these is Persian which has thirty-two letters. To accommodate the extra sounds four Arabic letters have been adapted as follows:

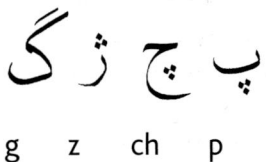

g z ch p

	
a	ا
b	ب
t	ت
th	ث
j	ج
\underline{h}	ح
kh	خ
d	د
dh	ذ
r	ر
z	ز
s	س
sh	ش
\underline{s}	ص
\underline{d}	ض
\underline{t}	ط
\underline{z}	ظ
ayn	ع
gh	غ
f	ف
q	ق
k	ك
l	ل
m	م
n	ن
h	ه
w	و
y	ي

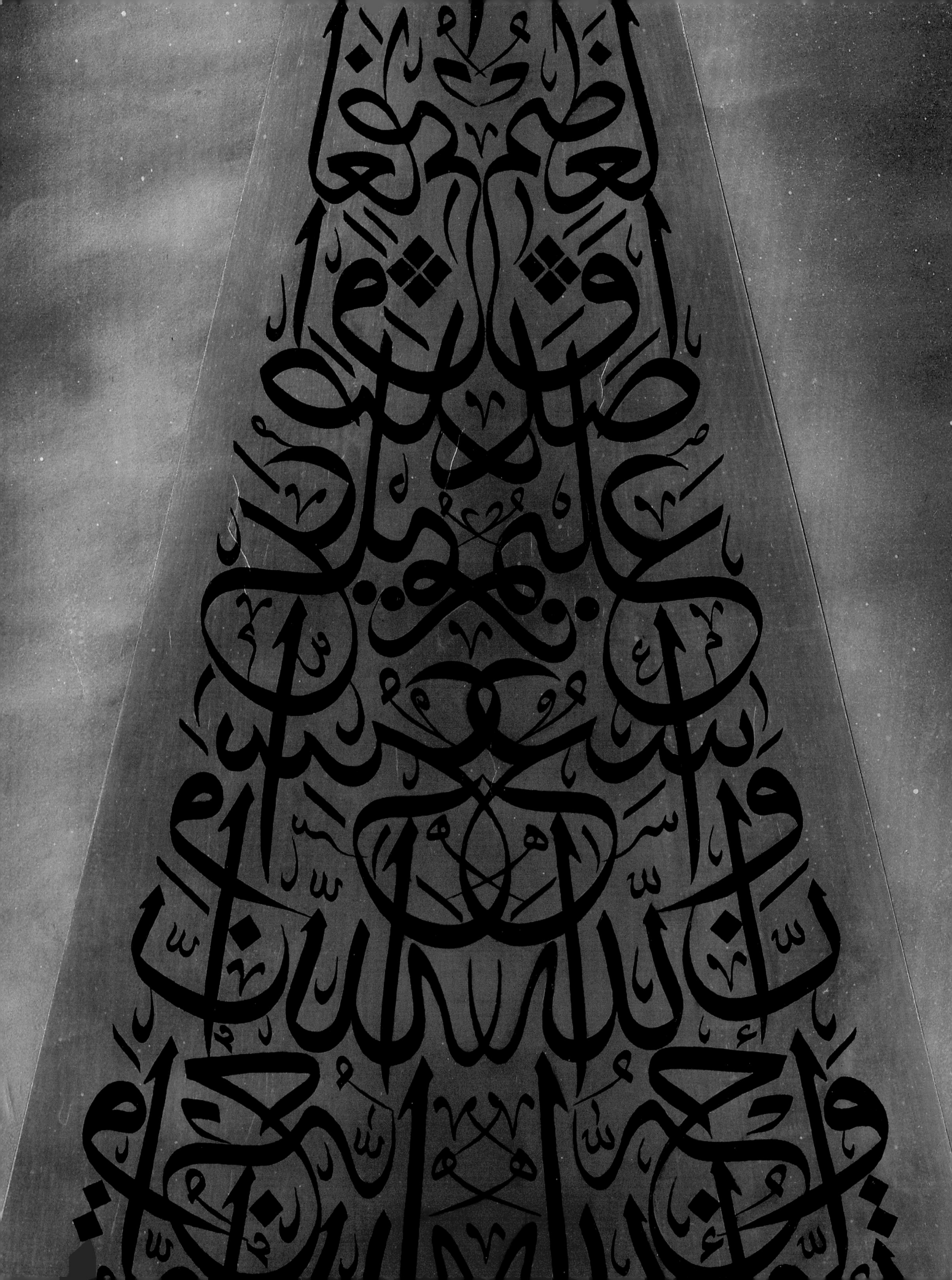

Arabic as the language and script of the Qur'an has a strongly sacred aspect. Arab calligraphers began in the late seventh century to transform what had been until this time disparate writings on stone into a structured script with complex sets of rules. It was to become one of the most beautiful scripts in the world and continues to inspire artists today. Traditionally calligraphers would have copied out whole sections of the Qur'an in the form of books. Now those inspired by sacred texts and the art of Arabic calligraphy in the Middle East and beyond, wherever the religion of Islam has spread, write single words or complete verses from the Qur'an or the Bible in all manner of forms and on a variety of materials, from paper to ceramics. They sometimes use and extend the boundaries of the canonical scripts – *kufic*, *thuluth* and others – developed by the great masters, or go beyond them entirely, creating their own inspired compositions.

1 A Sacred Script

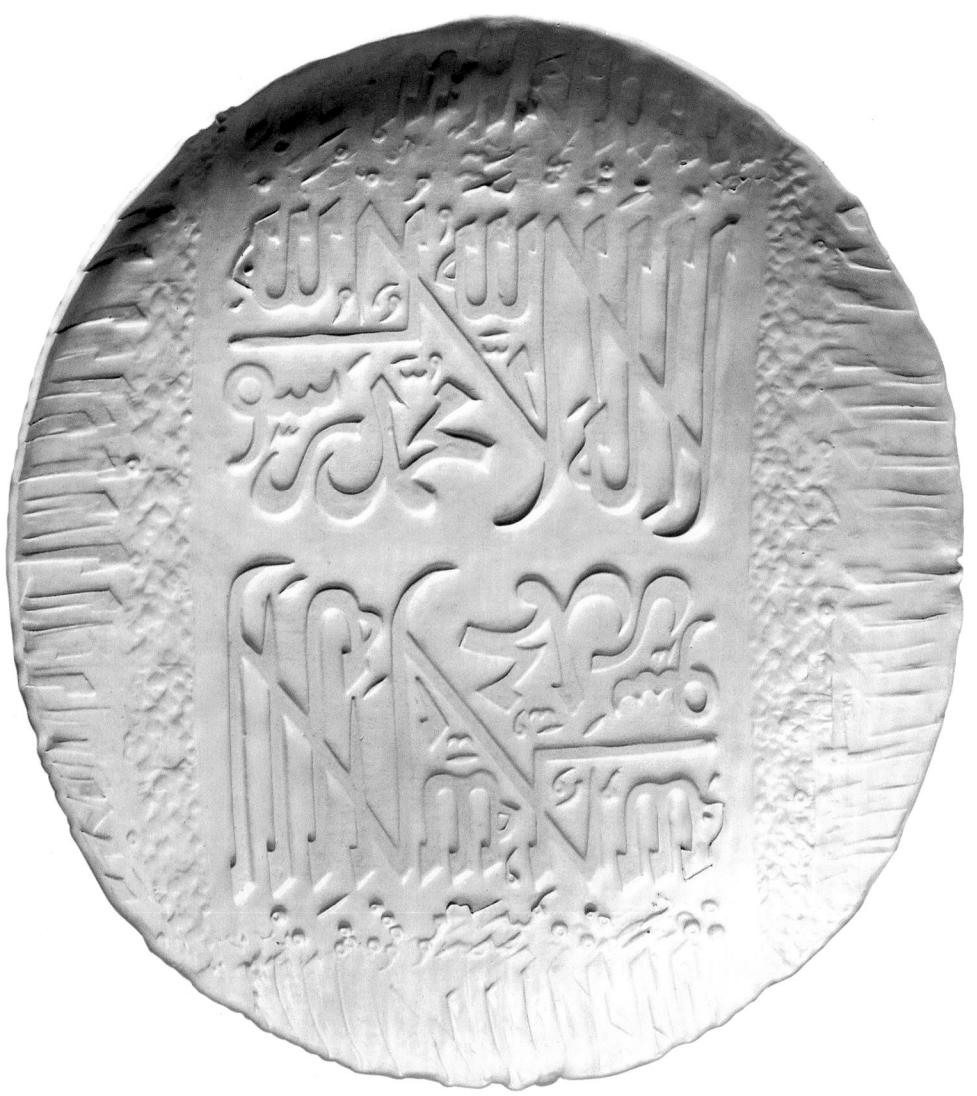

1 Wasma'a Chorbachi

Untitled

PORCELAIN DISH, 1991
D 39.0 cm
IRAQ/USA
1993 6-24 1

The *shahada* is the Islamic profession
of faith and consists of the words
'There is no God but God, Muhammad
is the Prophet of God'. It is carved here
into the surface of the dish, inscribed
twice, facing in different directions.

2 Charles-Hossein
Zenderoudi

Untitled

SILKSCREEN ON PAPER (14/20),
FROM AN EDITION WITH COLOUR
VARIATIONS, 1986
H 66.0 cm, W 50.5 cm
IRAN/FRANCE
1991 4-8 01

'Praise belongs to God, the Lord of all Being,
the All-merciful, the All compassionate,
the Master of the Day of Doom.
Thee only we serve; to Thee alone we pray
 for succour.
Guide us in the straight path,
the path of those whom Thou hast blessed,
not of those against whom Thou art wrathful,
nor those who are astray.'

(Qur'an: *Fatiha*)

The text from the *Fatiha*, the opening of the Qur'an,
is written in the highly decorative *nasta'liq* script
particularly favoured by Iranian calligraphers. There is
also a *basmala* in *diwani* script. Zenderoudi, as one of
the prime exponents of the *Saqqakhaneh* school of art
in Iran (see Introduction, p. 19), frequently turned to the
traditional script for inspiration.

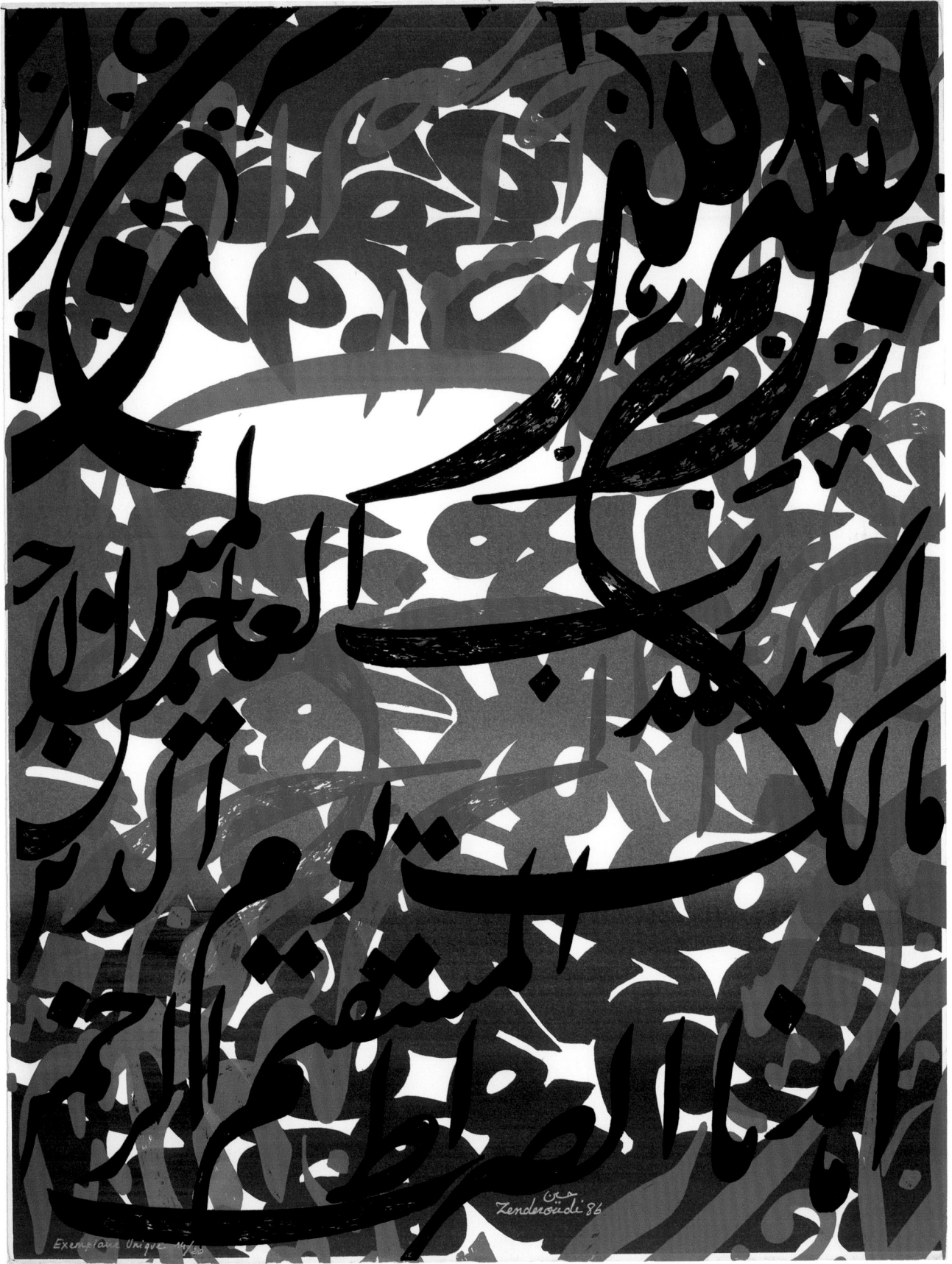

3 Ghani Alani

Untitled

BLUE AND RED INKS ON
HAND-COLOURED PAPER,
c. 1990

H 23.0 cm, W 449.0 cm

IRAQ/FRANCE

2003 3-28 01

BROOKE SEWELL PERMANENT
FUND

'Basmala
God.
There is no god but He, the
Living, the Everlasting.
Slumber seizes Him not, neither sleep;
to Him belongs
all that is in the heavens and the earth.
Who is there that shall intercede with Him
save by His leave?
He knows what lies before them

and what is after them,
and they comprehend not anything of His knowledge
save such as He wills.
His Throne comprises the heavens and the earth;
the preserving of them oppresses Him not;
He is the All-high, the All-glorious.'

(Qur'an 2:255)

This well-known verse from the Qur'an is regarded as being especially
potent and protective (see also cat. 8). Alani has inscribed it in *muhaqqaq*
script (similar to *thuluth*) in the unusual format of a horizontal scroll.

4 Osman Waqialla

Kaf ha ya ayn sad

INK AND GOLD ON VELLUM LAID DOWN ON CREAM-
COLOURED PAPER, 1980

H 17.5 cm, W 13.0 cm

SUDAN/UK

1998 7-16 01

BROOKE SEWELL PERMANENT FUND

This calligraphic page is inscribed with Chapter 19
('Maryam') from the Qur'an in tiny *naskh* script
written around the five boldly written letters in
thuluth script, *kaf ha ya ayn* and *sad*, which appear
at the beginning of this chapter. These single letters
are some of 'the mysterious letters of the Qur'an'
which precede 29 of the 114 chapters. They are
imbued with magical protective properties and are
often found engraved on amulets.

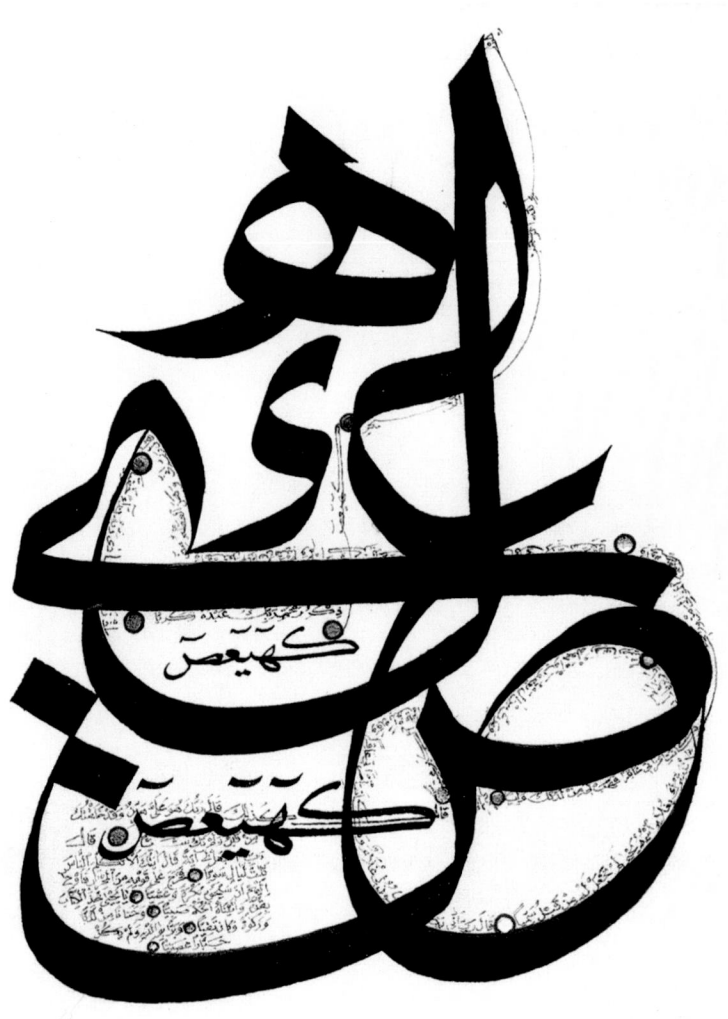

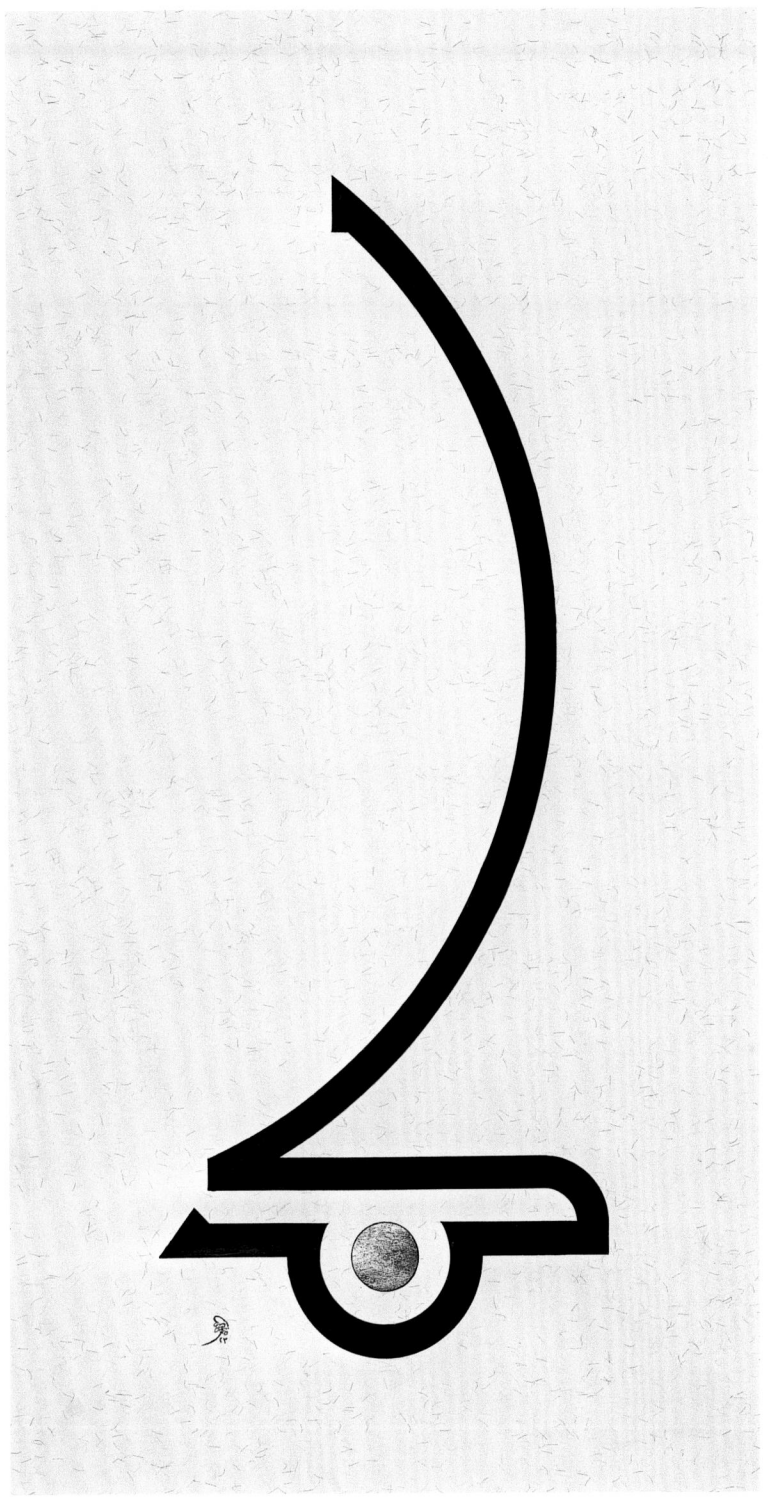

5 Nassar Mansour

Kun

INK AND GOLD ON PAPER,
2002

H 46.0 cm, W 25.0 cm

JORDAN/UK

2006 2-7 01

BROOKE SEWELL PERMANENT
FUND

In this composition the word *kun* ('be')
is simply inscribed in kufic script. The
word alludes to the phrase in the
Qur'an, 'and the day he [God] says
"Be", and it is' (Qur'an 2:117).

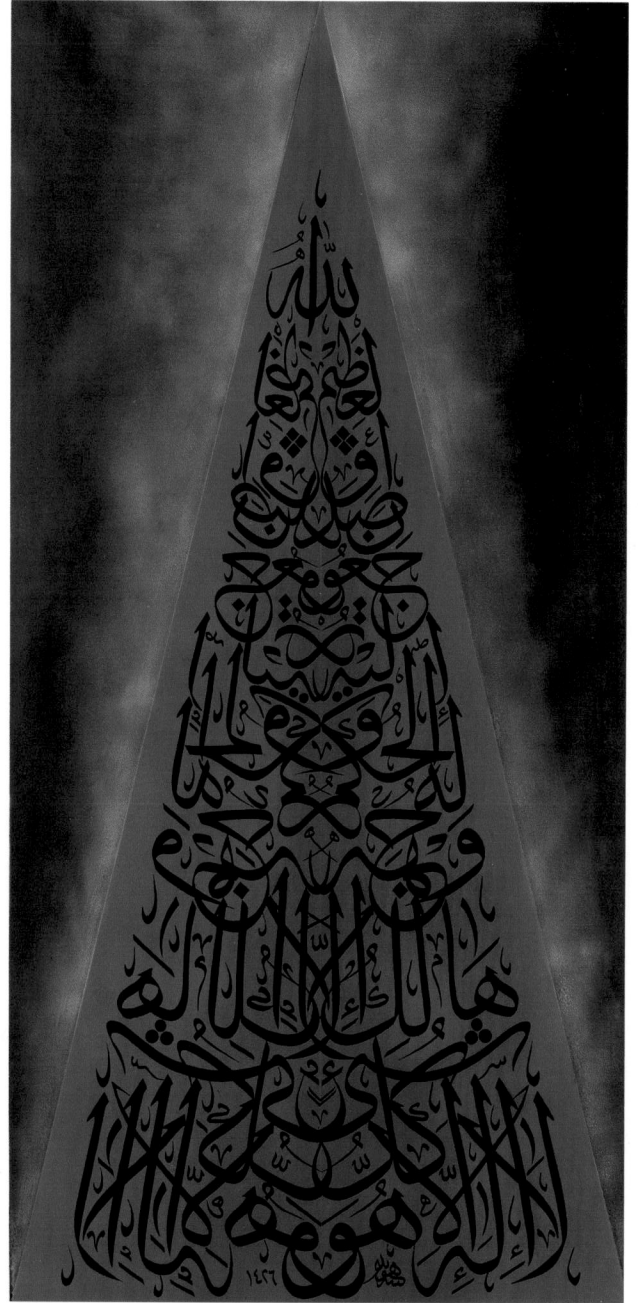

6a

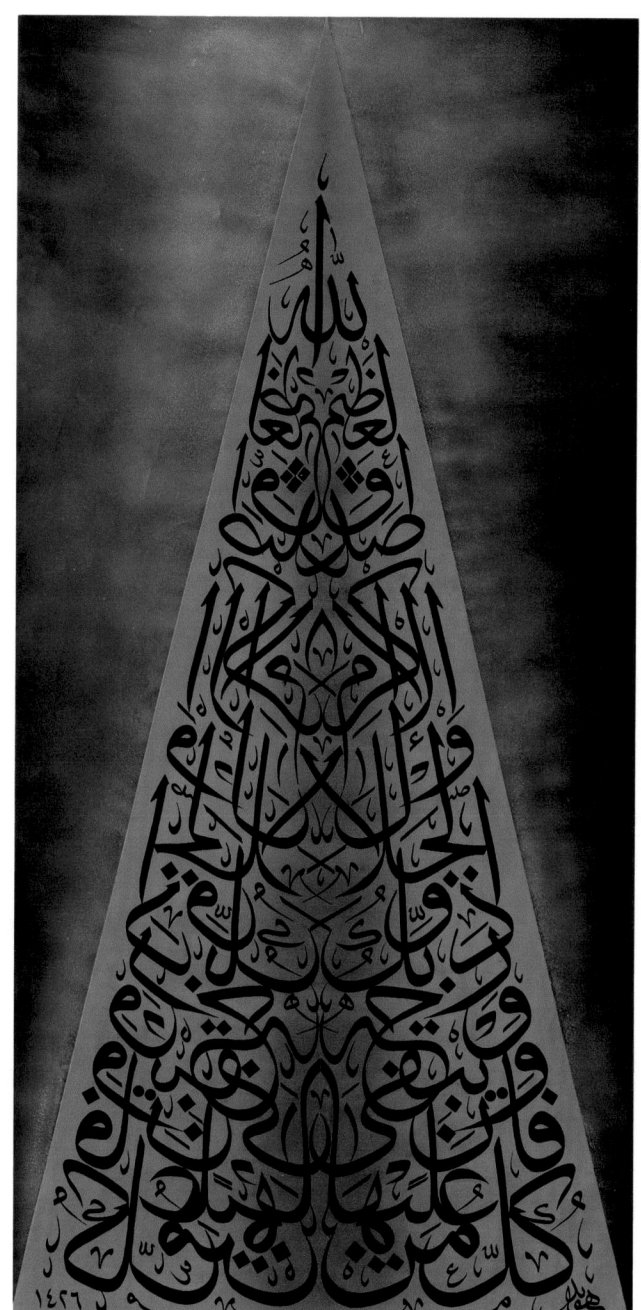

6b

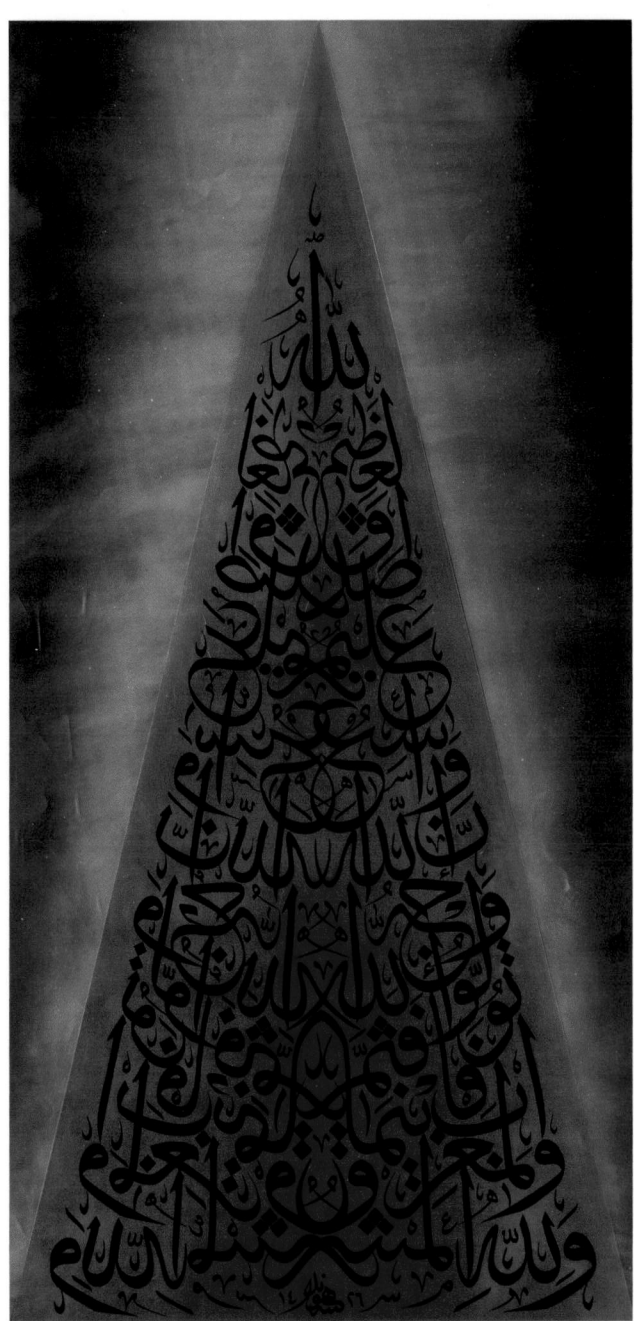

6c

6a–c Fou'ad Kouichi Honda

Untitled

THREE CALLIGRAPHIES, BLACK INK ON COLOURED
GROUNDS, 2004

H 131.5 cm, W 71.5 cm

JAPAN

2005 5-10 01-03

BROOKE SEWELL PERMANENT FUND

Honda follows the Turkish calligraphic
tradition, but in innovative formats. These
bold triangular compositions in *jali thuluth*
script are inscribed in mirror writing, where
the left side of the composition is written
in reverse, one of the calligraphic traditions
particularly popular in the Ottoman era.
In each of the texts 'Allah' is at the top. The
passages are from Qur'an 28:88 (6a); 55:26
(6b); 2:115 (6c).

7 Ahmed Moustafa

The heart of sincerity

SILKSCREEN ON PAPER, 1978
H 65.0 cm, W 96.5 cm
EGYPT/UK
1987 6-4 05

The composition in mirror writing (see cat. 6) is inspired by Qur'an Chapter 112 ('Sincere religion'). The complete chapter, which consists of only four lines, is written out in its entirety in detached letter shapes with letters from it creating a bold symmetrical arrangement. All the letters have been given a numerical value. The numbers alongside the letters therefore indicate how often the letters appear in the chapter as well as the order in which they appear. Moustafa's work is based on his study of traditional Arabic calligraphy and the rules of proportion that lie at its heart, as expounded by the tenth-century Abbasid vizier and calligrapher Ibn Muqla. Moustafa discovered that

'the exact geometric basis of proportioned script does not simply provide a mathematical rationale for Islamic calligraphy, explaining why this art form is so harmonious and aesthetically pleasing in its effect, but it implies something far more extraordinary: that the Arabic script, like music, is a finely tuned abstract vocabulary embodying universal mathematical laws, and therefore has the power to have an objective moral and spiritual effect upon the viewer.'

(Moustafa 1998: 12)

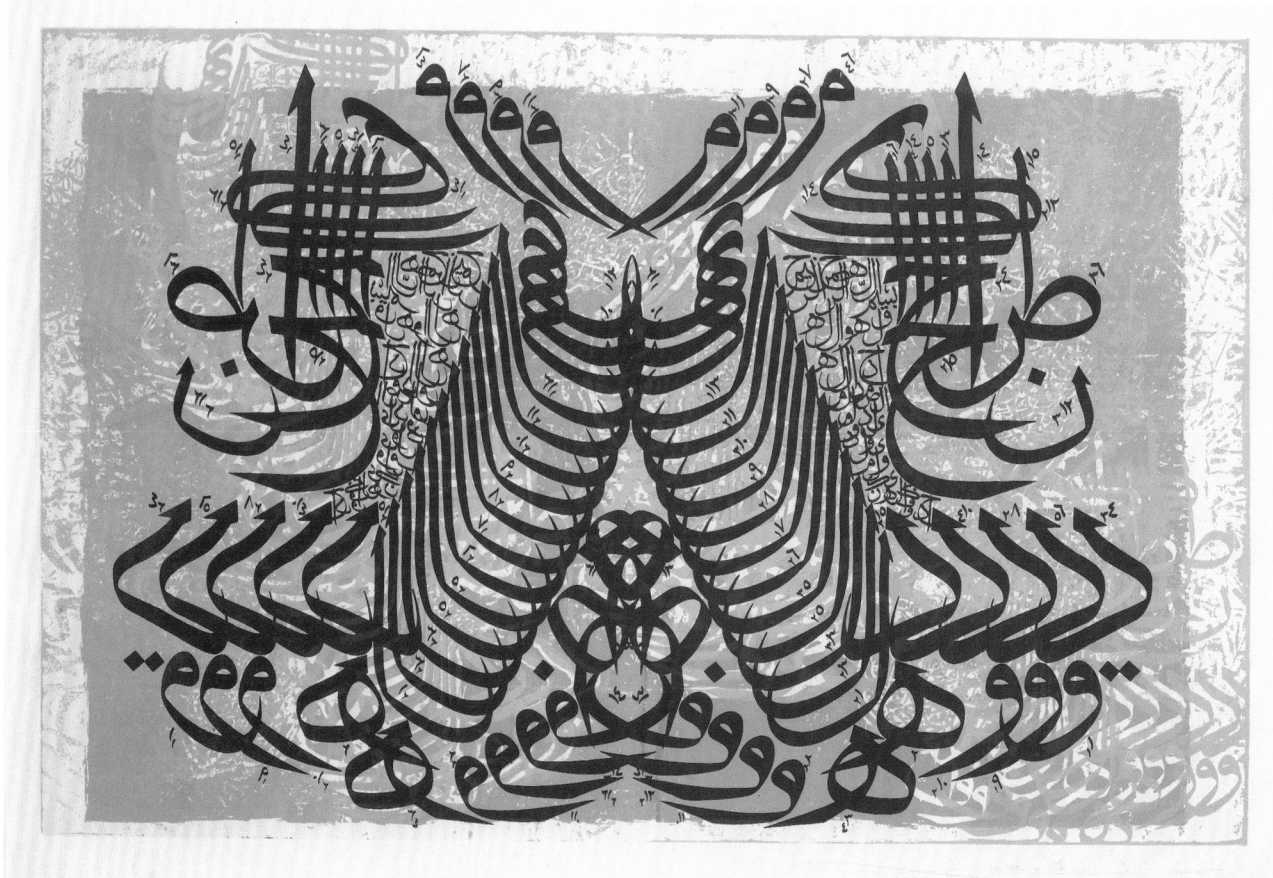

7

8 Ahmed Moustafa

The attributes of divine perfection

OIL AND WATERCOLOUR ON PAPER, 1987
H 125.0 cm, W 149.0 cm (IMAGE)
EGYPT/UK
LENT BY THE ARTIST

In this complex calligraphic work in several script styles, the central element is a cube, an embodiment of the Ka'ba at Mecca. It is open to reveal within each individual cube one of the *asma' al-husna*, the 'Beautiful Names of God', in square *kufic*. On the sides are the words 'Muhammad is the Prophet of God'. In the background is the 'throne verse' (*ayat al-kursi*, Qur'an 2:255), interlaced

with the words 'May his glory be magnified'. In the foreground is the verse from the Qur'an referring to the Names of God:

'Say call upon God, or call upon the merciful; whichsoever you call upon, to Him belong the Names Most Beautiful.'

(Qur'an 17:110)

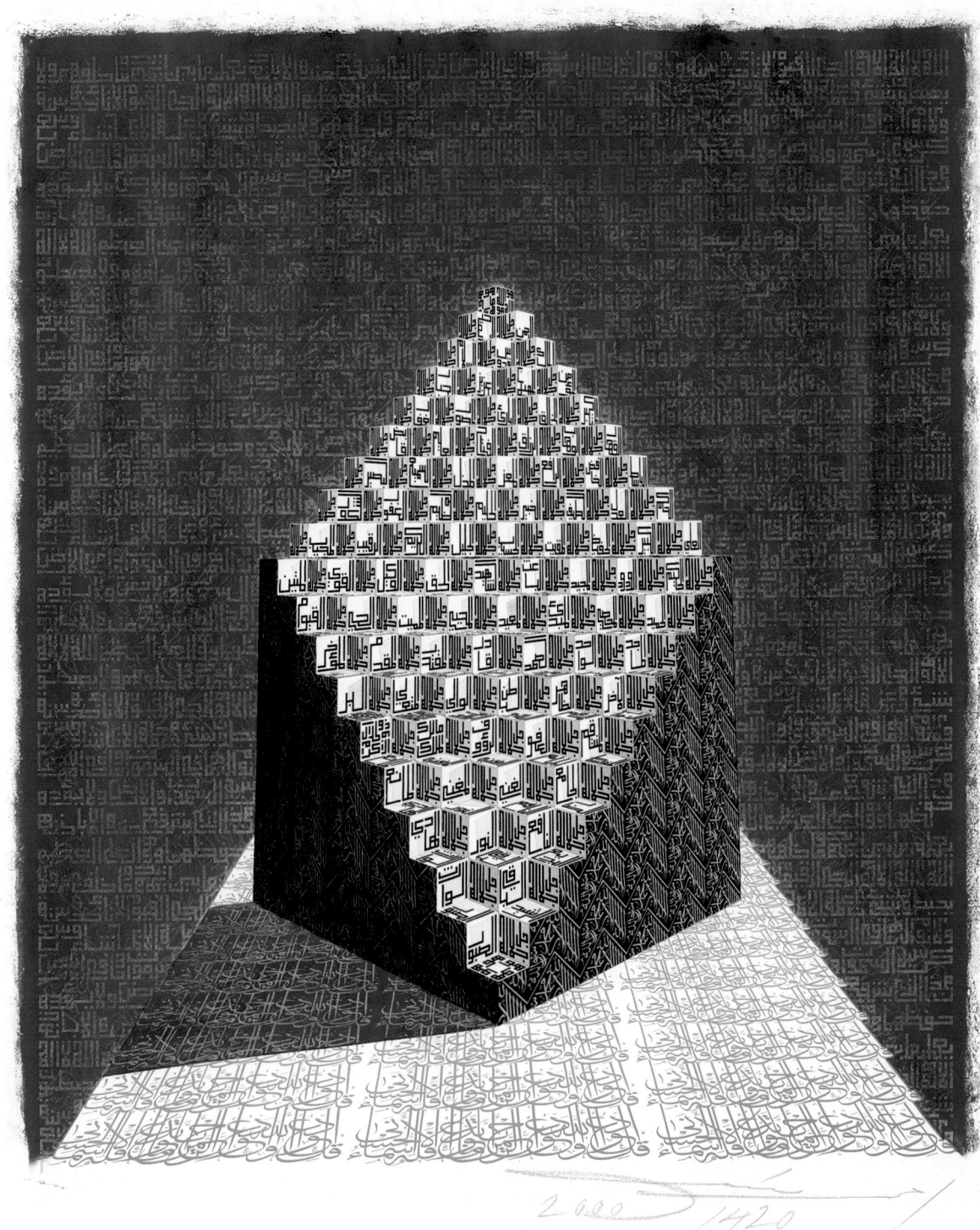

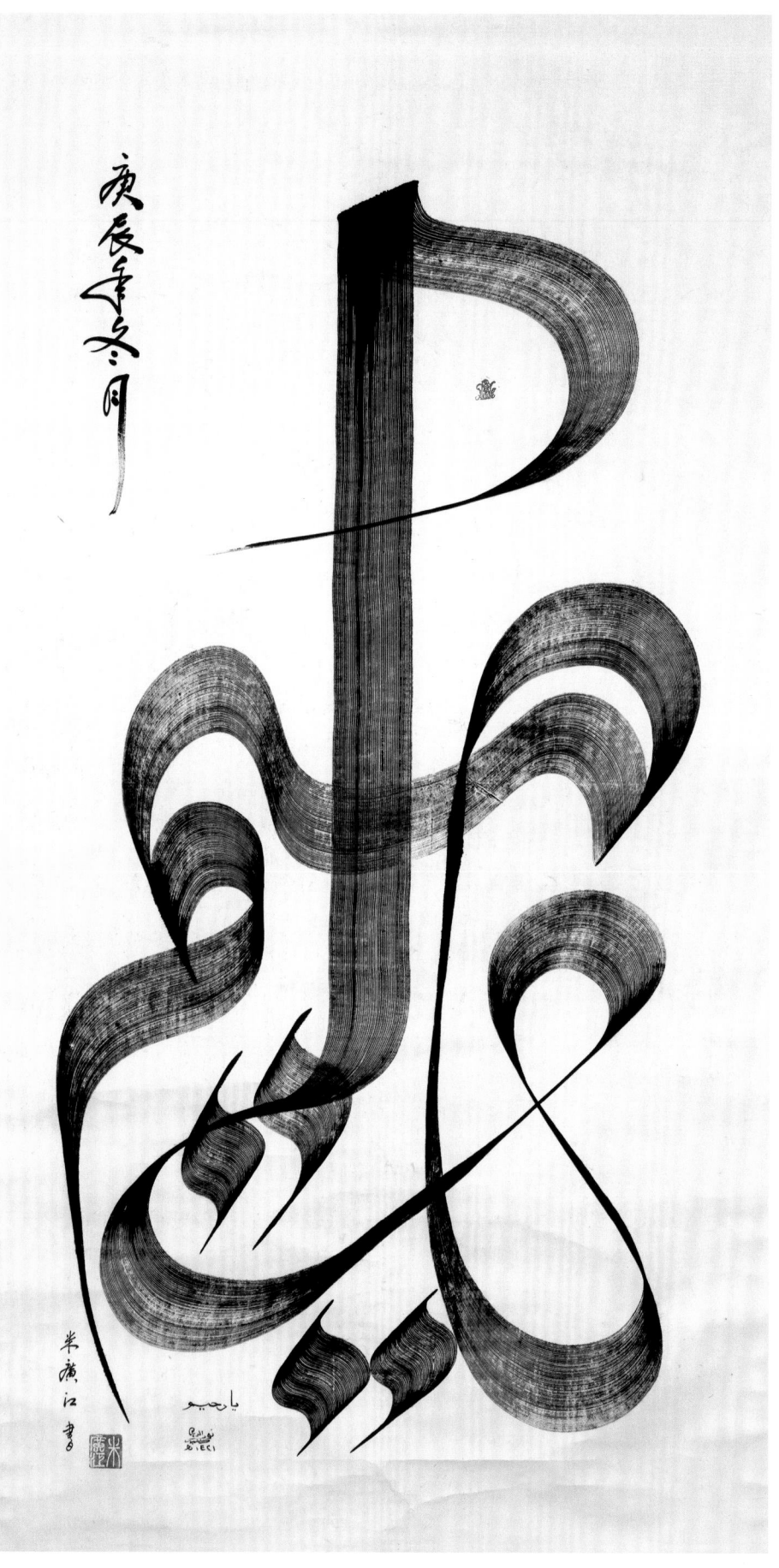

9 Haji Noor Deen Mi Guanjiang
Ya rahim

INK ON PAPER, 2000
H 230.0 cm, W 102.0 cm
CHINA
2005 1-17 01
BROOKE SEWELL PERMANENT FUND

In the *sini* (Chinese) script characteristic of the calligraphies of Chinese Muslim artists are the words 'O Merciful' (*ya rahim*), one of the 'Beautiful Names of God' (*asma' al-husna*). The Chinese inscription on the left consists of the date 'Winter Month, 2000'. The artist has signed his name in Arabic and added his personal seal, which bears his name in Chinese.

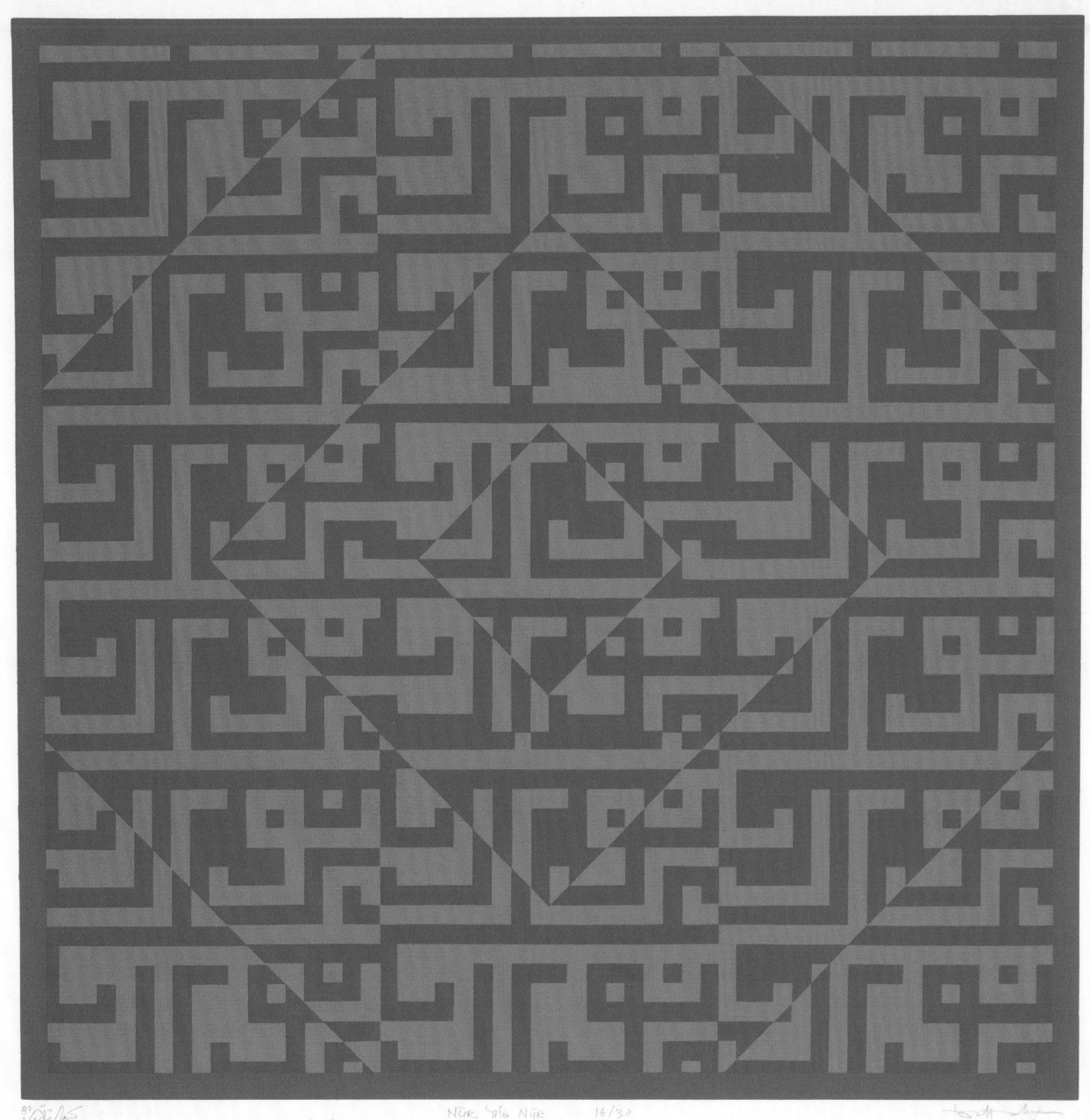

10 Kamal Boullata
Nur 'ala nur

SILKSCREEN ON PAPER (16/30),
1982
H 76.5 cm, W 56.0 cm (paper)
PALESTINE/FRANCE
1997 7-16 03
BROOKE SEWELL PERMANENT
FUND

'*Nur 'ala nur*' ('light upon light') is from the Chapter of
Light (*al-Nur*, Qur'an 24:35): 'Light upon light, God guides
whom He will to his light.'

'Throughout the 1980s, I have been alternatively using verses
from Christian as well as Muslim sources where the word "light"
occurs. Having been raised in a Jerusalem Christian Arab family
I felt free to borrow words from the Holy Qur'an or from the
Sufis as well as from the Gospel of St John and from Church
liturgy where the word appears. Light has been central to my
work and it still is.'

(Personal communication)

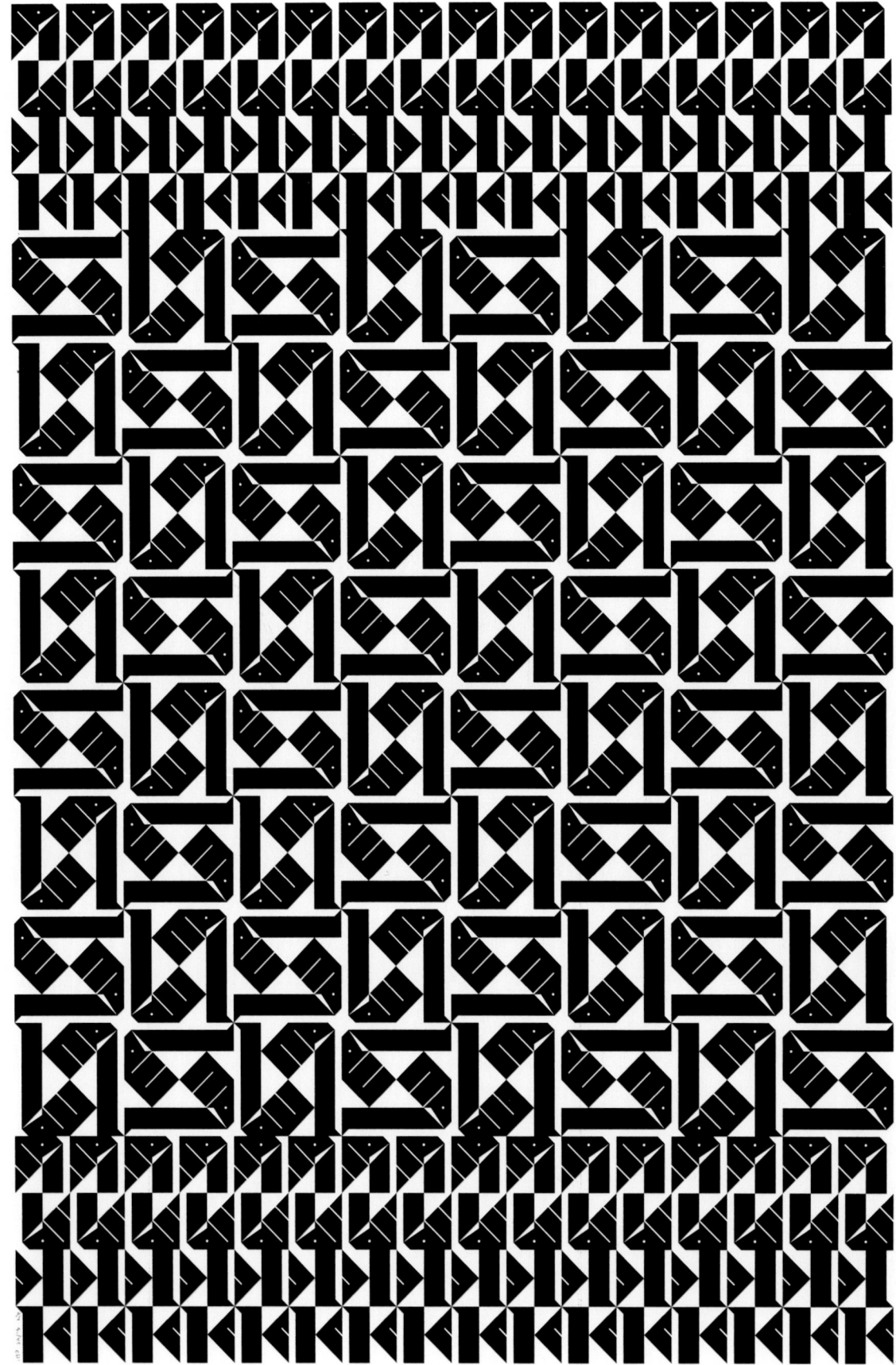

11 Samir al-Sayegh

Allah

SILKSCREEN ON PAPER (32/40), 1996
H 70.0 cm, W 50.0 cm
LEBANON
2005 7-25 03
BROOKE SEWELL PERMANENT FUND

Artist and poet Samir al-Sayegh has
been exploring the possibilities of
Arabic calligraphy for many years.
In this black-and-white composition
he turned the word 'Allah' into
geometric shapes.

12 Mouneer al-Shaarani

By their fruits you shall know them

GOUACHE AND INK ON PAPER, 1993
H 70.0 cm, W 70.0 cm
SYRIA
COLLECTION OF DR ANWAR GARGASH

Shaarani has developed a characteristic calligraphic style,
sometimes echoing traditional scripts. He is inspired by a
wide variety of texts, which include ancient Arabic poetry
and texts from the Qur'an. In this calligraphy he has
chosen a verse from the Bible, Matthew 7.20, which is the
title of this work.

long enough
to defer payment of
the review contract
between passengers and captain.

their bodies
from the Journey

Rome declared
L'arrivée came

Poetry and the rich literary traditions of the Middle East have always played a pivotal role in the cultures of the region. The works grouped together here are inspired by literature and the sentiments evoked by particular writers. The first works in this section include paintings and calligraphies that focus on early Arabic literature. In Arab tribal kingdoms before the coming of Islam, a powerful oral tradition existed that ensured the survival of a remarkable body of Arabic poetry, which continues to be cherished and learnt today. This includes poetry by writers such as Zuhayr ibn Abi Sulma, author of one of the *mu'allaqat*, ('the hanging ones') – the seven odes (*qasidas*) reputed to have been the greatest poems ever composed and honoured by being hung up in the enclosure at Mecca. Poems such as these often dramatically evoke the life of the desert, with tales of love, chivalry, honour and battle written in beautiful language. Iranians, too, have their favourite poets: Umar Khayyam, author of the famous *rubayat*, and Hafez, the acknowledged master of Persian lyric poetry, are both represented here. The writing of modern Iranian poet Forough Farokhzad also appears in Shirin Neshat's work. Another group of works included here show artists drawing their inspiration from modern Arab poets of the region: Adonis, Mahmoud Darwish, Badr Shaker al-Sayyab and others who articulate the sentiments and preoccupations of the modern generation. In many cases artists and poets work closely together, creating printed or hand-crafted books in the tradition of the French *livres d'artistes*. Other artists are moved by the great mystic writers such as Ibn 'Arabi, al-Hallaj and Rumi, and yet others are inspired by stories such as the evocative tales of *The Thousand and One Nights*.

Literature and Art

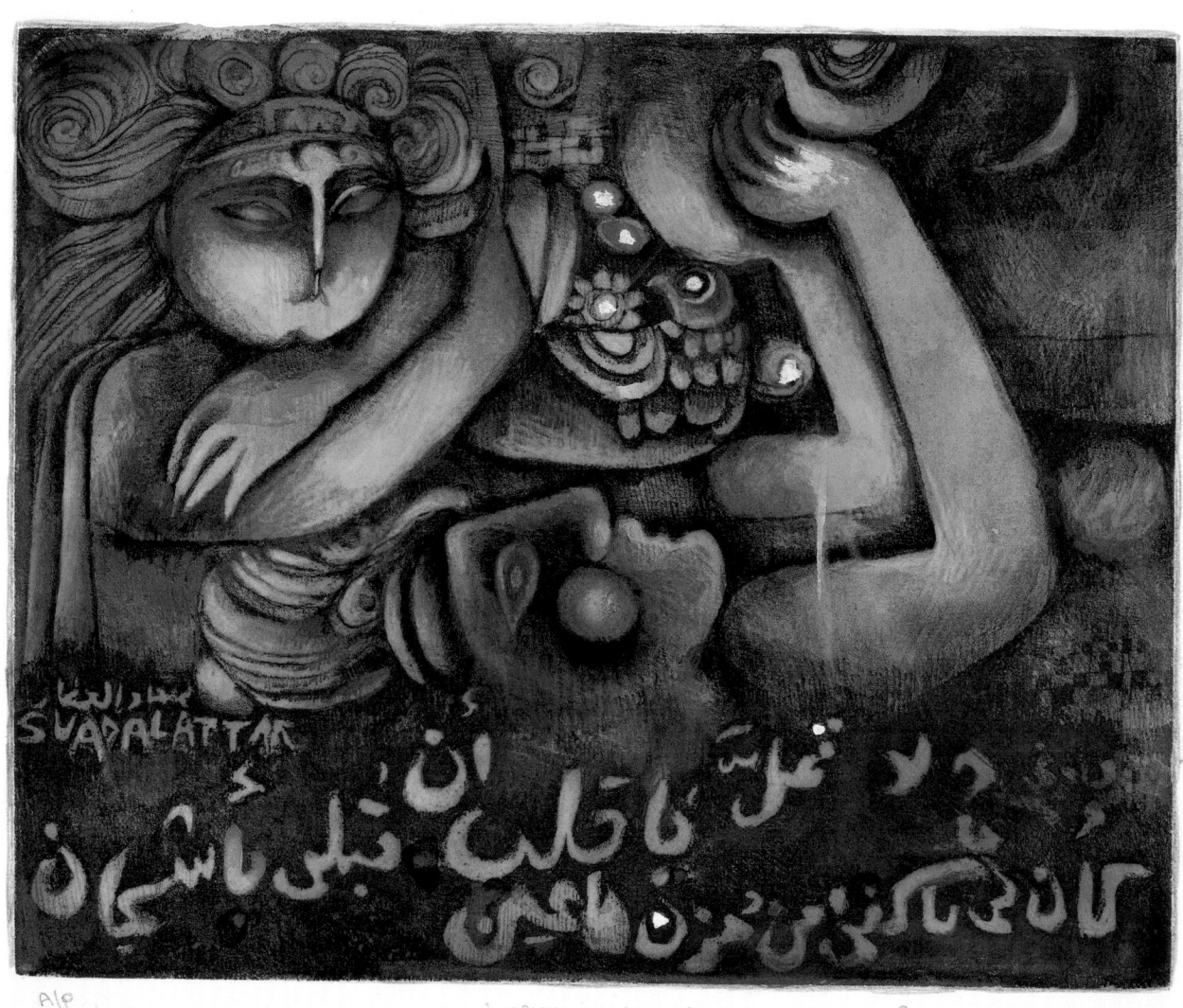

13 Suad al-Attar

Inspiration from a poem

HAND-COLOURED SOFT-GROUND ETCHING
AND AQUATINT, ARTIST'S PROOF, 1999

H 33.0 cm, W 50.0 cm

IRAQ/UK

2000 3-27 02

PRESENTED BY THE ARTIST

'Sorrow alighted in my heart, and I melted
Even as lead melts when engulfed by flame.
Wherefore, O eyes, pour forth thy tears,
 nor stint your flow ...
Nor tire, O heart
At being tried with sorrow.'

(Translated Suheil Bushrui, Attar 2004: 130)

This verse from the early Arab poet Layla bint
Lukayz (al-Udhari 1999: 34) is inscribed at the base
of the painting. Suad al-Attar's work is characterized
by dreamy figural imagery, often drawn from the
ancient Mesopotamian past.

14 Ghani Alani

Untitled

BLACK INK ON PAPER, 1990s
H 60.0 cm, W 50.0 cm
IRAQ/FRANCE
2003 3-28 03
BROOKE SEWELL PERMANENT
FUND

Inscribed in *thuluth* script and written in different directions are verses from the last section of the *mu'allaqa* (or 'hanging poem') of the pre-Islamic poet Zuhayr ibn Abi Sulma (d. 609), one of the pre-Islamic poems regarded as the masterpieces of pagan Arab poetry.

'He, who drives not invaders from his cistern [tribal watering-place and also, metaphorically, his tribe's or his own "pool" of virtue] with strong arms [weapons], will see it demolished; and he, who abstains ever so much from injuring others, will often himself be injured.

Whenever a man has a peculiar cast in his nature, although he suppose it concealed, it will soon be known.

How many men dost thou see, whose abundant merit is admired, when they are silent, but whose failings are discovered, as soon as they open their lips!

Half of man is his tongue, and the other half is his heart: the rest is only an image composed of blood and flesh.'

(Translated Jones 1782. Commentary Julia Bray)

15 Hassan Massoudy

Untitled

COLOURED PIGMENTS ON PAPER, 1995
H 76.0 cm, W 56.5 cm
IRAQ/FRANCE
2005 7-15 01
BROOKE SEWELL PERMANENT FUND

'A gesture from one man to another is more noble than pearls or coral.'

A line from the poetry of Waliba ibn al-Hubab (d. c. 786), very little of which survives. He was born in Kufa in Iraq, wrote poetry about wine and licentious love, and was a teacher of the great Arab poet Abu Nuwas (d. c. 813). The word *insan* ('man' or 'person') is boldly isolated from the others in black. To achieve these broad strokes Massoudy uses a piece of board dipped in coloured pigments. The complete phrase is written in red in the angular *kufic* style of script.

16 Hassan Massoudy

Untitled

ETCHING (48/99), 1982
H 49.5 cm, W 60.0 cm
IRAQ/FRANCE
1988 2-3 01

The phrase *kur wa anta hurr* ('come forward and you are free') is written in bold and repeated in continuous lines that fade away towards the top of the page. It is from the popular epic *sirat 'Antar*, written in about the twelfth century, about the celebrated warrior-poet 'Antara ibn Shaddad (525–615). Chivalrous and brave, he was famously in love with his uncle's daughter 'Abla. However, as a child of mixed birth (with an Arab father and a black mother), he grew up as a slave and was freed only when he was needed to fight for his tribe, the 'Abs. When all appeared lost for the tribe, his uncle begged him to fight and said these words, making it clear to him that he was now a freedman and an Arab (Massoudy 2001a: 54).

16

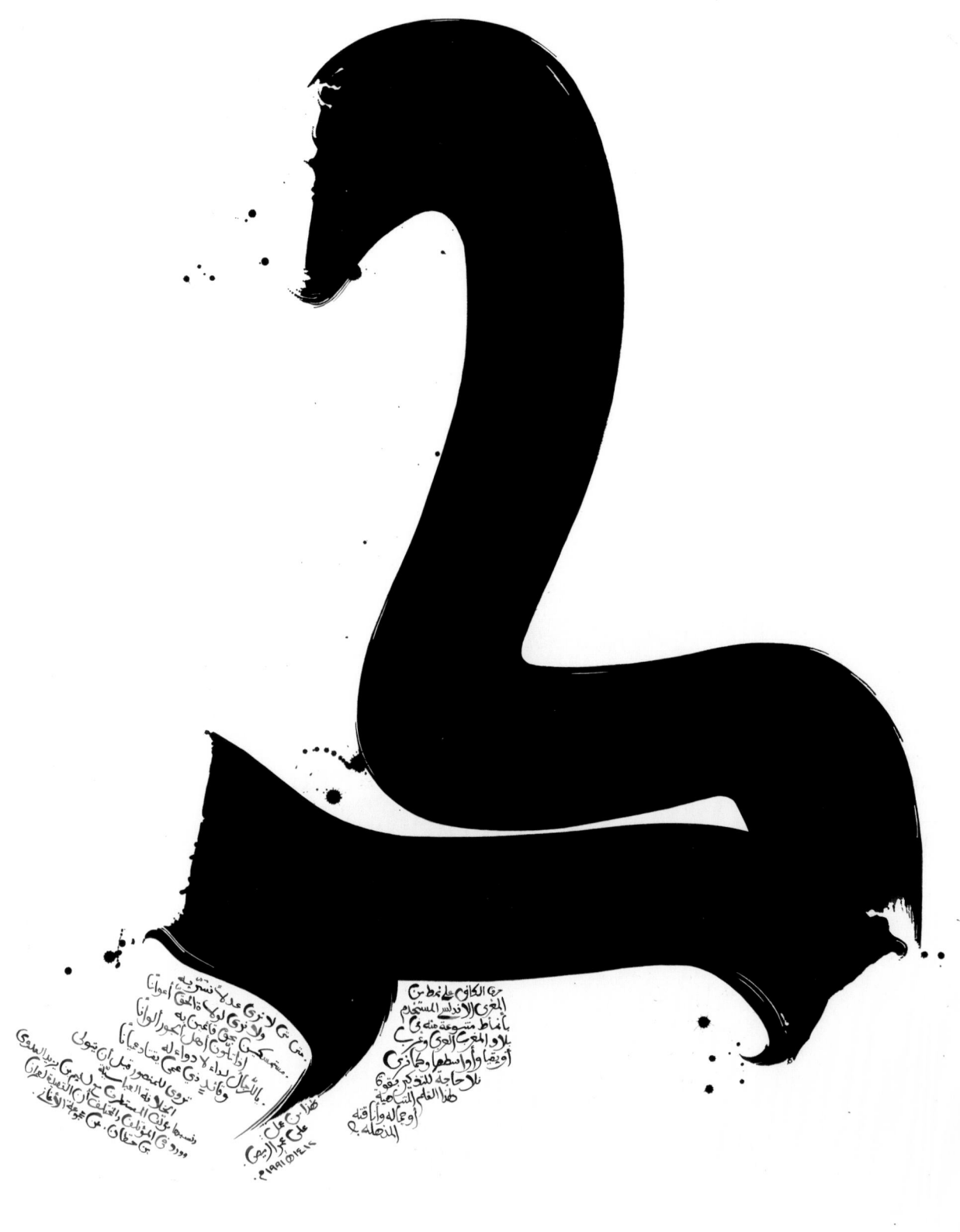

17 Ali Omar Ermes

Harf al-kaf (*Brushwork in Maghribi*)

BLACK INK ON PAPER, 1991
H 153.0 cm, W 123.0 cm
LIBYA/UK
1992 12-15 01
PRESENTED BY THE ARTIST

Ermes focuses on the single letter, in this case the letter *kaf*, 'K', deliberately basing his calligraphic style on the Maghribi script of his native North Africa. In another link with tradition, he signs his paintings in the traditional manner frequently employed by medieval craftsmen: 'this is among the work of ...'. His dramatic works are always given an additional layer of meaning by the inclusion of tiny lines of poetry that have a bearing on the behaviour of those in power and so on. The verse he has chosen here is attributed to Caliph al-Mansur (d. 775) and comments on the injustice of the society of the day, lamenting its lack of concern for the plight of the poor.

18 Ali Omar Ermes

Shadda

WATERCOLOUR AND GOLD ON PAPER, 1980
H 43.0 cm, W 42.5 cm
LIBYA/UK
1987 2-2 01

In this painting Ermes has featured the *shadda*, the symbol used in Arabic to double letters. Around the *shadda* he has inscribed passages from the *Kitab al-bayan wa al-tabyin* (*The book on elegance of expression and clarity of exposition*) by al-Jahiz (c. 776–868/9). A prolific writer and the leading literary personality of his age, he includes sayings by various poets and writers associated with Basra in Iraq – such as the blind poet Bashshar ibn Burd (714–84) and Hasan al-Basri (d. 728), the latter known for his short pious treatises. One of the passages featured in this composition is a gnomic verse taken from a praise poem said to be by Bashshar:

'If you see the need to take advice, then rely on that of
 an eloquent or a decisive man.
Do not be ashamed of seeking counsel from others: [a bird's]
 flight feathers are supported by those behind them.
Let weak men dawdle. Don't go to sleep! Resolve never sleeps.'

(Translated Julia Bray)

19 Jila Peacock

Ten poems from Hafez

HAND-MADE BOOK OF 10
SILKSCREENS WITH POEMS ON
JAPANESE PAPER, GLASGOW
PRINT STUDIO, 2004
H 33.1 cm, W 43.2 cm (closed)
IRAN/UK
2006 2-8 01
BROOKE SEWELL PERMANENT
FUND

'Until your hair falls through the fingers of the breeze,
My yearning heart lies rent in two with grief.
Black as sorcery, your magic eyes
Render this existence an illusion.
The dusky mole encircled by your curls,
Is like the ink-drop falling in the curve of J,
And wafting tresses in the perfect garden of your face,
Drop like a peacock falling into paradise.'

(Translated Jila Peacock from the Diwan of Hafez; see also Bell 1995)

Following the tradition of zoomorphic calligraphy which
became particularly popular in Iran and Turkey in the
nineteenth century, in this book Iranian-born Jila Peacock
has used the Persian text of whole poems from Hafez, the

fourteenth-century lyric poet of Shiraz, to create images of
animals mentioned in the poems, such as the peacock
illustrated here. Her approach is highly innovative. Using
subtle colours and the *nasta'liq* script, developed in the
fifteenth century specifically for writing in Persian, she
builds up her legible word shapes by squeezing them into
the creature's silhouette. For Jila, whose mother tongue is
English but whose first written language was Persian, the
making of this book marks a personal journey, revisiting
the culture of her early childhood. In a recent interview she
said, 'I am really a painter, not a calligrapher, and my aim in
making these visual translations is to show an artistic
response to the luminous world of Hafez's love poems.'

19

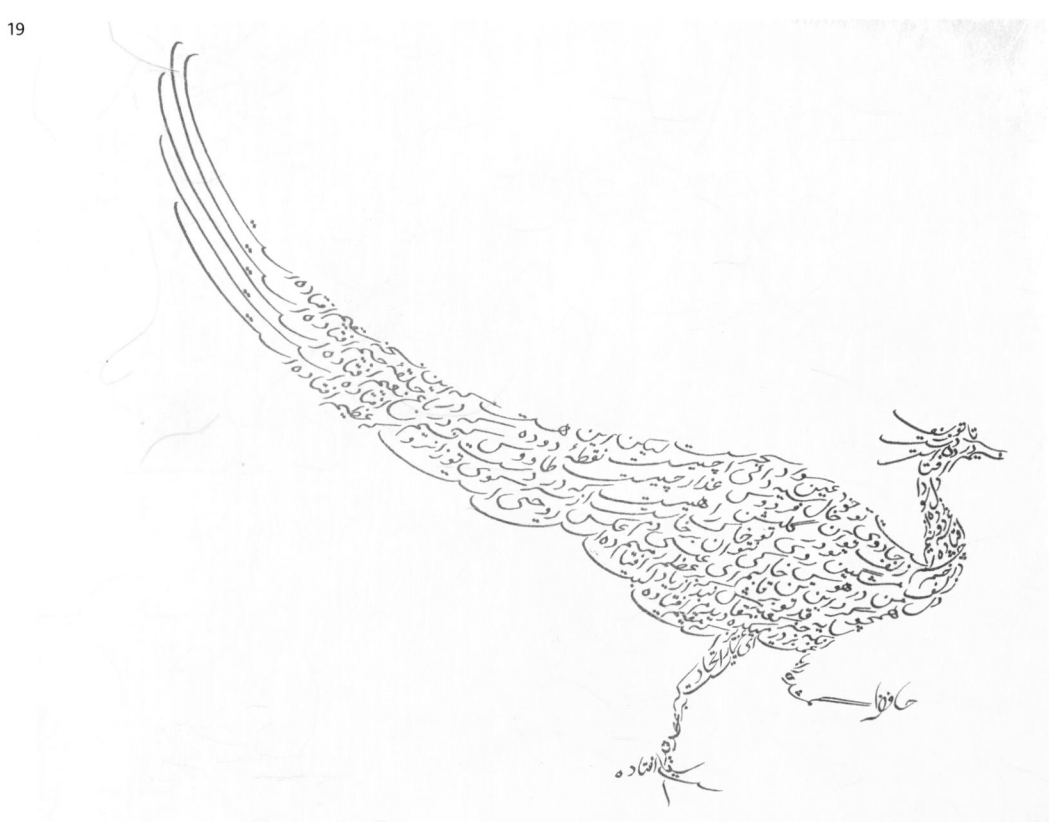

20 Farhad Moshiri

Drunken lover

OIL ON CANVAS, 2003
H 280.0 cm, W 175.0 cm
IRAN
2005 7-6 01
BROOKE SEWELL PERMANENT
FUND

'The enchanted lover, always drunk and disgraced,
Frenzied, love-mad and crazed.
When sober, grieving he will be
When drunk again, what will be, will be.'

(Translated Farhad Moshiri)

These lines by the celebrated Iranian poet Umar Khayyam
(d. 1123), inscribed in *nasta'liq* script on a jar, have been
described as a type of 'blasphemous prose' that Khayyam
wrote alongside his poetry. In Moshiri's words, 'I see a

poem written on a wall, bumper sticker or TV ... Iranians
utter poems casually without knowing who it's from ...
It affects me one way or the other so I use it' (personal
communication). Moshiri began his jar paintings in 2001.
The form reflects for him a fascination with archaeology,
in particular with the 'aesthetics of excavation, the formal
aspect of the work, the aged look and everything, rather
than the history unearthed'. The surfaces of his canvases
are therefore deliberately cracked (Singh-Bartlett 2005: 76).

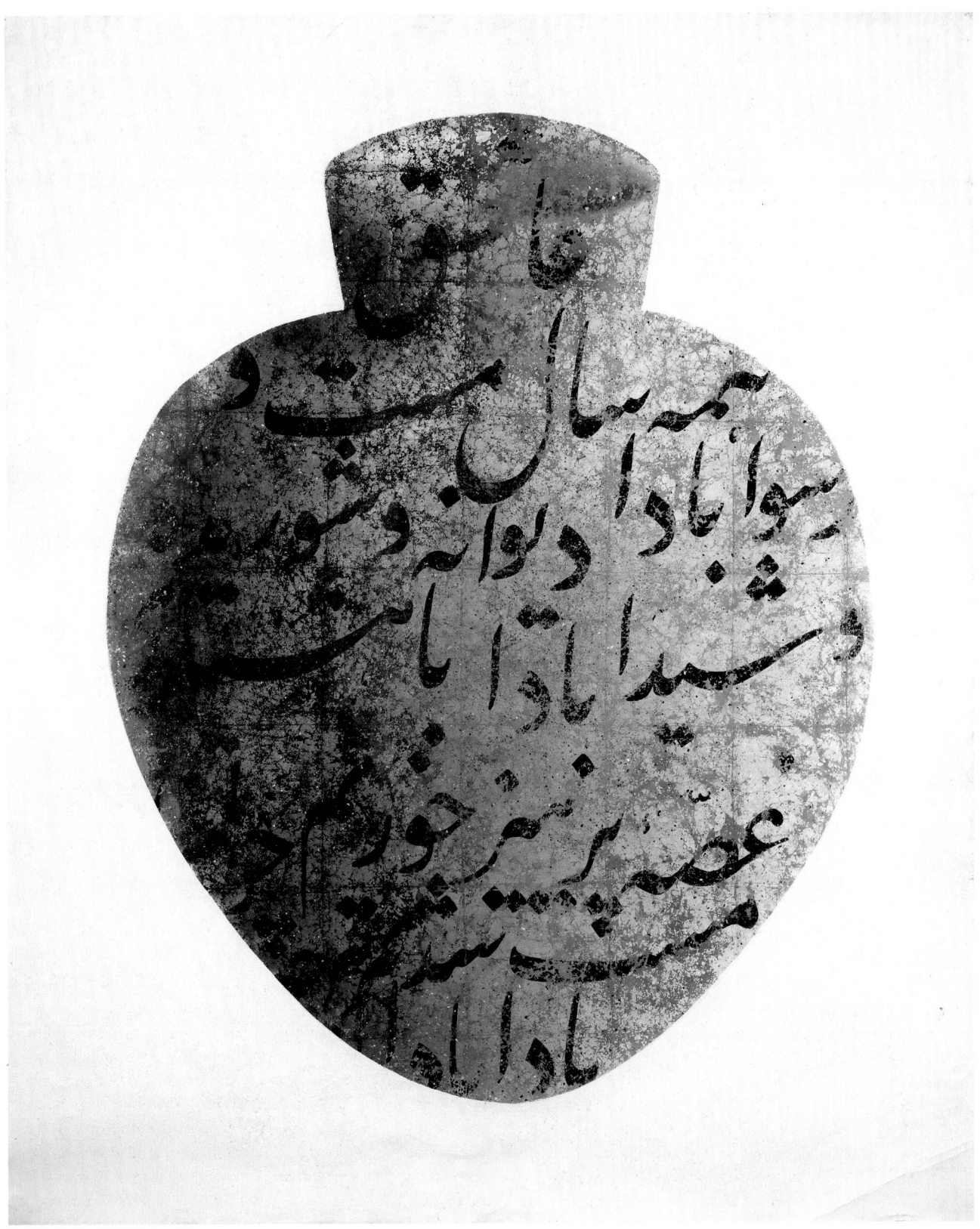

21 Shirin Neshat
Offered eyes

BLACK-AND-WHITE GELATIN
PRINT WITH INK, 1993
W 22.0 cm, H 33.5 cm
IRAN/USA
PRIVATE COLLECTION

Inscribed within the eye is the poem 'I feel sorry for
the garden', by Iranian poet Forough Farokhzad
(1935–67):

'No one is thinking about the flowers
No one is thinking about the fish
No one wants to believe
that the garden is dying
that the garden's heart has swollen under the sun
that the garden
is slowly forgetting its green moments.'

(Translated Shirin Neshat)

Many of Shirin Neshat's images are focused on Iranian
women. She questions stereotypes and passionately
believes in women's emancipation, as did Forough
Farokhzad before her untimely death in 1967. This
poem is included in the collection *Let us Believe in
the Beginning of the Cold Season*, published
posthumously in 1974.

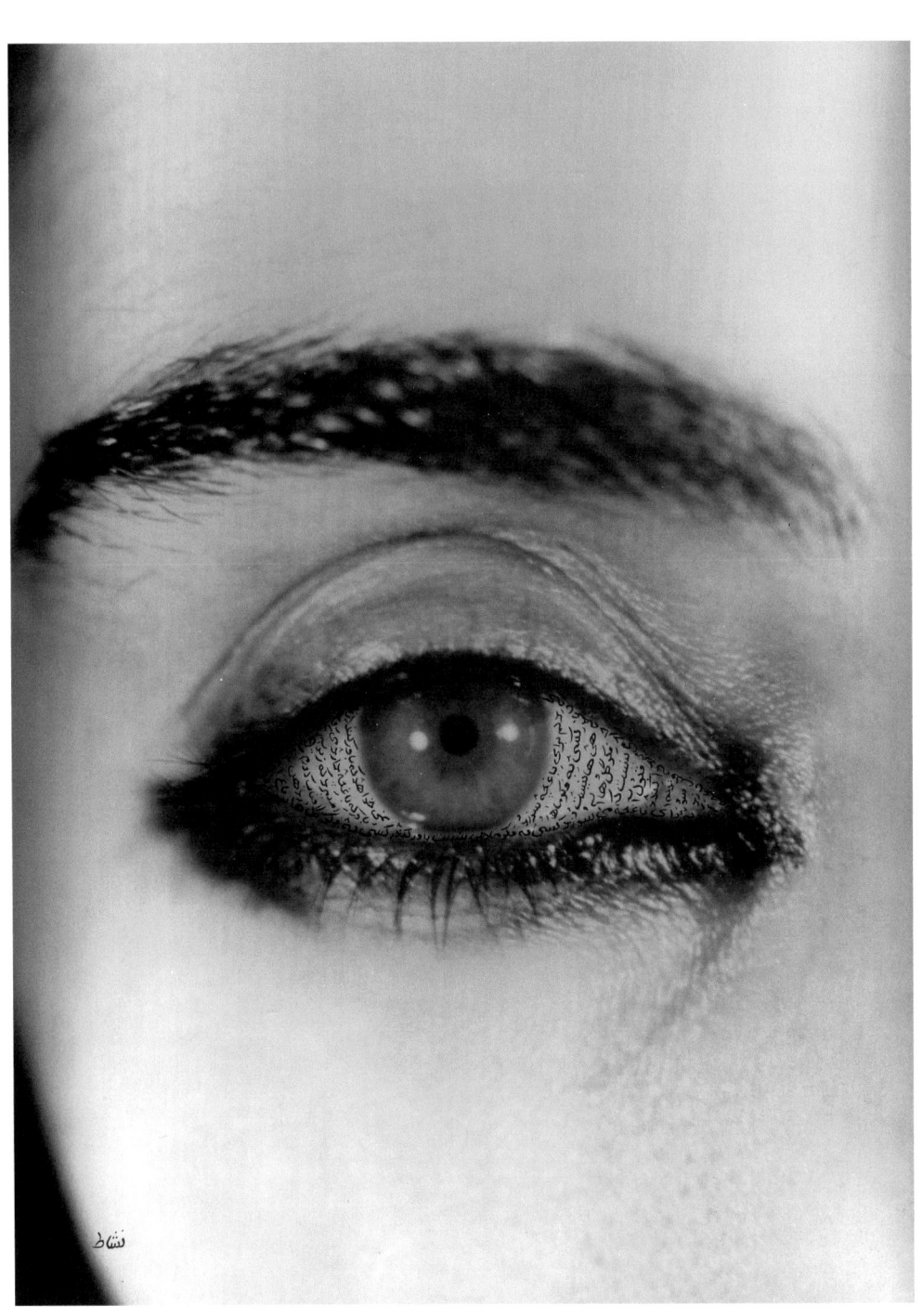

اليوم نهار مبارك يوم اجازة للقناصه

انتيفون تحد الطه نجب

اذ تموت اليوم نهار مبارك *

على خط التماس والا زرقاون عيناها

لا غضب فيهما لا نقمة لا ألم ملقى

على وجهها ودفترها في كل غضب من

22 Etel Adnan

Nahar mubarak
(Blessed day)

JAPANESE FOLD-OUT BOOK,
1990

H 16.0 cm, W 190.0 cm
(opened)

LEBANON/USA

1990 11-17 01

The writer and artist Etel Adnan began working with
Japanese folding paper during the 1960s. Combining her
interests in literature and art, her now renowned *livres
d'artistes*, in which she transcribes in her own hand Arabic
poetry from a variety of sources, have placed her with Iraqi
artist Shakir Hassan al-Said firmly at the centre of the
genre known as *hurufiyya* (see pp. 15–19). This poem,
'Blessed day', is by the Lebanese poet Nelly Salameh Amri,
now living in Tunis. It was written during the Lebanese civil
war and its central figure is Antigone. It begins:

'Today is a blessed day. A day off for the snipers.
Antigone addresses the King. She has to die. Today is a blessed
day. She has to express questions which carry no anger, no need
for revenge, no sorrow. But her duty is written on his dark skin as
sorrow, revenge and anger. Antigone's action is due to her
compassion for the dead and not to any love for the living.'

(Translated Simone Fattal)

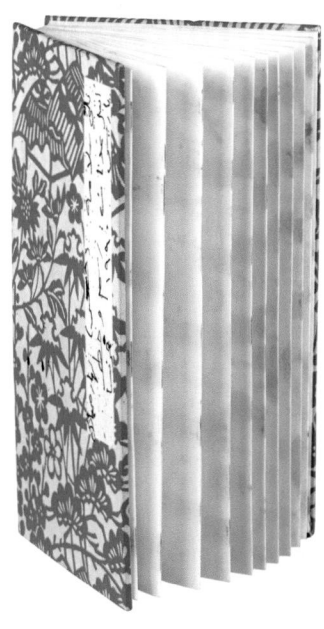

أول الكلام

جسدانا هديرٌ /
تقولين ـ أصغي
أقول وتُصْغين ، تَختلطُ الكلماتُ
جسدانا ذبائح / تهوين أهوي
حولنا لهبٌ وتخايلُ/ تهوين أهوي

تتجمّع بيني وبينكِ، تشتعل الكلماتُ.

23 Kamal Boullata

Beginnings

HAND-MADE BOOK, (27/40),
PRODUCED BY PYRAMID
ATLANTIC, 1992
H 21.5 cm, W 11.5 cm (closed)
PALESTINE/FRANCE
1997 7-16 01
BROOKE SEWELL PERMANENT
FUND

'Our two bodies thunder
You say, I listen
I say you listen, words mingle.
Our two bodies and offering
You fall, I fall
Around us flares, fantasies
You fall, I fall.
Between you and me
Words gather
And blaze.'

'Beginnings of words' by Adonis, the nom de plume of
the Syrian-born poet Ali Ahmad Said (b. 1929), now
naturalized Lebanese and one of the foremost poets of
the Arab world. The collection *Beginnings* draws together
eight of his poems, transcribed in Arabic and translated
into English by Kamal Boullata and Mirene Ghossein.
Geometric patterns on the cover and within the book
in different colours echo the mood of the poems.

24a–b Dia al-Azzawi

Adonis

1 ORIGINAL GOUACHE AND
5 HAND-COLOURED
LITHOGRAPHS (1/6), SERIF
GRAPHICS AND AL-SAQI
BOOKS, IN HAND-PAINTED
FOLDER AND BOX, 1990
H 39.0 cm, W 109.5 cm
(opened)
H 41.5 cm, W 30.4 cm (box)
IRAQ/UK
1990 11-23 1

Al-Azzawi has selected five poems by Adonis in this
collection, writing them out by hand, each illustration
evoking the particular mood of each poem. Two of these
fold-out lithographs are shown here. The first (24a)
consists of lines from Adonis's well-known narrative poem
'A tomb for New York', written in 1971 following an
extended stay in the city. This passage highlights his
concerns about racial inequality in the United States:

'HARLEM

I do not come from outside. I know your rancour. I know its
good bread. There is no cure for famines except sudden thunder,
and there is no end for prisons except the thunderbolt of
violence. I see your fire advancing under the asphalt in hoses
and masks, in piles of garbage carried on the throne of the
freezing air, in outcast footsteps wearing the history of the wind
like a shoe.'

(Translated Jayyusi and Brownjohn, in Jayyusi 1987: 146)

The second (24b) illustrates lines from Adonis's poem
'This is my name', written in 1968.

24a

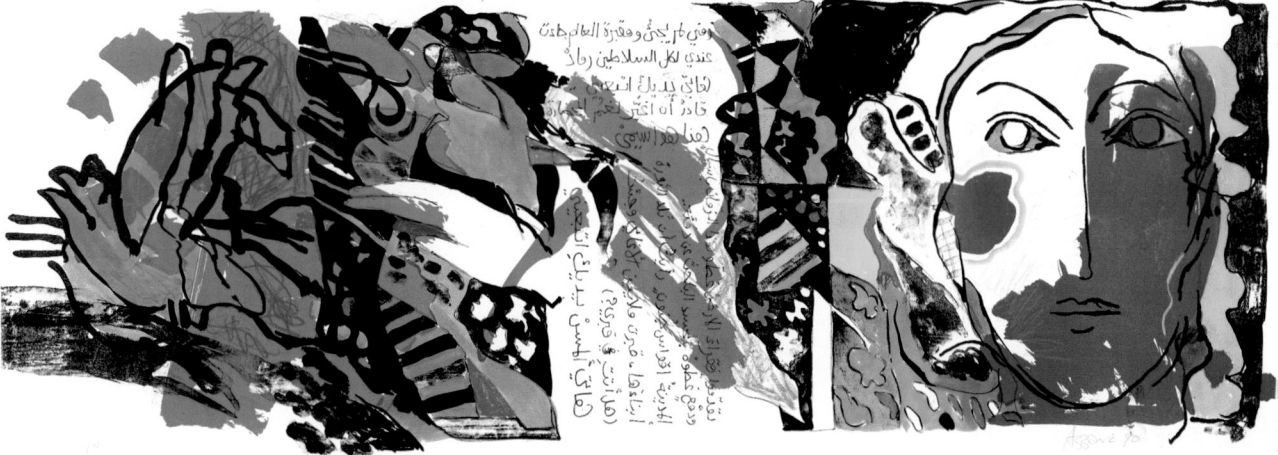

24b

25 Ghassan Ghaib

Al-Mumis al-amya

BOUND BOOK, HAND-MADE,
34 PAGES, ACRYLIC AND
WATERCOLOUR ON PAPER, IN
PAINTED WOODEN BOX, 2000

H 29.5 cm, W 29.5 cm

IRAQ

LENT BY DIA AL-AZZAWI

'Night closes in once more, then the city and the passers-by
Drink down the dregs, like a sad song.
The street lamps, like Oleanders, have blossomed,
Like the eye of Medusa malevolently turning every heart to
 stone,
Like the omens that foretold fire to the inhabitants of Babylon.
From what forests did this night come? From what caves?
From what wolf's den?
From what nest among the graves did it rise, flapping its wings,
 dark brown like a crow?'

(Translated De Young 1998: 234)

The first eight lines of '*al-Mumis al-amya*' ('The blind
whore'), an epic poem of 500 lines set in 1950s Baghdad
by Iraqi poet Badr Shaker al-Sayyab (1926–64). This book
consists of the beginning of the poem and a series of
Ghaib's abstract illustrations, one of which is shown here.

26 Rachid Koraïchi

L'enfant jazz

UNBOUND BOOK, 28 PAGES
OF TEXT, 28 PAGES OF
ILLUSTRATIONS. LITHOGRAPHS
(4/98), 1998

L 94.0 cm, W 14.0 cm

ALGERIA/FRANCE

2005 7-9 03

BROOKE SEWELL PERMANENT
FUND

Almost reminiscent in form of Tibetan palm-leaf texts, the poetry on single folios is by Algerian novelist and poet Mohammed Dib (1920–2003). Expelled from Algeria in 1959 because of his support for the Algerian war of independence, remarkably he settled in France and wrote numerous novels in French. In 1994 he received the Grand Prix de la Francophonie from the Académie Française. Written in 1998, *L'enfant jazz* is an abstract narrative poem about aspects of life, loss and war seen through the eyes of a young boy. Jazz represents the unexpected, while the child evokes conscience. The Arabic text is written by the calligrapher Abdelkader Boumala. Koraïchi's lithographs in sepia and black inks consist of lines of Arabic (sometimes in reverse), lines of poetry in French, and signs and symbols that evoke the Islamic magical vocabulary. They are the hallmark of Koraïchi's style, which he has developed on a variety of media, including ceramics and textiles.

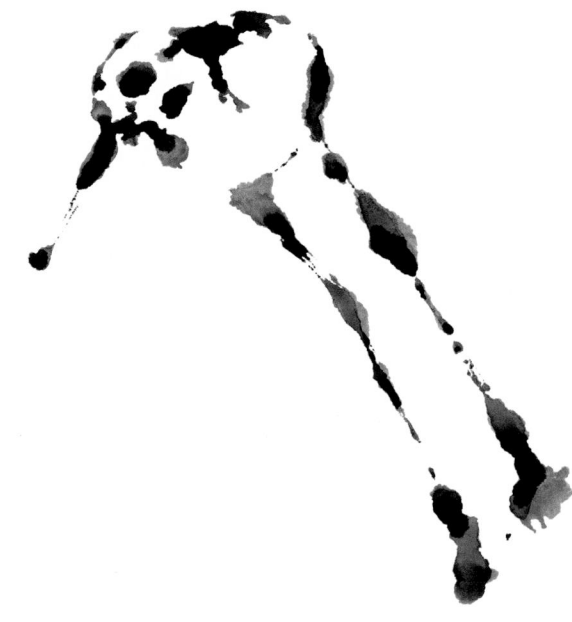

27a

27b

27a–d Abdullah Benanteur

Birds die in Galilee

UNBOUND HAND-MADE BOOK, CHINA INK, WATERCOLOUR AND MONOPRINT ON 30 FOLDED SHEETS OF PAPER, 2001

H 25.5 cm, W 22.0 cm (closed)

ALGERIA/FRANCE

2006 2-3 01

BROOKE SEWELL PERMANENT FUND

'Flocks of birds fell like paper
Into the wells
And when I lifted the blue wings
I saw a growing grave.
I am the man on whose skin
Chains have carved a country.'

(Translated Kabbani 1986: 45)

The last verse of *Birds die in Galilee* by the Palestinian poet Mahmoud Darwish (b. 1942). Each of the 30 pages is made up of three sections: two outer leaves (27a and 27b), one of which (27a) has the verse of poetry, and an inner page with a separate monoprint (27c).

27c

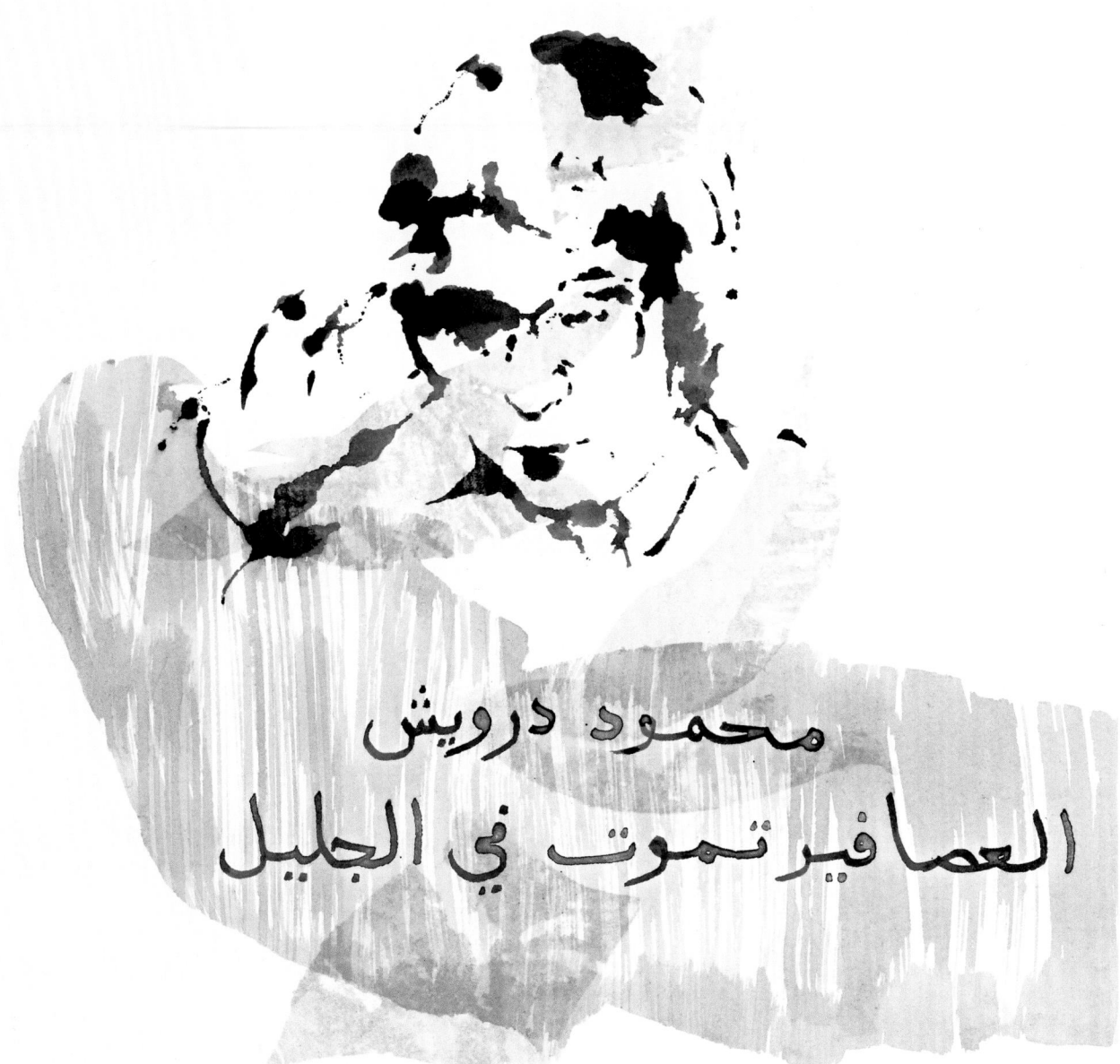

محمود درويش
العصافير تموت في الجليل

27d cover, with portrait of Mahmoud Darwish

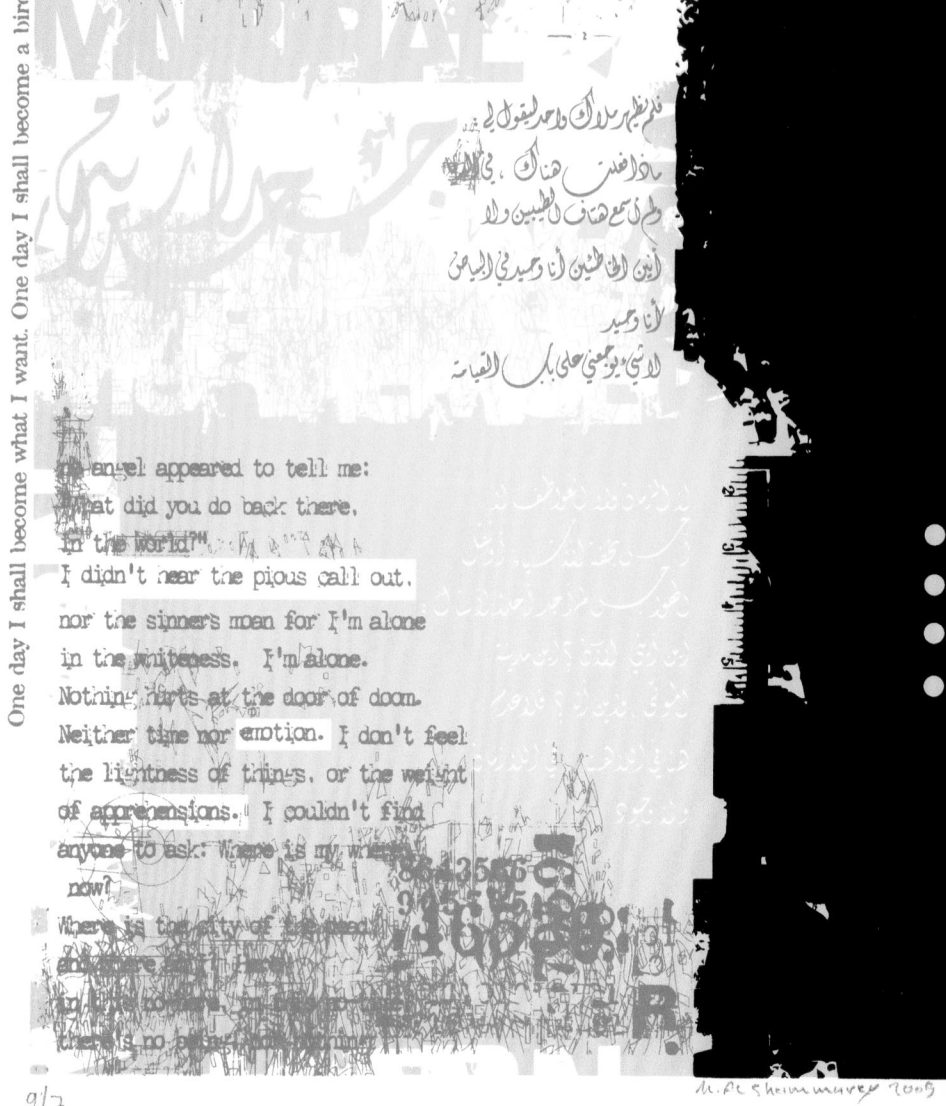

28a

28a–b Mohammed al-Shammarey

Mural

BOOK, 9 SILKSCREENS (9/17), IN WOODEN BOX AND SLIP CASE, 2005

H 47.0 cm, W 41.7 cm (box)

IRAQ

2006 1-28 01

BROOKE SEWELL PERMANENT FUND

'No angel appeared to tell me:
"What did you do back there, in the world?"
I didn't hear the pious call out,
nor the sinners moan for I'm alone
in the whiteness. I'm alone.
Nothing hurts at the door of doom.
Neither time nor emotion. I don't feel
the lightness of things, or the weight
of apprehensions. I couldn't find
anyone to ask: Where is my where now?
Where is the city of the dead,
and where am I? Here
in this no-here, in this no-time,
there's no being, nor nothingness.'

(Translated Boulus 2000)

An extract from the poem *Mural*, written by Mahmoud Darwish (b. 1942) in 1999 after suffering a near-fatal illness. Although poems such as these are intensely personal, as the foremost Palestinian poet Darwish is often read as the voice of his people. For al-Shammarey, Darwish's questioning of life and death not only echoed his own feelings but reminded him strongly of the *Epic of Gilgamesh*.

'The set of paintings are scattered around the black circle that represent immortality, as if they were draft texts written by Darwish during his illness ... it shows readiness, at times, to receive death, while at other times appearing totally indifferent to either life or death.'

(Personal communication)

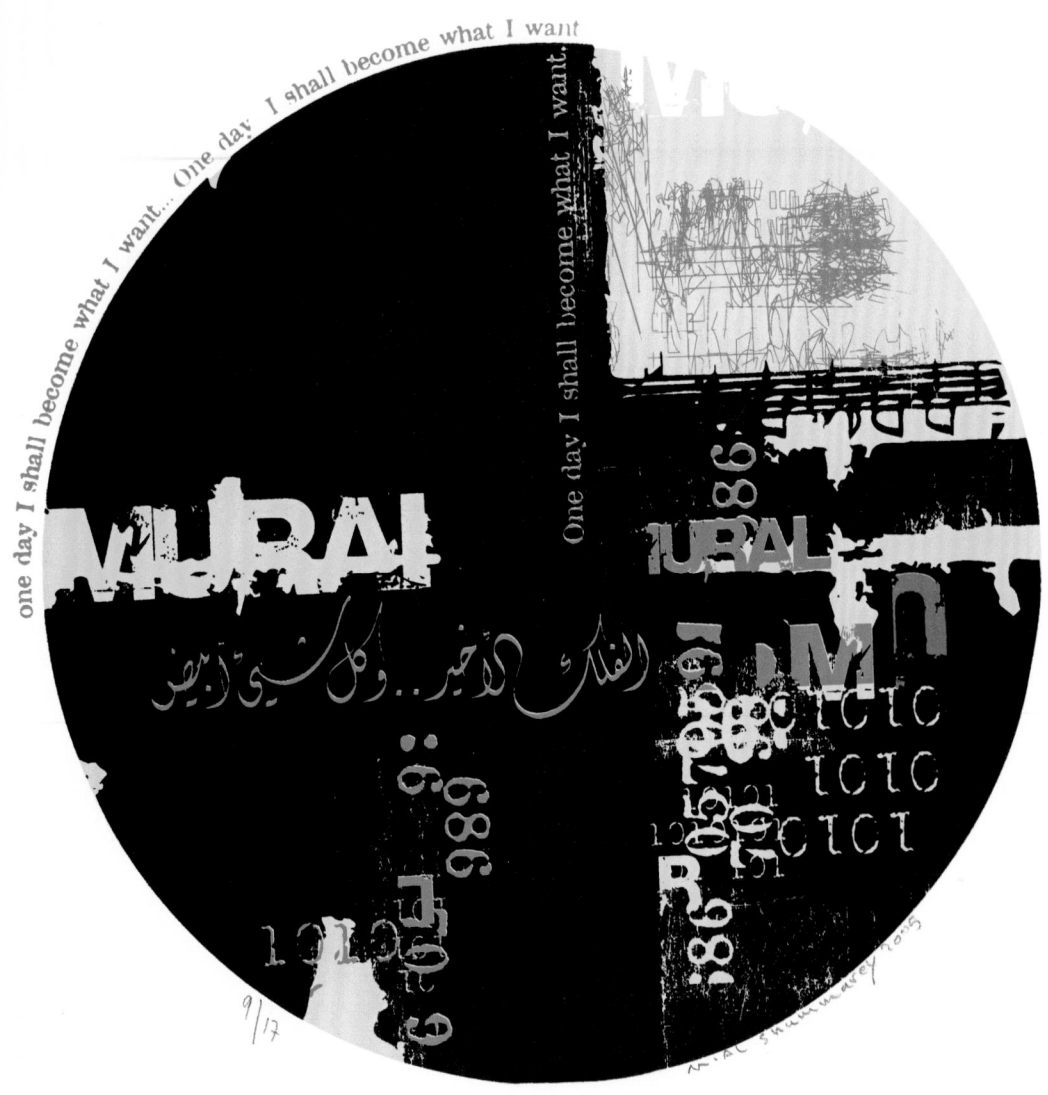

28b cover

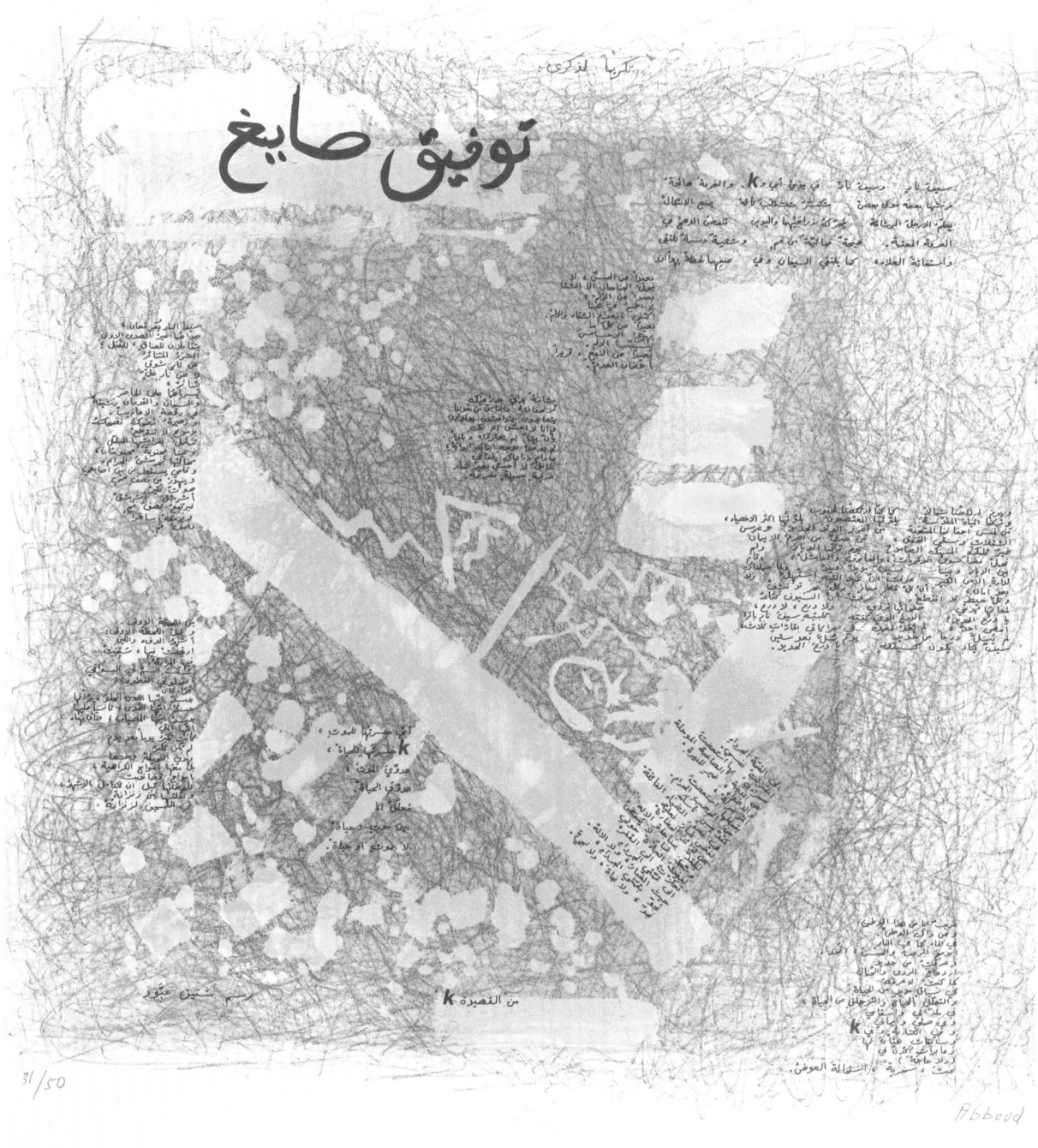

توفيق صايغ

29a

29a–b Shafic Abboud,
Dia al-Azzawi and Mohammed
Omar Khalil

Homage to Tawfiq Sayegh (a),
*Khalil Hawi and Salah Abd al-
Sabbour* (b)

A SET OF 3 LITHOGRAPHS AND 3 POEMS
(31/50), 1988

H 65.0 cm, W 56.2 cm (paper)

LEBANON/FRANCE, IRAQ/UK, SUDAN/USA RESPECTIVELY
1991 4-9 01-03

This collection was published by Syrian critic and poet
Riyad al-Rayyes in 1988 to mark the London Festival
of Arab Culture. Illustrated here are Khalil's print (29b)
depicting wrestlers for Egyptian poet Salah Abd al-
Sabbour (b. 1931) and Abboud's abstract composition
'*Qasida K*' (29a) by Palestinian poet Tawfiq Sayegh
(1923–71), lines from which are as follows:

'Detours and evasions
and no way forward.
The rain never slackens
it pours over London's
white on white faces.
A London of dark skies, walls, and stone hearts
One large unquenchable lavatory.
My chest weighs with the nightmare of days ...'

(Translated Adnan Haydar and Jeremy Reed, Jayyusi 1992: 16–17)

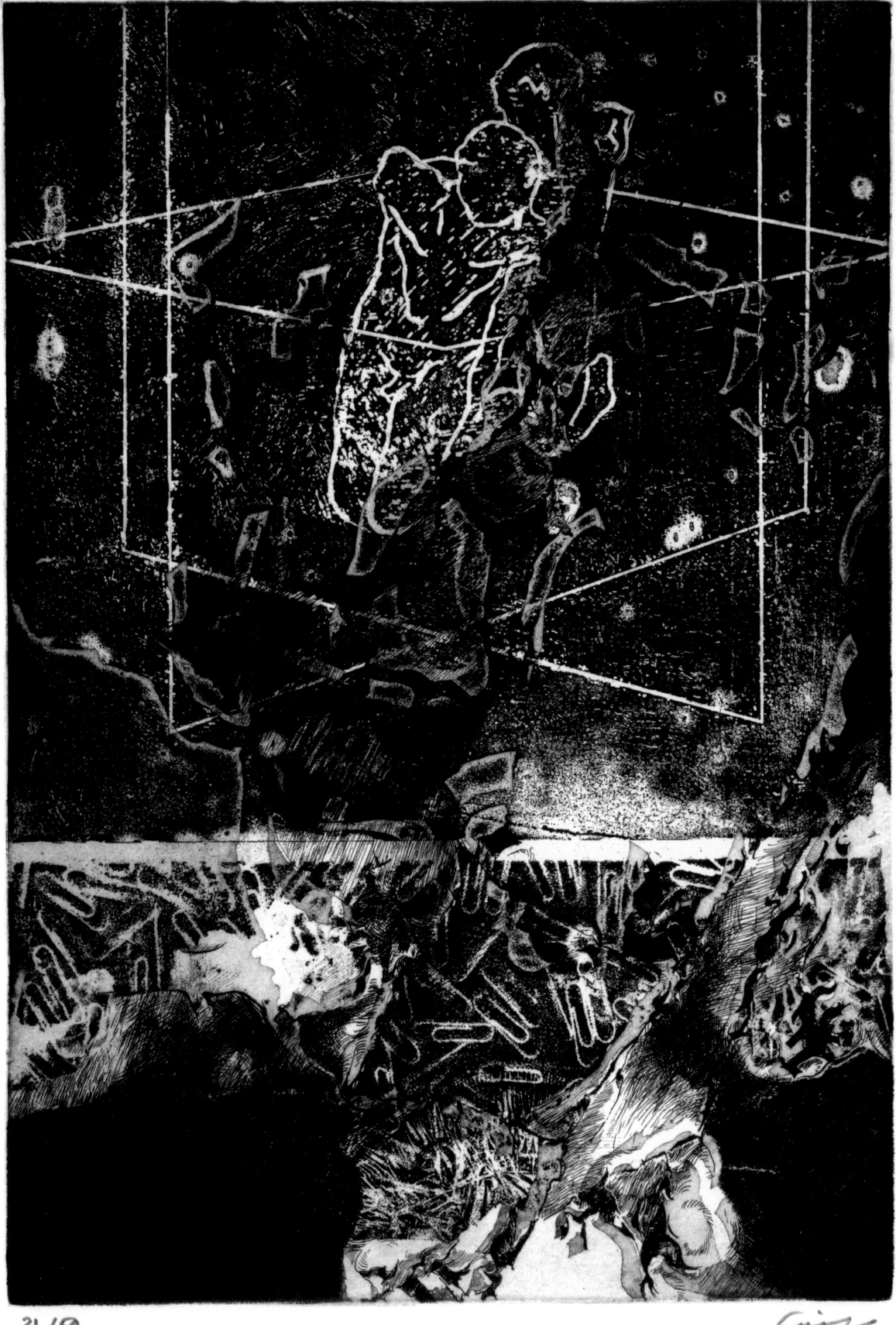

31/50

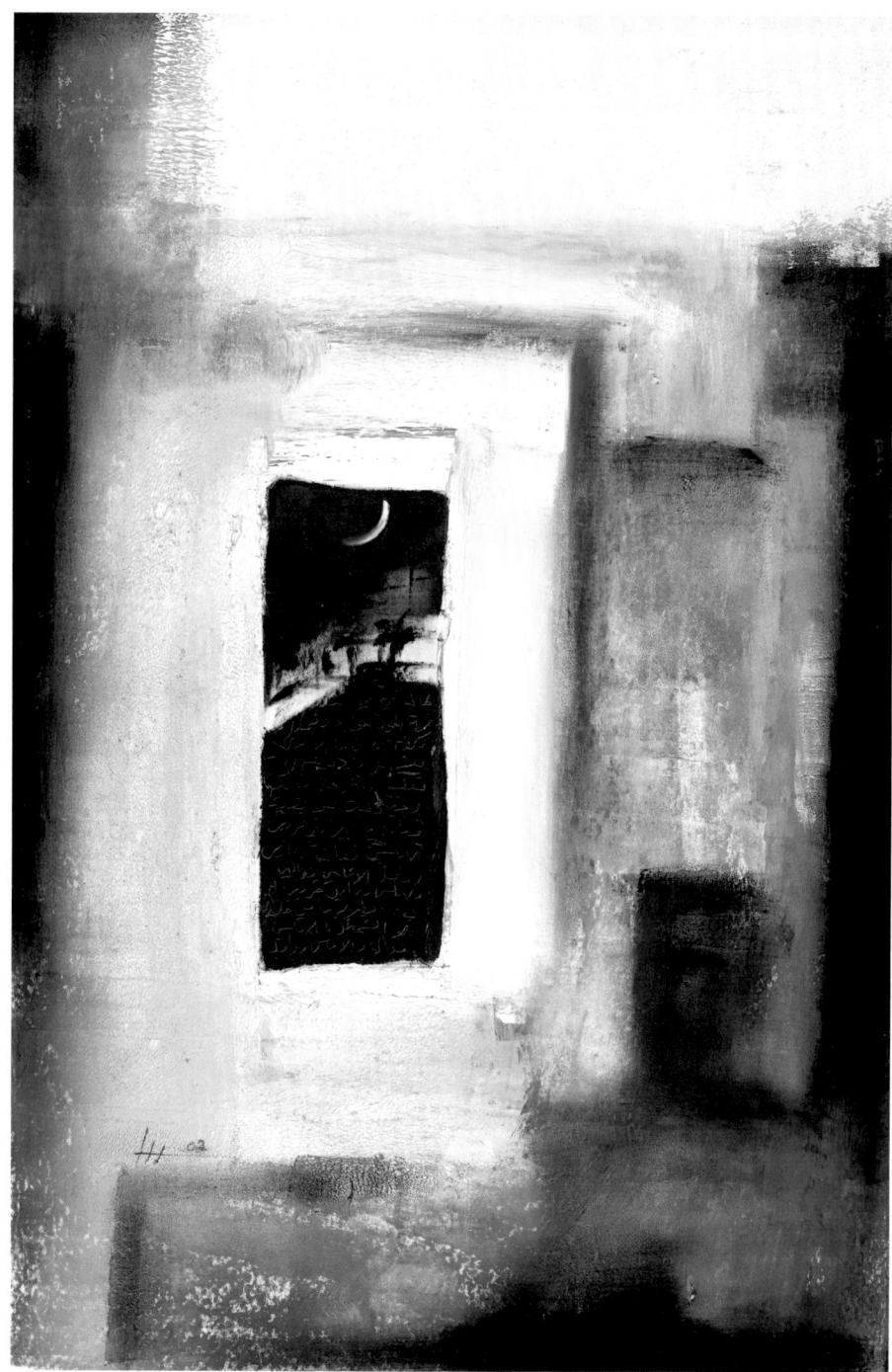

30 Sina Ata

The grey years

OIL ON PAPER, MOUNTED
ON CARD, 2002
H 46.0 cm, W 31.0 cm
IRAQ/JORDAN
2005 7-21 03
BROOKE SEWELL PERMANENT
FUND

'In one glorious town
I had friends and orchards
and stars that bred light to others
and vineyards where time ran up and
 down and wondered
and shoreless dreams on a voyage of
 honour
What has become of my town
but desolate ruins,
vacant evenings and
the faces of the departed.'

(Translated Sina Ata)

The first verse of the poem 'Glorious town', inscribed within the painting. This painting is one of a series of eight done for a book of Arabic poetry of the same name, written by the artist's father Ata Abdul Wahab. He started writing poetry in prison in Iraq where he spent thirteen years between 1969 and 1975, a period he refers to as his 'grey years'. This title is inspired by a time when rain did not fall for a whole year, causing all the crops to die.

31 Satta Hashem

O misfortunate land

INK AND WHITE PIGMENT ON
PAPER, 2001

H 28.0 cm, W 20.0 cm

IRAQ/UK

2005 7-22 02

BROOKE SEWELL PERMANENT
FUND

'From what breach rises the smoke
like a banner of the dead
hoisted en route to you, Amura?
Which martyr, save you my friend, has not returned
And been admitted into this abandoned garden?
Blind as I am, but our dry throats united us in thirst in exile;
Oh what agony your conquered land gives me.'

(Translated Faleh Jabbar)

From 'O misfortunate land' by Iraqi poet Fawzi Karim. Born in Baghdad in 1945, Karim has been living in Britain since 1978. In this dark poem, written in November 1982, Karim describes indirectly the tragedy of the Iraqi wars. In his drawings Hashem has tried to show the word and the image as part of this battlefield, not as a picture of it. He returned, he says, to the ancient Assyrian reliefs and mythology 'to mix them with our real and unreal lives' (personal communication).

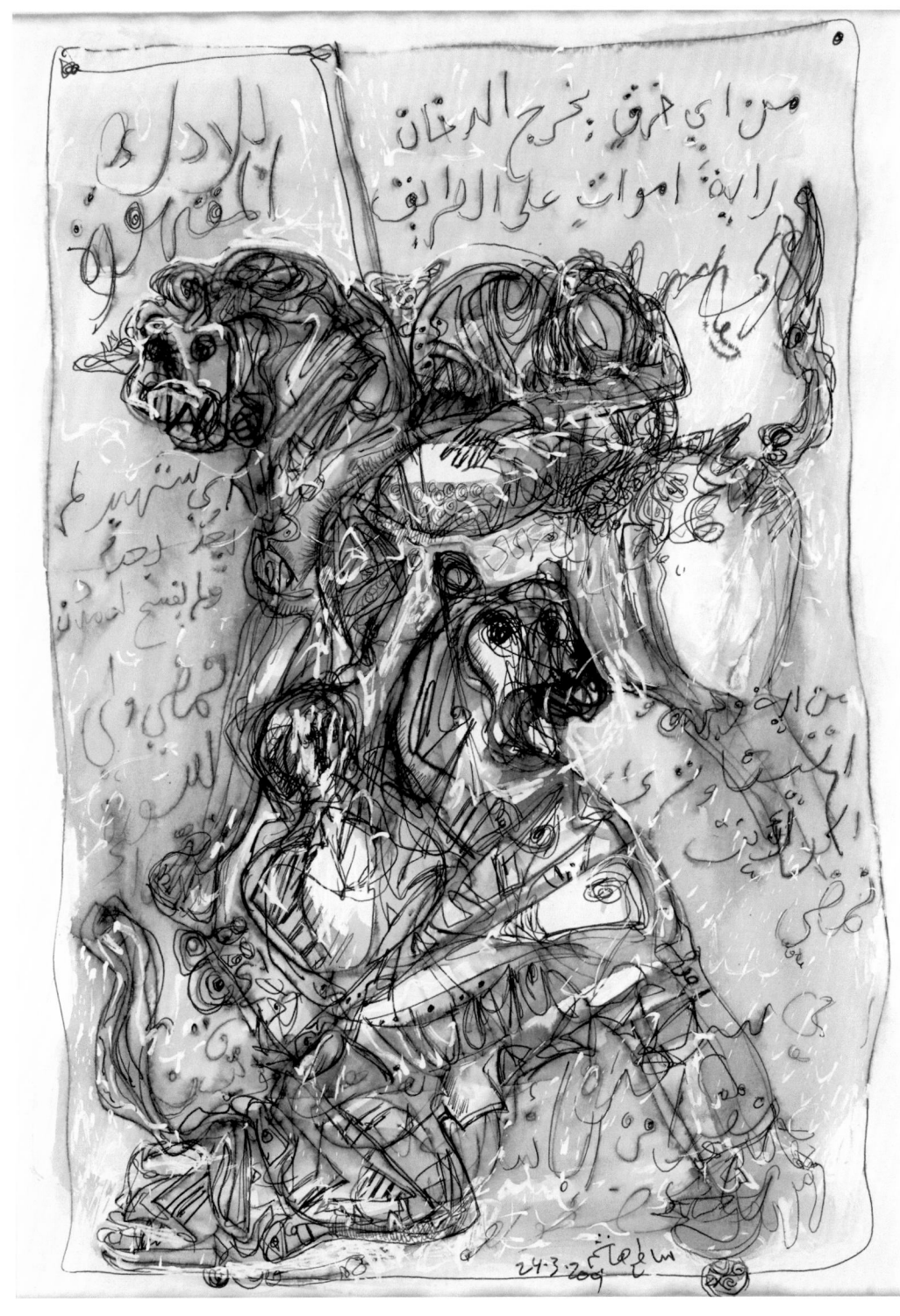

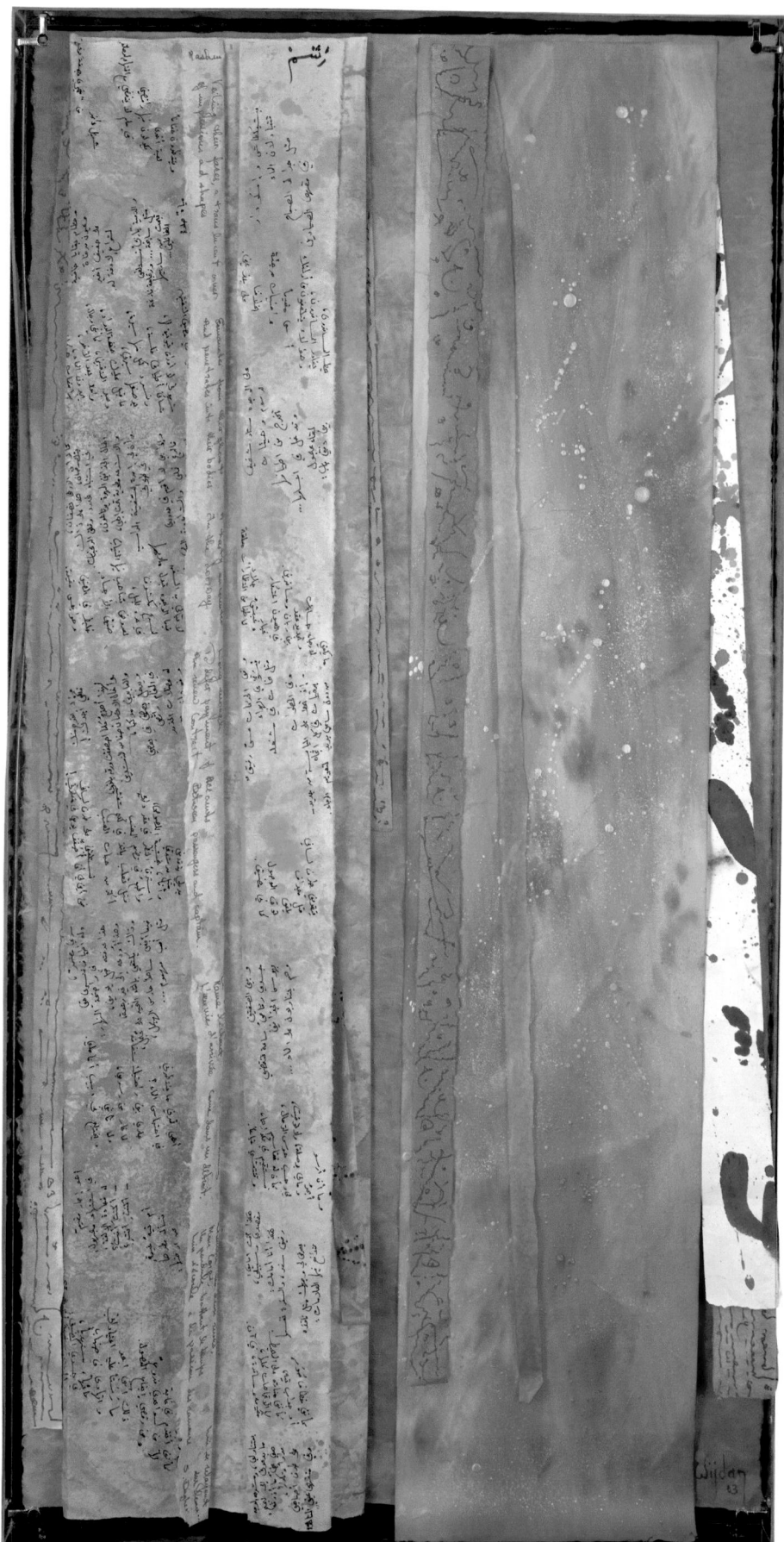

32 Wijdan

Rashm I

WATERCOLOUR, CHINA INKS AND LIQUID
GOLD ON PAPER, 2003
H 145.0 cm, W 74.0 cm
JORDAN
2004 5-11 1
BROOKE SEWELL PERMANENT FUND

'Veiling their faces, a translucent cover
Of impressions and shapes
Emanates from their ghosts,
And penetrates into their bodies ...
A hasty encounter
In the doorway:
Long enough
To defer payment of accounts
And renew contract
Between passengers and captain.'
(Translated Georges Dorlian and Juan Camilio
Gomez-Rivas)

On strips of coloured paper Wijdan
has inscribed 'Rashm I' in English and
French, a poem in several sections by
Lebanese poet Charbel Daghir (the rest
of the poem is in Arabic only). She
describes the mode of script written
here as 'calligraffiti': 'A style that has
no known rule, belongs to no known
school of calligraphy and differs from
one handwriting to another' (Ali 1997:
167). Her theories about the use of
Arabic script by modern Middle Eastern
artists are articulated in her *Modern
Islamic Art* (1997).

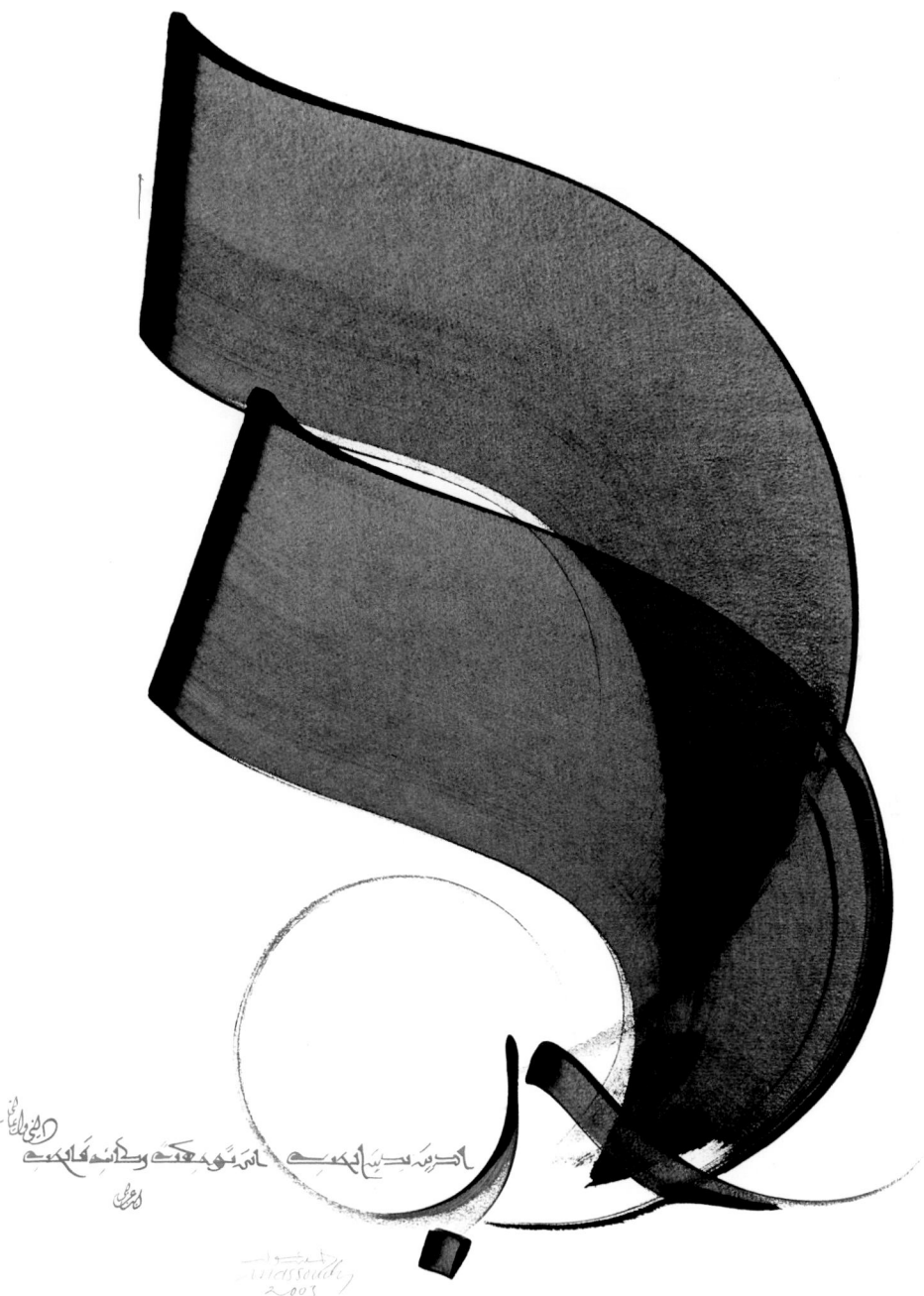

33 Hassan Massoudy

Untitled

COLOURED PIGMENTS ON
PAPER, 2003

H 75.0 cm, W 55.0 cm

IRAQ/FRANCE

2005 7-15 02

BROOKE SEWELL PERMANENT
FUND

'I follow the religion of Love: whatever way Love's camels take, that is my religion and my faith' (Ibn 'Arabi/ Nicholson 1911: 66–70). Muhyi al-Din Abu Bakr ibn Muhammad ibn al-'Arabi (1165–1240), the influential Sufi master and writer, was born in Murcia in southern Spain and spent much of his life travelling in the Middle East. His tomb in Damascus is an important focus of pilgrimage. These lines are from the *Turjuman al-Ashwaq* (*The Interpreter of Desires*), a collection of sixty-one mystical odes. Written as love poems to a young girl, these were in fact allegories of divine love and addressed to God. In the painting, the single word *al-hubb* ('love') is isolated in blue, with the rest of the line inscribed in red in *kufic* script.

العارف

وقال لى احترق العلم فى المعرفة، واحترقت المعرفة فى الوقفة. وقال لى كل أحد له عدة الا الواقف، وكل ذى عدة مهزوم. وقال لى الوقفة تعين سهدى لاظن فيه. وقال لى العارف يشك فى الواقف والواقف لا يشك فى العارف. وقال لى ليس فى الوقفة واقف والا فلا وقفة. وليس فى المعرفة عارف والا فلا معرفة وقال لى ما بلغت معرفة من لم يقف، ولا نفع علم من لم يعرف. وقال لى العالم يرى علمه ولا يرى المعرفة، والعارف يرى المعرفة ولا يرانى، والواقف يرانى ولا يرى سواى. وقال لى الوقفة على الذى يجير ولا يجار عليه. وقال لى الوقفة تميثاقى على كل عارف عرف أو جهله. فإن عرف خرج من المعرفة الى الوقفة، وإن لم يعرفه مرتجحت معرفته بجده. وقال لى الوقفة نورى الذى لا يجاوز لاظن، وقال لى الوقفة صمود، والصمود ديمومة، والديمومة لا يقوم لها الحدثان. وقال لى لا يرى حقيقة الا الواقف. وقال لى الوقفة وراء البعد والقرب، والمعرفة فى القرب، والقرب من وراء البعد، والعلم فى البعد وهو وحده.

34 Nazar Yahya

Al-Waqfa

HAND-MADE BOOK, 10 DIGITAL PRINTS WITH
COLLAGE (7/10), IN SLIP CASE, 2005

H 35.5 cm, W 30.0 cm

IRAQ

2006 1-28 01

BROOKE SEWELL PERMANENT FUND

'Whenever the vision is broadened the
words become narrowed.' These words,
written on the back of the book, are
from the *mawaqif* of Muhammad ibn Abd
al-Jabbar al-Niffari, a mystic living in the
tenth century who is associated with the town of Niffar
in ancient Nippur. He writes in a passionate way about
his encounters with the divine. His text *al-Mawaqif*
consists of seventy-seven individual 'stations' (*waqfa*),
each in the form of a brief divine revelation addressed to
the seeker whom God has held in that station. '*Al-waqif*'
is therefore the man who has attained the highest rank
of Sufi knowledge of the Creation and can now stand
before his Creator. The page illustrated here is called
al-Arif ('the man of knowledge').

'Knowledge is consumed in gnosis, and gnosis is consumed
in staying. Everyone has equipment, save the stayer: and
everyone that has equipment is routed.
Staying is an eternal specification, in which is no opinion.
The gnostic doubts of the stayer: the stayer doubts not of
the gnostic.
In staying there is no stayer, else it is not staying: in gnosis
there is no gnostic, else it is not gnosis.
The gnosis of him that stays not attains not: the
knowledge of him that has no gnosis profits not.
The knower sees his knowledge, but does not see gnosis;
the gnostic sees gnosis, but does not see Me; the stayer
sees Me and does not see other than Me.'

(Translated al-Niffari/Arberry 1935: 36, lines 70–6)

35 Shirazeh Houshiary
Round dance

ETCHING ON PAPER (PROOF
SET), 1992
H 77.0 cm, W 76.0 cm
IRAN/UK
1995 11-8 05

One of a set of five colour etchings and poems by the
mystic poet Jalal al-Din Rumi (1207–73). The shapes refer
to the rotation of the earth and the planetary system,
while the black drawing consists of chants and prayers. It
is not Houshiary's intention that the script should be read
but rather, as the artist herself has said, 'The word loses its
meaning and form is born from this.' The accompanying
poems from Rumi such as the following do not specifically
refer to the image but complement it: 'Walk to the well.
Turn as the earth and moon turn, circling what they love.
Whatever circles come from the centre' (British Art in Print
1995: 116–19).

36 Mustafa Ja'far
Ya kulla kulli

INK ON PAPER, 2005
H 125.0 cm, W 30.0 cm
IRAQ/UK
2006 2-13 01
BROOKE SEWELL PERMANENT FUND

'O, You who are the whole of my entire being, be with me;
for if You are not with me, then who can be?'

(Translated Mustafa Ja'far)

In elegant *diwani* script, Ja'far has created a vertical
rendition of this text, one of a number of verses
attributed to the celebrated Sufi mystic Husayn ibn
Mansur al-Hallaj (*c.* 858–922) (al-Hallaj 1955: 125).
Spreading his doctrine through his preaching as well
as his mystical poetry, he was charged with heresy
and crucified in Baghdad.

In answer to the question 'Why al-Hallaj?' Mustafa
Ja'far replied as follows:

'I am fascinated by his meticulous choice of words, rhythm
and his use of repetition to emphasize his innermost
emotions. I strive to capture the visual enchantment of
his verses whenever I choose to work on one.'

(Personal communication)

37 Kamal Boullata

Ana al-haqq

SILKSCREEN ON PAPER (15/30), 1983

H 76.0 cm, W 30.0 cm (paper)

PALESTINE/FRANCE

1997 7-16 03

BROOKE SEWELL PERMANENT FUND

The phrase *Ana al-haqq* ('I am the truth') was famously uttered by the Sufic mystic al-Hallaj (*c.* 858–922), and was one of a series of extravagant mystical statements that angered the religious establishment and led to his crucifixion – as Hallaj was thereby presuming to speak in the voice of God and identifying himself with God as the sole truth. 'Truth' is also one of God's '99 Names'

(*asma' al-husna*), on which mystics may meditate. Deliberately echoing the incantations of mystics, Boullata frequently focuses on single words or short phrases such as this. His characteristic compositions use lettering based on the traditional *kufic* script, creating powerful geometric patterns of words.

38 Sabiha al Khemir

The birds choose their spokesman

INK ON PAPER, 1993–4
H 30.5 cm, W 44.5 cm
TUNISIA
LENT BY THE ARTIST

This illustration comes from the story of the *Island of Animals*, a tenth-century text set in Basra which expresses, in the form of a fable, the teachings of Islam concerning man's responsibilities towards animals. It focuses on a central question: by what authority does man consider himself superior to animals? In this tale, the messenger of the king of the jinn asks the birds to chose one of their number to represent them at his court, in which the dispute between man and the animals is being heard. Here the king of the birds, the *simurgh* (the Arabic for his name appears on his neck), is asking the peacock for his advice. The simurgh eventually chooses the nightingale because of the sweetness of his voice (Johnson-Davies 1994: 28–32).

39a–c Nja Mahdaoui

La volupté d'en mourir: conte d'ʿAli ibn Bakkar et de Shams al-Nahar

SILKSCREENS, 31 PAGES (40/40), 1992
H 57.5 cm, W 38.5 cm
TUNISIA
2005 7-9 02
BROOKE SEWELL PERMANENT FUND

The text is translated from Arabic into French by the Algerian writer and scholar of Arabic literature Jamel Eddine Bencheikh (1930–2005), from a manuscript in the Bibliothèque Nationale in Paris. This story from the tales of *The Thousand and One Nights* is told by Sheherezade over a period of thirteen nights is set during the caliphate of Harun al-Rashid (786–809), and concerns the fatal love between a Persian youth known as ʿAli ibn Bakkar and the caliph's favourite concubine Shams al-Nahar. The tragic story evokes the atmosphere, tension and luxury of the court, while Mahdaoui's illustrations based on Arabic letter forms (see cat. 64) are a remarkably innovative approach to the relationship between text and image. The pages shown here consist of the opening of the story (39a), a single 'calligraphic' design (39b) and a passage from about halfway through (39c).

39a

39b

les plus fermés et t'apportera de mes nouvelles que tu devras transmettre à 'Alî b.Bakkâr. Tu seras notre intermédiaire.»

Shams an-Nahâr se leva, encore qu'elle put à peine faire un mouvement. Le joaillier la conduisit jusqu'à la porte de la maison. Il revint s'asseoir, ébloui encore par tant de beauté, stupéfait par la qualité de son discours, étonné par son élégance et ses manières. Il resta ainsi, pensif, à faire le tour de ses qualités jusqu'à ce que son esprit s'apaise. Il se fit servir à manger mais se sustenta à peine. Il se changea et se rendit chez 'Alî b.Bakkâr à la porte duquel il frappa. Les jeunes serviteurs de son hôte apparurent aussitôt et le conduisirent jusqu'à leur maître qu'il trouva étendu sur sa couche. Le jeune prince reprocha au joaillier d'avoir tardé et ainsi accrû sa douleur. Il éloigna ses serviteurs, fit soigneusement fermer les portes et dit:

«Je n'ai pas trouvé le sommeil depuis que tu m'as quitté. La jeune servante est venue me voir hier et m'a remis une lettre cachetée de la part de sa maîtresse.»

'Alî b.Bakkâr raconta à son hôte tout ce qui s'était passé et ajouta: «Je ne sais plus que faire. Ma patience est à bout. Abû l-Hasan pouvait au moins me tenir compagnie car il connaissait Shams an-Nahâr.»

39c detail of page 19

In this section words and writing take on another role. Their inclusion in the work of abstract artists from the late 1940s has a theoretical base. The first two works, for example, are by the Iraqi artists Madiha Omar and Shakir Hassan al-Said, who are key and pioneer figures of the movement sometimes described as *hurufiyyah* (after *harf*, meaning letter; see Introduction, pp. 15–19). Omar was fascinated by the structure of Arabic letter forms, which she rediscovered: 'each letter as an abstract image fulfils a specific meaning', she wrote in her declaration on Arabic calligraphy (Omar 1946). Shakir Hassan al-Said believed that the Arabic script reflected 'the history of the Arab individual and social reality which remained stored in the intellectual consciousness of culture and society' (Said 1981; Shabout 1999: 244). Even figurative Syrian artist Fateh al-Moudarres suddenly started to insert scratched words into his paintings. The messages are subliminal. In some works the words are clear but the meaning is abstract – Tanavoli's *Heech in a cage*, for example. In other pieces, although words and phrases can be discerned, it is the shape of the letter and how it combines with others that is important; legibility becomes secondary. The Tunisian artist Lassaad Metoui describes himself as an architect of words, Siah Armajani re-creates the rhythms of Persian poetry, and Jacob El-Hanani metamorphoses the repetition of prayers in his orthodox Jewish childhood into intense grids resembling ancient microscript. Khaled Ben Slimane's repetition of words is an echo of Sufi incantations, and Farhad Moshiri is inspired by the calligraphic practice sheets known as *mashq*. Other artists focus on the magical properties of letters and numbers.

Deconstructing
the Word

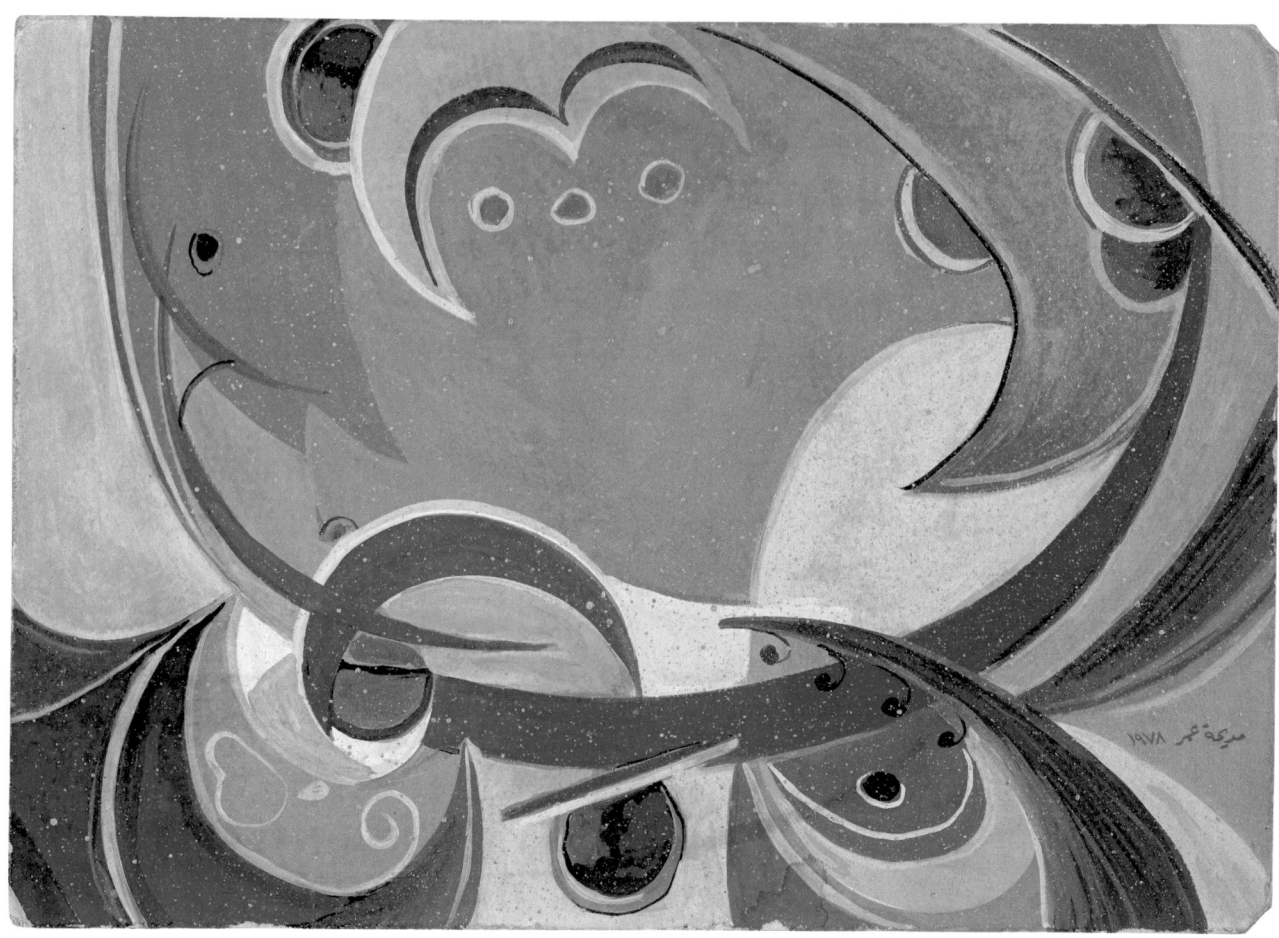

40 Madiha Omar

Untitled

MIXED MEDIA ON BOARD,
1978

H 31.0 cm, W 44.0 cm

IRAQ

LENT BY DIA AL-AZZAWI

Madiha Omar is reputed to be the first artist to have begun to incorporate Arabic calligraphy into Iraqi abstract art. The inspiration did not come in her native Iraq but in Washington in the mid-1940s, where she studied. She encountered there the work of Nadia Abbott, the scholar of the early Arabic script, which immediately fascinated her. Writing in 1949 about the properties of specific letters, she says 'the letter *ya* "Y" has a vigorous personality that expresses many meanings; the letter *ayn*, which has no equivalent in English, is a powerful vital letter that signifies in Arabic two different meanings; it is a spring of water as well as the eye with which people see; the letter *lam* "L" awards delicate musical movements' (Omar 1946, Shabout 1999: 161).

41 Shakir Hassan al-Said

Al-Hasud la yasud (The envious shall not prevail)

ACRYLIC ON WOOD, 1979
H 84.5 cm, W 123.0 cm
IRAQ
LENT BY SALMA SAMAR DAMLUJI

Al-Said was a key figure in the Iraqi artistic movement and one of the earliest to use isolated Arabic letters or phrases in abstract art. Strongly influenced by Sufism, particularly by the work of al-Hallaj, his paintings became a search for abstraction in which the Arabic letter played an increasingly key part: 'The letter is not just a linguistic symbol. It is the only isthmus to penetrate from the world of existence to the world of thought' (Shabout 1999: 245). Characteristic of a phase of his work are studies of walls which allowed him to consider the effects of the passage of time and people. Of these works he wrote, 'I prefer to write the letter in my paintings in the manner of children, school students and semi intellectuals, rather than in the manner of machines and calligraphers' (Shabout 1999: 246). The painting depicts a street wall segment. The same type of grafitti was often found on city streets in Baghdad and the Middle East. The phrase 'the envious shall not prevail' is a favourite Arab proverb, used to guard against the force of envy that is often repeated and is common to popular culture and tradition.

42 Mohammed Muhriddin

Untitled

GOUACHE AND COLLAGE ON PAPER,
1990
H 25.0 cm, W 20.8 cm
IRAQ
1995 4-10 04

As with the work of Shakir Hassan al-Said, Muhriddin's abstract composition suggests a wall covered in grafitti; a cut-out door is in the centre with the shadowy face of a man wearing dark glasses. The Arabic letters and numbers include '*S*' and 9.

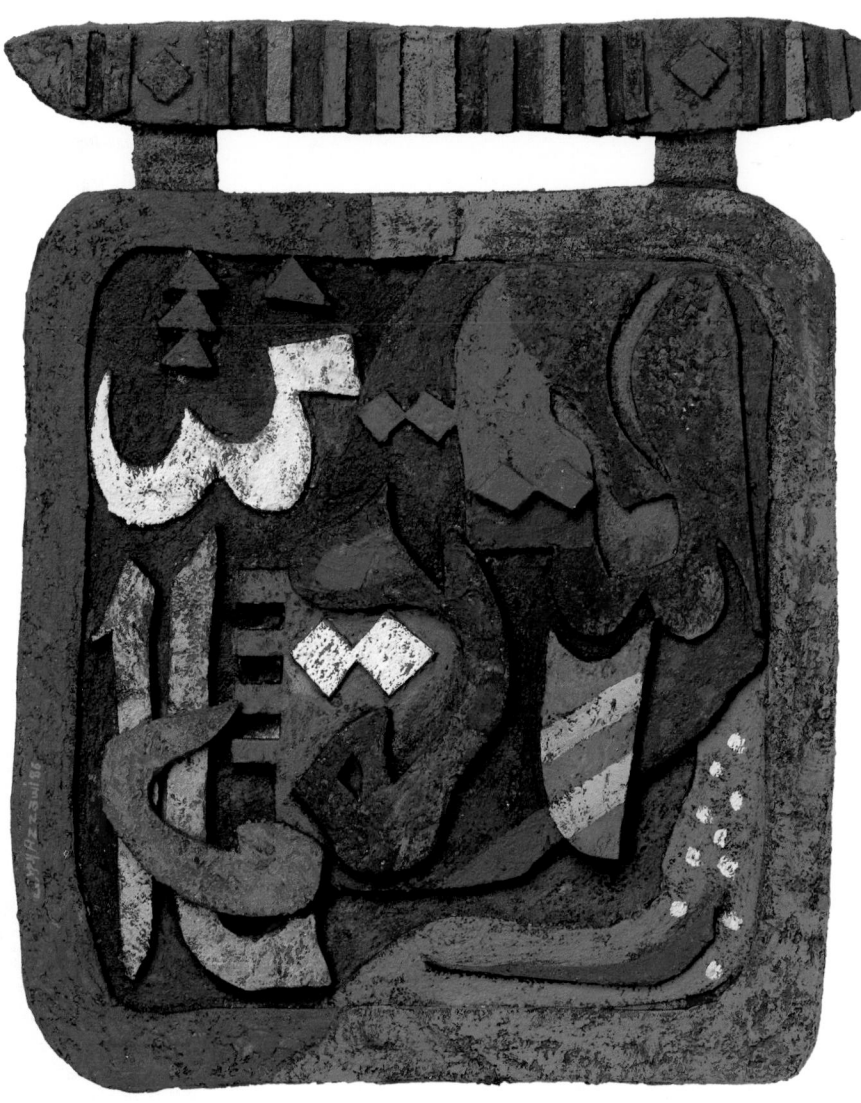

43 Dia al-Azzawi

Oriental scene

MIXED MEDIA, ACRYLIC AND FOAM BOARD, 1986
H 51.0 cm, W 41.0 cm
IRAQ/UK
1989 4-19 01

This is one of a series of works that al-Azzawi dedicated to the abstract manipulation of Arabic letters. Here the letters lose any meaning and take on simply an aesthetic value, becoming, in his own words, 'like Baghdad streets and narrow alleys' (Shabout 1999: 293). One of the hallmarks of al-Azzawi's work is the extraordinary richness of colour manifested therein. Colour for him has a psychological aspect: he considers black, for example, used here for the background, to be 'one of the basic colours of Iraqi culture, in which tragic tradition occupies a large portion' (Shabout 1999: 272).

1/10 Nasiri 89

44 Rafa al-Nasiri

Untitled

ETCHING WITH AQUATINT ON
PAPER (1/10), 1989
H 56.5 cm, W 66.0 cm
IRAQ
1996 5-15 01

An abstract composition, at
the centre of which a large
Arabic letter resembling the
letter *ayn* lies against a
burnished ground. Below is a
roundel containing letters and
words. In Nasiri's graphic work,
a constant source of
inspiration has been the sun-
scorched desert of his native
Iraq, which is evoked here.

45a–e Rashad Selim

Ayn and om tonalities,
Marsh Eye series

5 MONOTYPE OFFSET PRINTS,
1998
H 85.0 cm, W 30.5 cm (each)
IRAQ/UK
1998 7-15 01-05
BROOKE SEWELL PERMANENT
FUND

This work is focused on a study of the Arabic letter *ayn*,
which Selim deliberately juxtaposes with the Sanskrit
om and the Greek *epsilon*, which it resembles. It was
conceived during the height of the destruction of the Iraqi
marshlands during the 1980s to 1990s, and Selim uses
ayn, which also means 'eye' in Arabic, intending to draw
attention to that disaster. The form of these works – long
narrow strips – deliberately echoes the unrolling of a
Mesopotamian cylinder seal.

45a

45b

45c

45d

45e

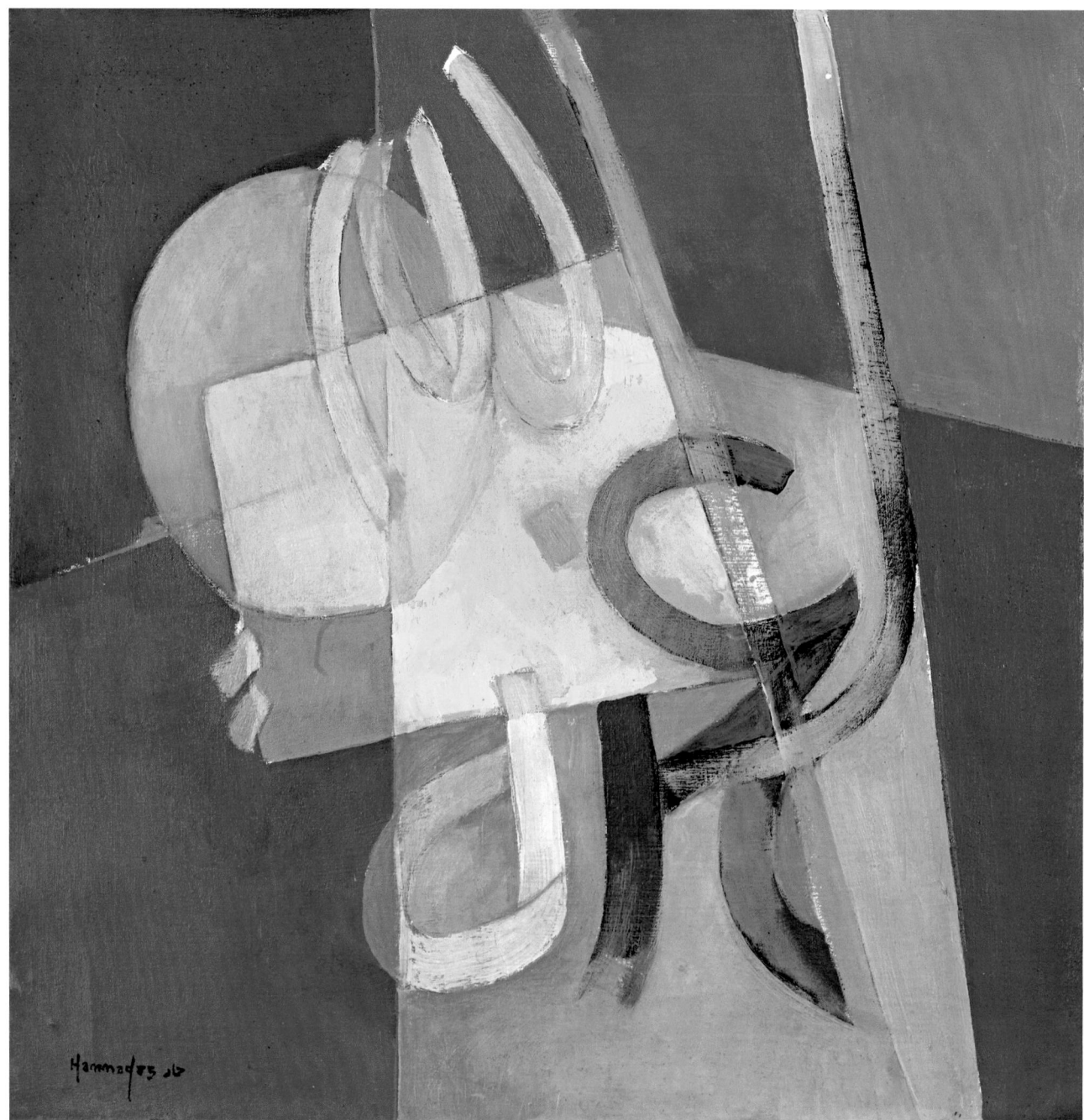

46 Mahmoud Hammad

Untitled

OIL ON CANVAS, 1985
H 60.0 cm, W 60.0 cm
SYRIA
2005 7-25 01
BROOKE SEWELL PERMANENT
FUND

Hammad was a pioneer of the Syrian artistic movement from the 1960s and the first Syrian artist to include Arabic letters in abstract compositions. In this work the phrase *al-izzatu lillah* ('glory belongs to God') is inscribed. The letter forms interact with plain geometric shapes and animate an overall abstract composition.

47a–b Fateh al-Moudarres

Untitled

2 GOUACHES ON WOODEN BOARD, 1966 (?)
H 19.5 cm, W 15.7 cm (each)
SYRIA
2005 7-8 01-02
BROOKE SEWELL PERMANENT FUND

Moudarres is principally a figurative painter whose work
was greatly influenced by icon painting. He rarely used
writing in his works, but when he did it took a form
resembling graffiti – often scratched through the surface
colour, as here. In the panel above the face in black on 47a
are the first words from Qur'an Chapter 108 (*al-Kawthar*,
'Abundance'): 'Surely we have given thee abundance.'

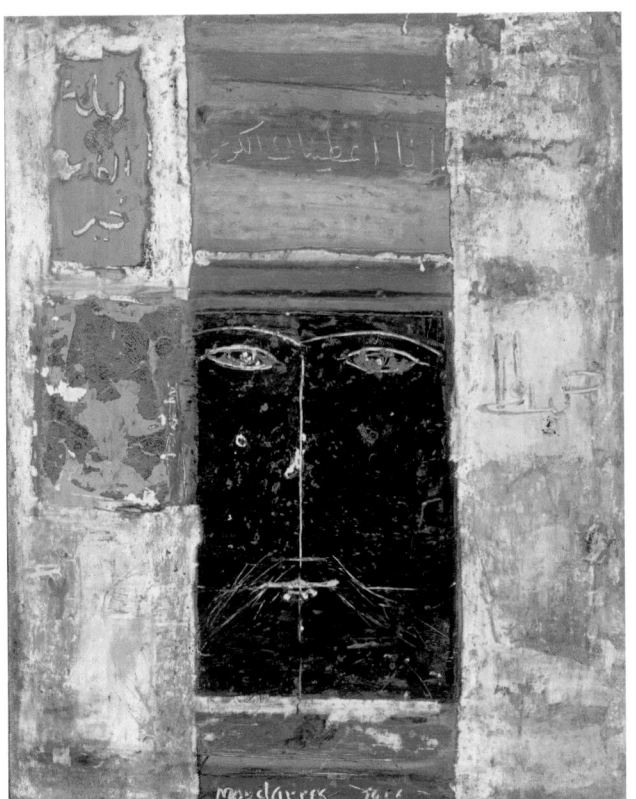

47a

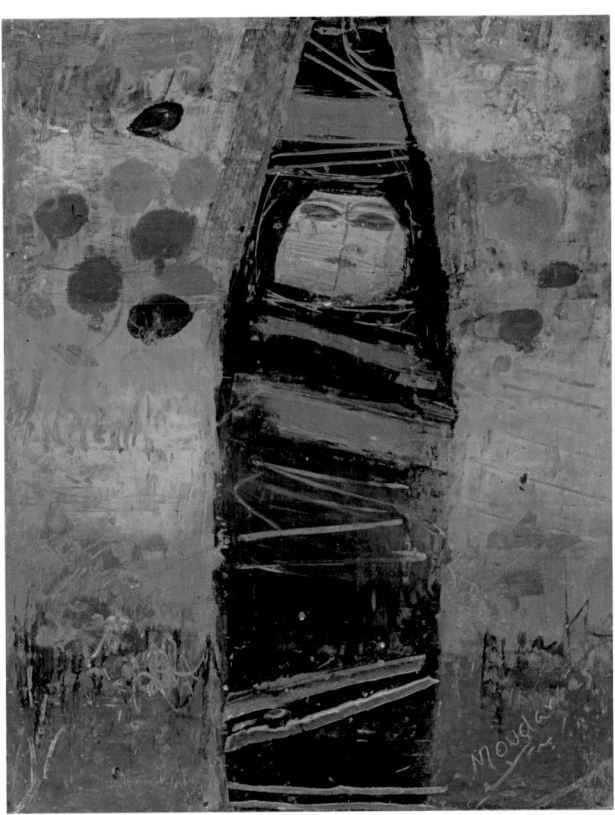

47b

5/40

48 Hussein Madi

Alphabet

LITHOGRAPH ON PAPER (8/40), 1994
H 69.8 cm, W 49.8 cm
LEBANON
2005 7-25 02
BROOKE SEWELL PERMANENT FUND

In thirty squares Madi has written the twenty-eight letters of the Arabic alphabet (as well as the combined letters *lam–alif*) preceded by the word 'Allah' in the first square. Each letter is multiplied and playfully turned into its own composition. Long fascinated by the Arabic script, since 1973 – when he first created his *Alphabet* – Madi in his graphic work and his sculptures has focused and worked with the pure form of the individual letter rather than the written context of the word.

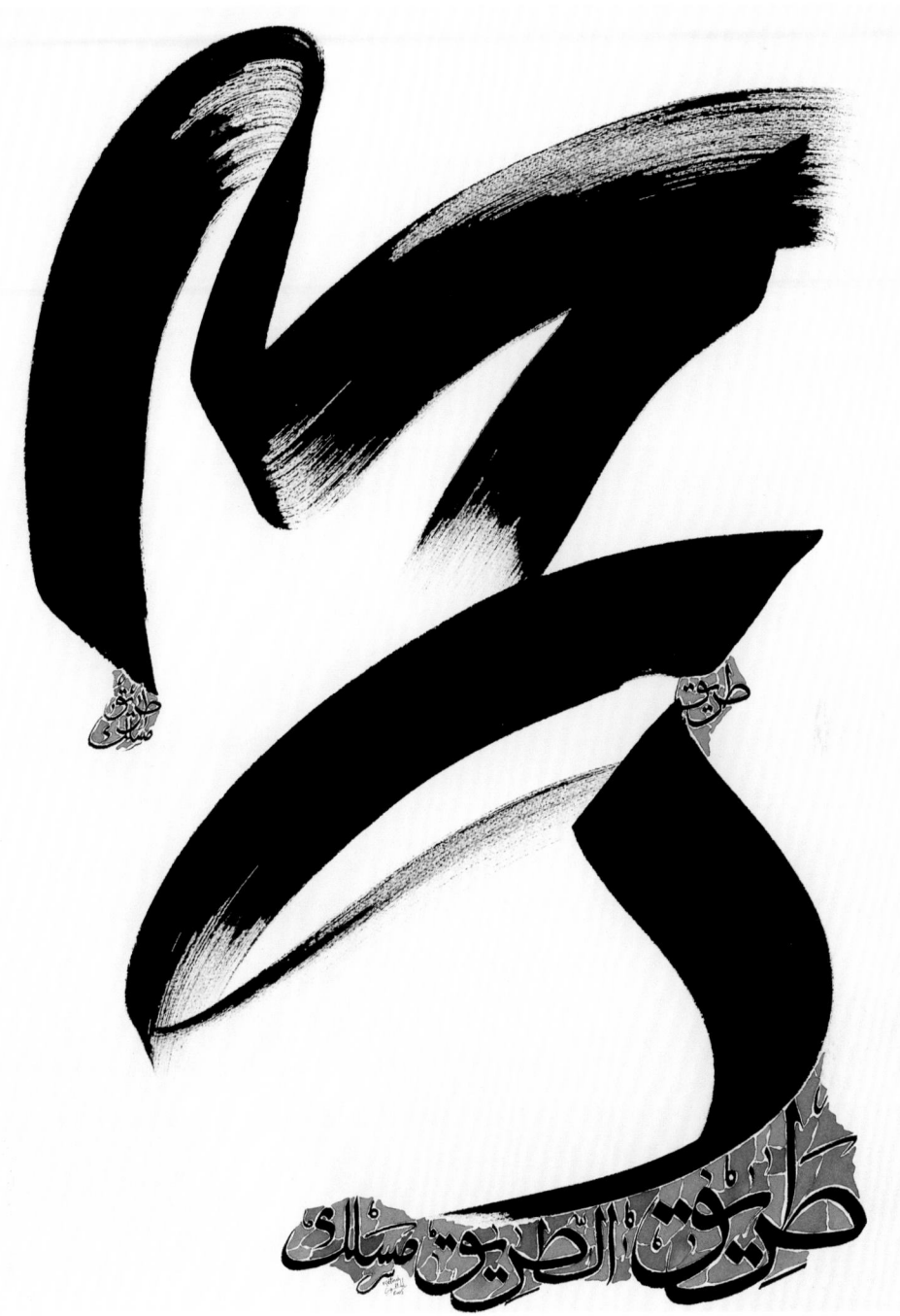

49 Lassaad Metoui

Untitled

BLACK INK ON PAPER, 2005
H 76.0 cm, W 56.0 cm
TUNISIA/FRANCE
2006 2-1 01
BROOKE SEWELL PERMANENT FUND

Utterly inspired by the shapes of the Arabic letter, Metoui describes himself as 'an architect of words' seeking to make the letters 'as poetic and as plastic as possible' (Metoui 1999: 8). His characteristic style is the use of single words or short phrases. Here he has written different forms of the word for 'path', *tariq*, *al-tariq* and *maslak*, the thick black strokes evocatively suggesting a steep and windy road.

50 Muhammed Ehsai

Untitled

COLOURED PAINTS ON
BOARD, *c.* 1990s
H 40.2 cm, W 40.2 cm
IRAN
2005 7-9 01
BROOKE SEWELL PERMANENT
FUND

Trained as a traditional calligrapher, Ehsai achieves an
extraordinary synthesis of the traditional form with
a very modern aesthetic. In his colourful calligraphic
paintings, letters represent what he describes as 'pure
visual elements'. The theme at the heart is the Word
of God (*kalam*):

'but my perspective on word-formations is not based
on literary criteria; my experiments with *kalam* create
compositions that look to the future at the same time
as relying on the millennial traditions of my forefathers.'

(Issa, Brown and Sutcliffe 2001: 129)

51 Abdul Qadir
al-Raes

Untitled

WATERCOLOUR ON PAPER,
2004

H 90.0 cm, W 70.0 cm

DUBAI, UAE

LENT BY ABD AL-RAHMAN
AL OWAIS

Al-Raes works in watercolour, achieving delicate paintings
that include landscapes and architecture of his native
Dubai. Increasingly turning now to abstract art, he often
creates floating square shapes which recall the local stone
houses of his childhood and overlays these with
juxtaposed Arabic letters.

82

DECONSTRUCTING THE WORD

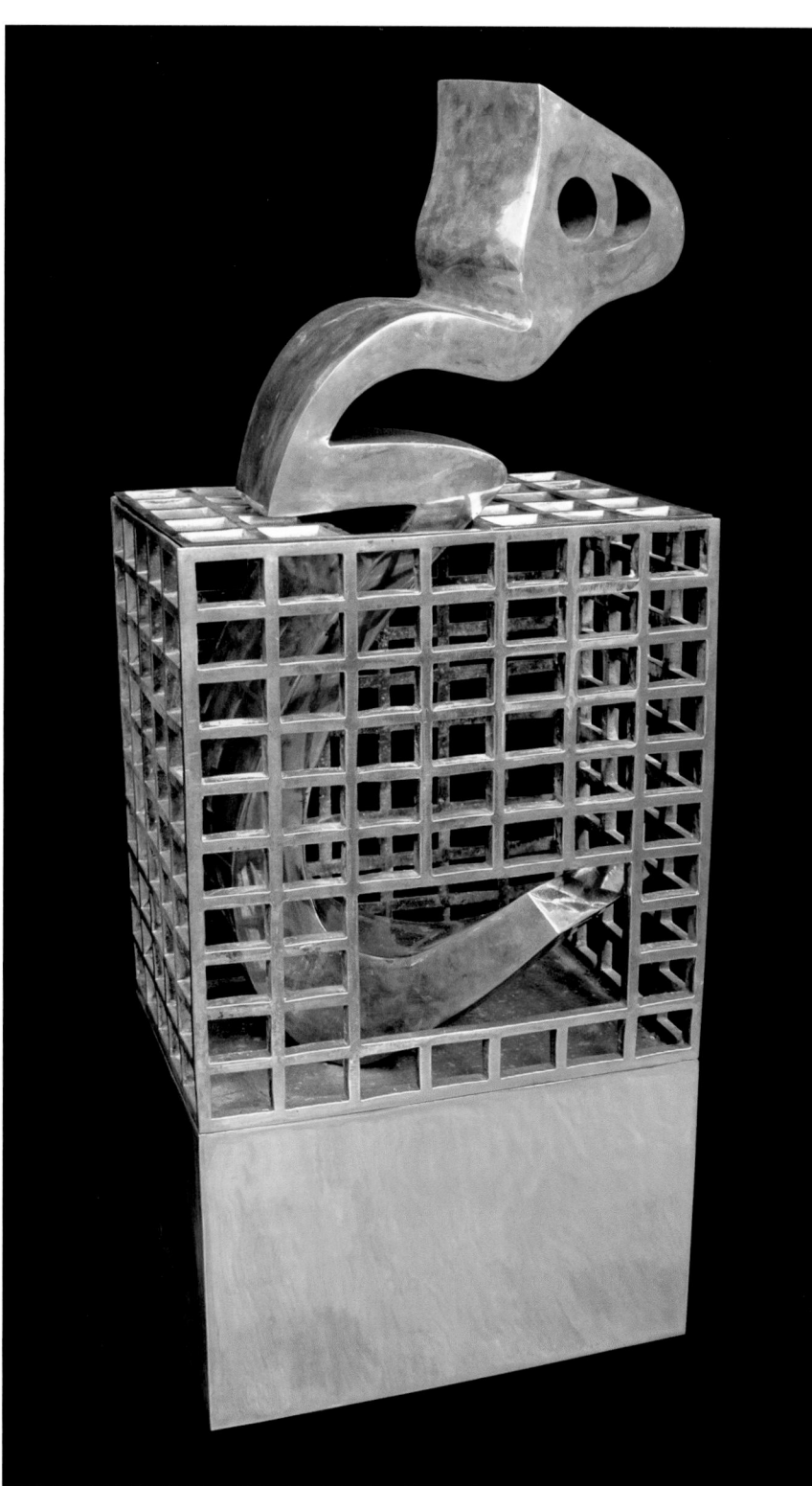

52 Parviz Tanavoli
Heech in a cage

BRONZE, 2005
H 118.0 cm, W 49.0 cm
IRAN
2006 2-6 1
BROOKE SEWELL PERMANENT FUND

The foremost Iranian artist Parviz Tanavoli was a founder member of *Saqqakhaneh*, a term coined for an artistic movement that began in 1960s Iran, and which sought to integrate popular symbols of Shi'a culture in art – a 'spiritual Pop Art', as it has been described. He has long been inspired by the word *heech* – meaning 'nothing' – which he has created in numerous and ever more ambitious forms. It has been said that the word symbolizes for him both an ambivalence towards the past and a sense of meaninglessness or dissatisfaction with an inadequate present. The letter forms are in the traditional Persian *nasta'liq* script, while the cage alludes to the *Saqqakhaneh* itself (see p. 17).

53 Salah Faisal al-Ali
Untitled

SILKSCREEN ON PAPER (2/50), 1981
H 65.5 cm, W 50.3 cm
IRAQ/SWITZERLAND
1987 12-19 01

Salah Faisal al-Ali has created an abstract composition using lines of script that give the impression of legibility. Within this *trompe l'oeil* composition words and phrases emerge and then are lost.

Salah. Al. Ali 81 2/8

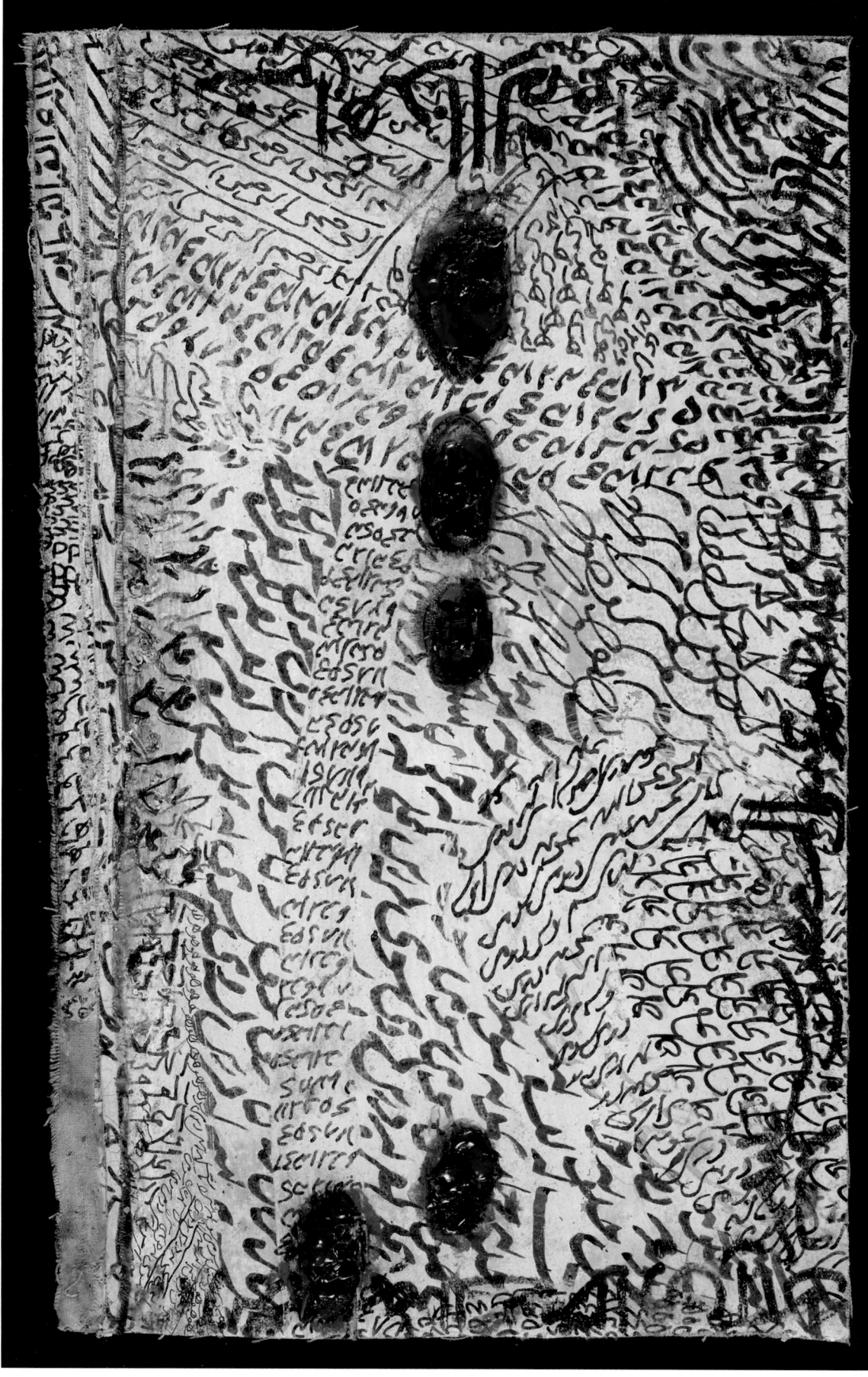

54 Siah Armajani

Letter 1960

INK AND SEALING WAX ON CLOTH, 1960
H 27.0 cm, W 17.0 cm
IRAN/USA
LENT BY ROSE ISSA

Armajani created word pictures for only a relatively short time during the 1960s. His work reflects a reverence for calligraphy, even though he does not follow traditional rules, and contains echoes of Persian poetry – his family held poetry in high esteem: 'Poets are venerated in Persian culture ... The poets always have the truth ... in Iran poets were the only ones who were allowed to voice political and social protest' (Balaghi and Gumpert 2002: 31). This work, which also includes repetitions of words and numbers following the magical tradition (see cats 69 and 70), is overlaid with red seals echoing the stamping of traditional documents.

55 Farhad Moshiri

3Y19D

OIL ON CANVAS, 2004
H 160.0 cm, W 170.0 cm
IRAN
PRIVATE COLLECTION

In addition to his works echoing ancient jars (see cat. 20), Moshiri is also interested in script repeating letters and words for their intrinsic beauty rather than particular meaning. He has been especially inspired by calligraphic practice sheets (in Persian *sia mashq*) in which the page is rendered black (*sia*) with the ink of repeated letters. The use of numbers in this composition is a deliberate reference to the *abjad* alphabet – the old Semitic order of the Arabic alphabet – in which letters had number equivalents that were used by makers of charms and talismans.

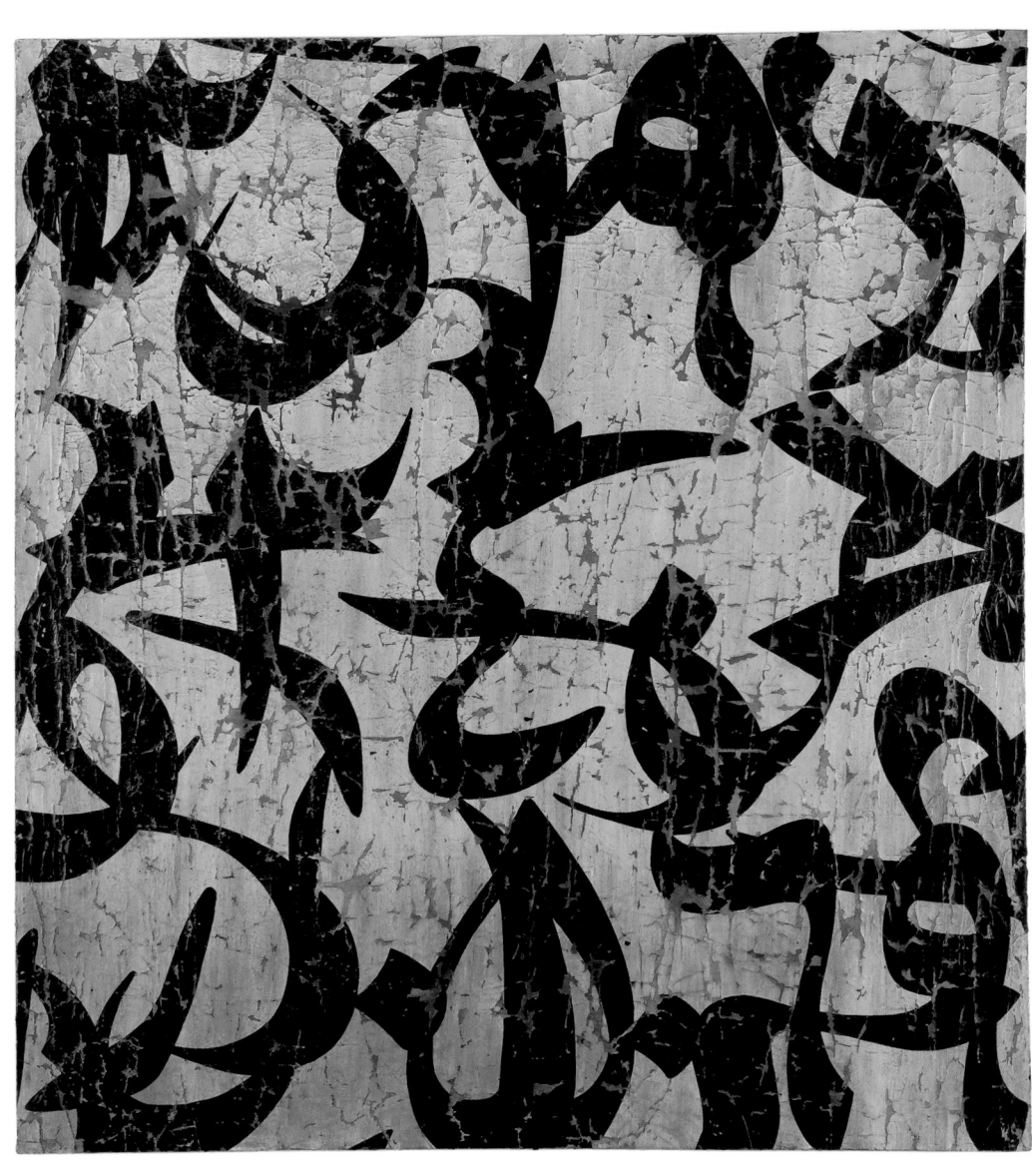

56 Wijdan
Calligraphic abstraction

MIXED MEDIA ON PAPER, 1993
H 11.5 cm, W 20.5 cm
JORDAN
1994 7-26 01

This painting of the Arabic letter *ha* is from Wijdan's *Kerbela* series, a collection of works focusing entirely on Arabic letter shapes. Wijdan describes the 'calligraphic school of art' and her use of Arabic script as 'a form of artistic identity through which I am able to gratify my creative instincts and establish my individuality as a contemporary Arab and Islamic artist' (Shawa, Wijdan 1994). Kerbela is the site in Iraq of the martyrdom of the Prophet Muhammad's grandson Husayn in AD 680. This cataclysmic event for Shi'a Muslims is re-enacted every year during the month of Muharram. For Wijdan the battle of Kerbela is the 'epitome of the greatest human tragedy in Arab and Islamic history. It stands for loyalty and betrayal, courage and greed, right and wrong. Each era had a Kerbela ... Palestine, Vietnam, Bosnia and Somalia are a few among many. I chose Kerbela as a subject for my art because I saw a hundred past Kerbelas and fear thousands more to come' (Shawa, Wijdan 1994).

57 Jacob El-Hanani
Three kav

INK ON PAPER, 1997
H 48.3 cm, W 48.2 cm
MOROCCO/ISRAEL/USA
2001 3-30 016

El-Hanani's compositions, drawn with pens, consist of weblike networks of delicate interlocking lines and symbols. He draws his inspiration largely from the ancient tradition of micrography. This was a technique of writing in tiny script, developed in the Middle East by scribes who were able to render entire sacred texts into minute form or create word pictures with lines of script. Some of the finest surviving examples of these are found in Hebrew writing.

58 Maliheh Afnan

Not Pahlavi

MIXED MEDIA ON PAPER,
UNDATED (*c.* 1990)
H 24.0 cm, W 32.0 cm
IRAN/UK
1991 10-29 01

Afnan's delicate abstract works come from her love of
scripts, particularly those of her native Iran. In this work
she creates a pattern of letters in relief that echo ancient
inscriptions.

'Maliheh Afnan's distrust of the obvious, of the brash, of the
shrill, has led her to create an expressive form that is as subtle
as the patina on ancient stones. Some of her *écritures* works
strike me as being like unearthed tablets from a civilisation that
is no more; cryptic missives that will only reveal themselves to a
patient eye with a delicate understanding of the human past.'

(Kabbani 1993)

59 Maliheh Afnan

Veiled threats

INK ON PAPER OVERLAID WITH GAUZE, 2005

H 60.0 cm, W 42.0 cm

IRAN/UK

2005 7-12 01

BROOKE SEWELL PERMANENT FUND

In this example of her work Afnan's distinctive vocabulary is clearly evident. The idea of the veil which she subtly evokes with the grey openwork fabric takes on a number of different meanings and becomes a universal theme; veiling in her own words 'not only women but threats and intentions' (personal communication).

60 Mahmoud Hamadani

Untitled

INK ON PAPER, 1999
H 56.0 cm, W 76.0 cm
IRAN/USA
2001 11-27 01
BROOKE SEWELL PERMANENT FUND

This drawing is from a series entitled *Requiem* inspired by the time Hamadani spent in Afghanistan in the 1990s. As a mathematician, he is fascinated by notions of order and chaos. After leaving Afghanistan in 1995, he started to draw systematically:

'like a composer searching for notes and creating melodies, I poured through lines and constructed patterns. Gradually this evolved into a personal vocabulary and an abstract calligraphy that I use to draw these lyrical essays.'

(Artist's statement)

61 Michal Rovner

Notebook 2

STILL FROM VIDEO INSTALLATION (2/2), 2004
ISRAEL/USA
LENT BY THE ARTIST AND THE PACE WILDENSTEIN
GALLERY, NEW YORK

As a photographer and film maker, Rovner
has in recent years created video
installations that centre around ancient
tablets and books, in which what at first
glance appears to be script turns out to be
grainy lines of people. In this work Rovner
has taken the theme of the notebook,
which is displayed blank and open.
Overlaid are tiny figures laid out in what
appear to be rows of text. The moving
bodies seem to rearrange themselves
constantly into new words and sentences
in an apposite example on the theme of
deconstructing the word.

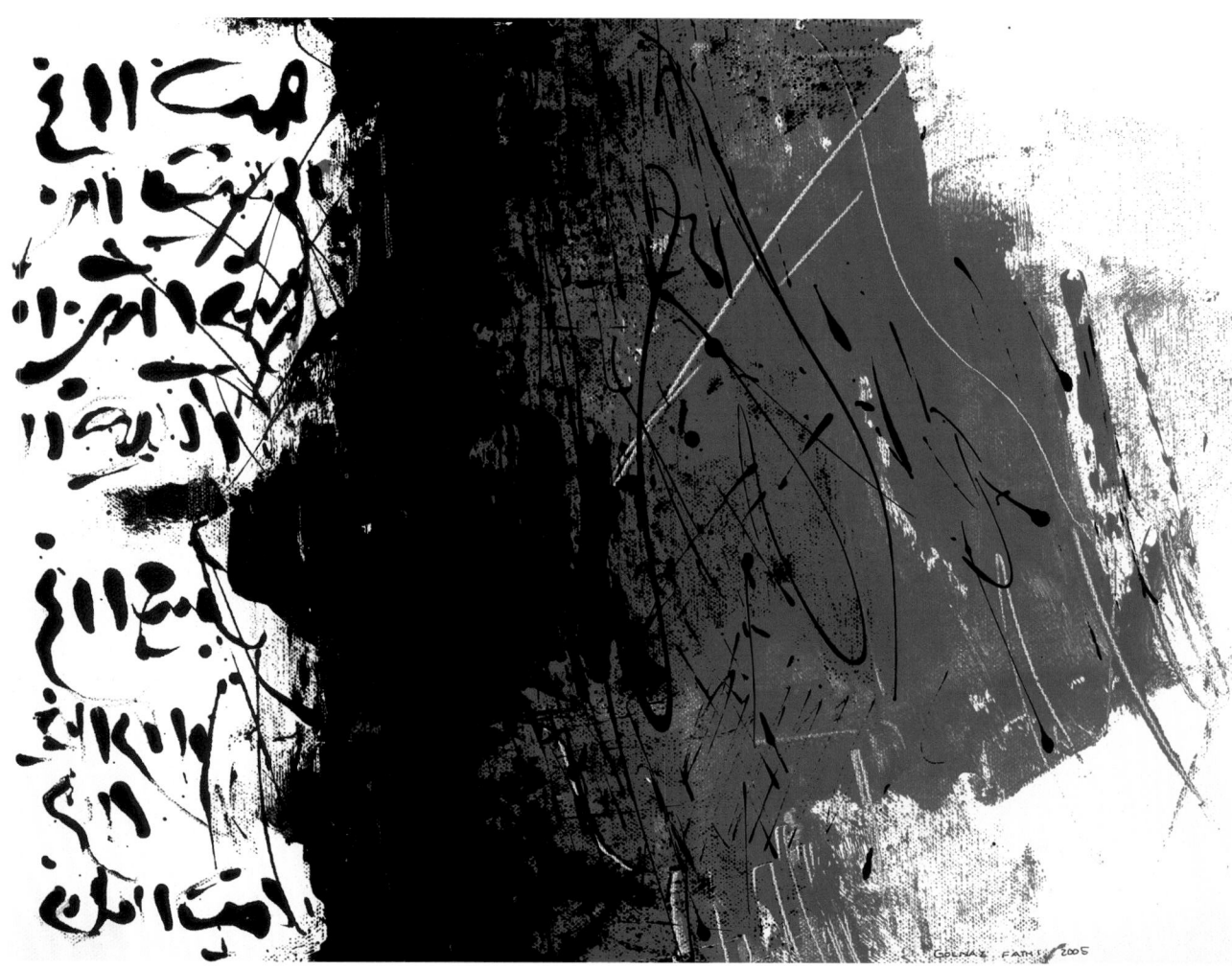

62 Golnaz Fathi

Untitled

OIL ON CANVAS
H 30.5 cm, W 40.5 cm
IRAN
PRIVATE COLLECTION

Trained as a calligrapher, Fathi often incorporates script
in her abstract works. As in Siah Armajani's work (cat. 54),
it is poetry that inspires her but it is deliberately beyond
legibility. As she said in a recent interview,

'It has always been Hafez and only one poem, but the point is
that the poem is [itself] not important. I know it by heart and
that is why I always use it unconsciously. Poetry is no longer
important, it is important that I can treat [it] just the way that
I want to exactly.'

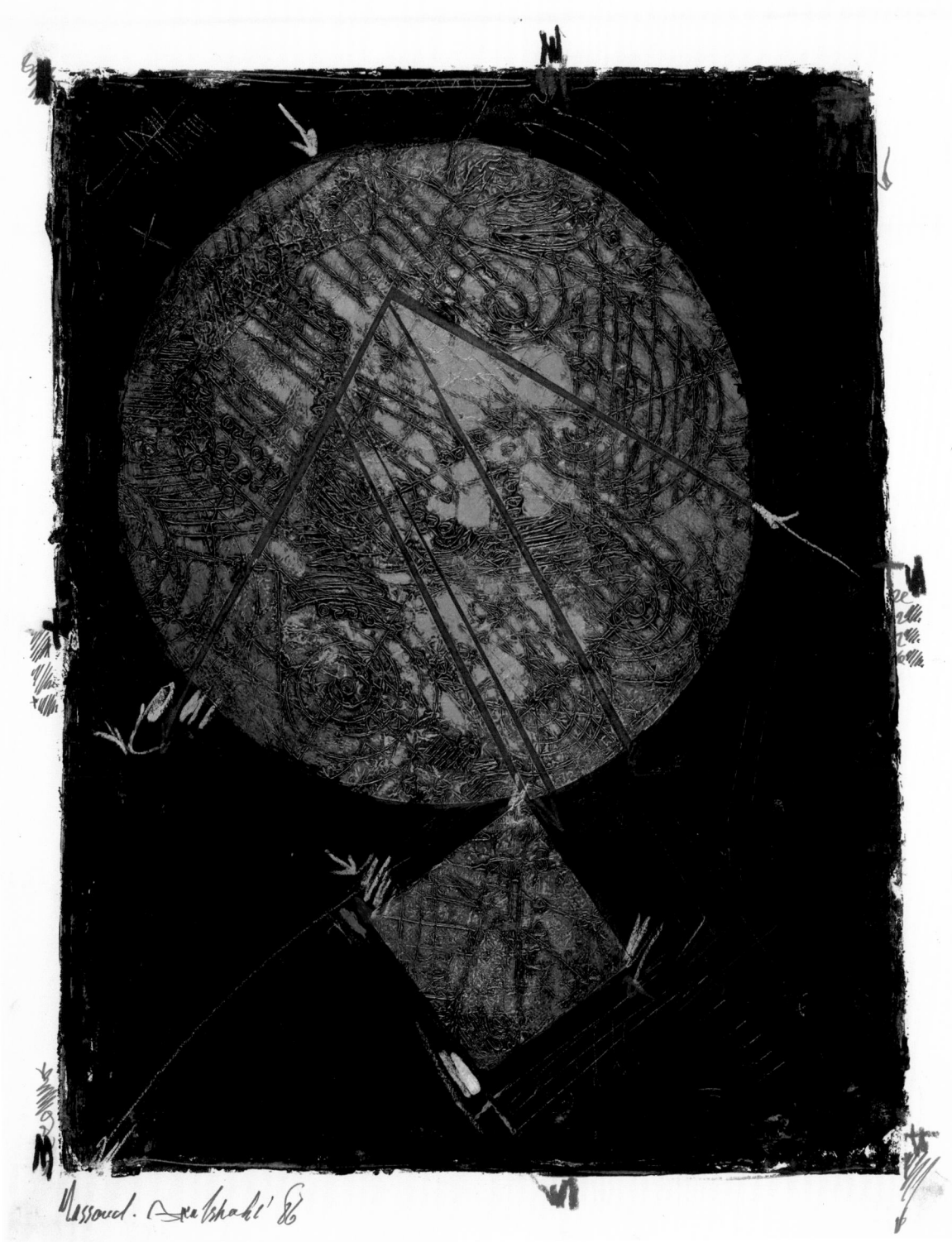

Massoud. Arabshahi '86

63 Massoud Arabshahi

Untitled black

MIXED MEDIA ON BLACK, 1986

H 61.0 cm, W 48.2 cm

IRAN

2000 7-24 05

BROOKE SEWELL PERMANENT
FUND

The mysterious lines and patterns in Arabshahi's work
deliberately evoke his ancient Iranian past. As an active
member of *Saqqakhaneh* – the art movement that
consciously reconsiders past traditions and incorporates
them into contemporary art – his work has had that past
as a constant theme. Among the lines can be detected
letters and words.



65 Farid Belkahia

Le regard du Soufi
(*The glance of the Sufi*)

WOOD AND PARCHMENT
PAINTED WITH NATURAL
PIGMENTS, 1994
H 21.5 cm, W 20.5 cm
MOROCCO
AF 1997,08.4

'It is only through our past that we can accede to modernity. I know of no ahistorical modernity', wrote Belkahia. Abandoning the use of oil and canvas during the 1970s – he preferred to work with natural materials such as sheepskin and wood, using henna, saffron and other natural dyes for decoration. His designs often evoke traditional motifs such as tattoos or magical numbers and symbols. The designs on this piece and cat. 66 are inspired by rituals known as *gnawa* after a people of that name who today live in southern Morocco. They have strong ritual traditions that include trance ceremonies, dance and music. These allow participants to communicate with the spirits (both good and bad) who are thought to play a powerful role in people's lives. The accompanying music often contains references to exile and slavery. The spiritual forces in *gnawa* rituals are represented by different colours: green, yellow, black and white. The designs on the works possibly allude to the form and movement of the dances and express the contradictory nature of the spiritual forces released during the state of trance.

66 Farid Belkahia

Procession

WOOD AND PARCHMENT
PAINTED WITH NATURAL
PIGMENTS, 1995
D 19.5 cm
MOROCCO
AF 1997,08.3

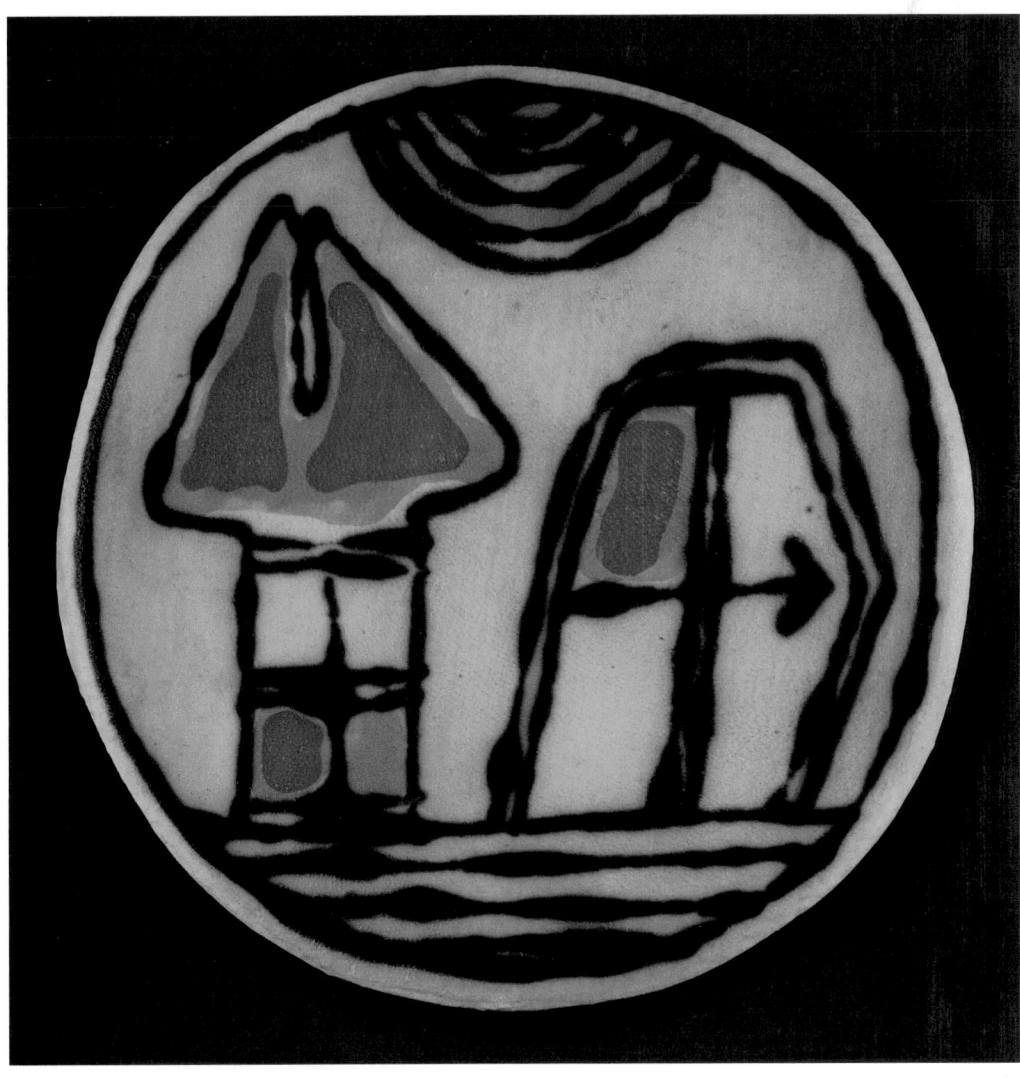

67 Khaled Ben Slimane

Untitled

CERAMIC PLATES (*TABAQ*),
PAINTED AND GLAZED, 1998
D 20.0 cm (each)
TUNISIA
1998.AF2.12-15

Splashes of colour and hurriedly written and repeated words are the hallmark of the pottery of Khaled Ben Slimane. His interest in writing began after finding a stash of old family contracts in 1979, which he transformed into beautiful glazed bricks covered in script. The texts he uses are written with a brush and are often combinations of illegible scribbles and symbols interspersed with real words written almost like grafitti. Included here are the words *wafaqani Allah* ('God has brought me success'). The repetitions of words and phrases so characteristic of his ceramic works come from Sufi Zikr, in which religious phrases are rhythmically repeated; he often listens to these before working.

68 Rachid Koraïchi

Untitled

PAINTED SILK BANNER, 1988
H 222.0 cm, W 190.0 cm
ALGERIA/FRANCE
1992 3-3 01
BROOKE SEWELL PERMANENT FUND

This textile is one of a series that was created for an exhibition called *Salomé* that took place in Paris (Koraïchi 1990). The composition is characteristic of Koraïchi's work: symbols, words and magical squares drawn from the Islamic magical tradition recall designs on West African talismanic shirts and magical bowls. These are combined with other symbols which, intentionally or not, recall Japanese pictograms.

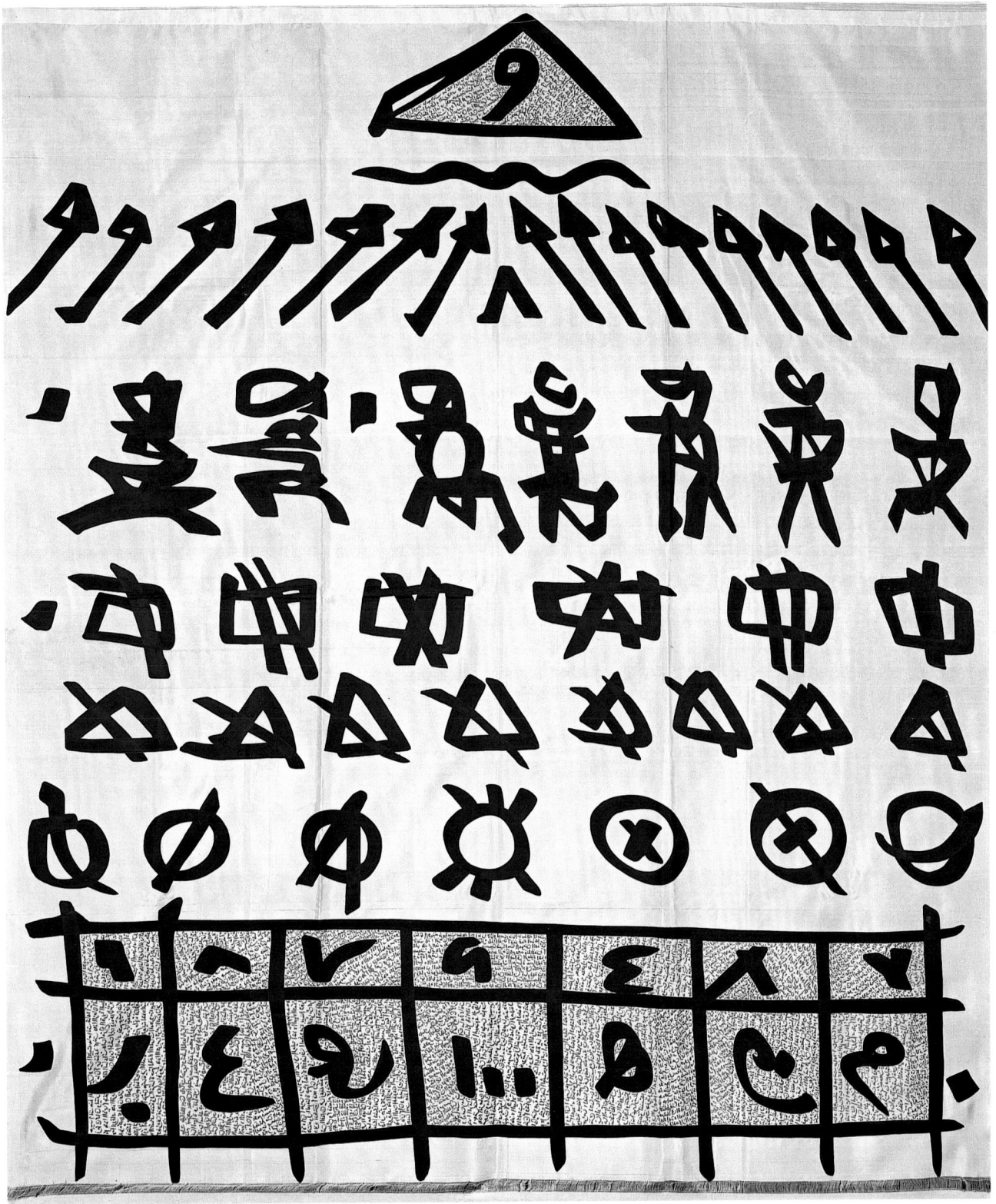

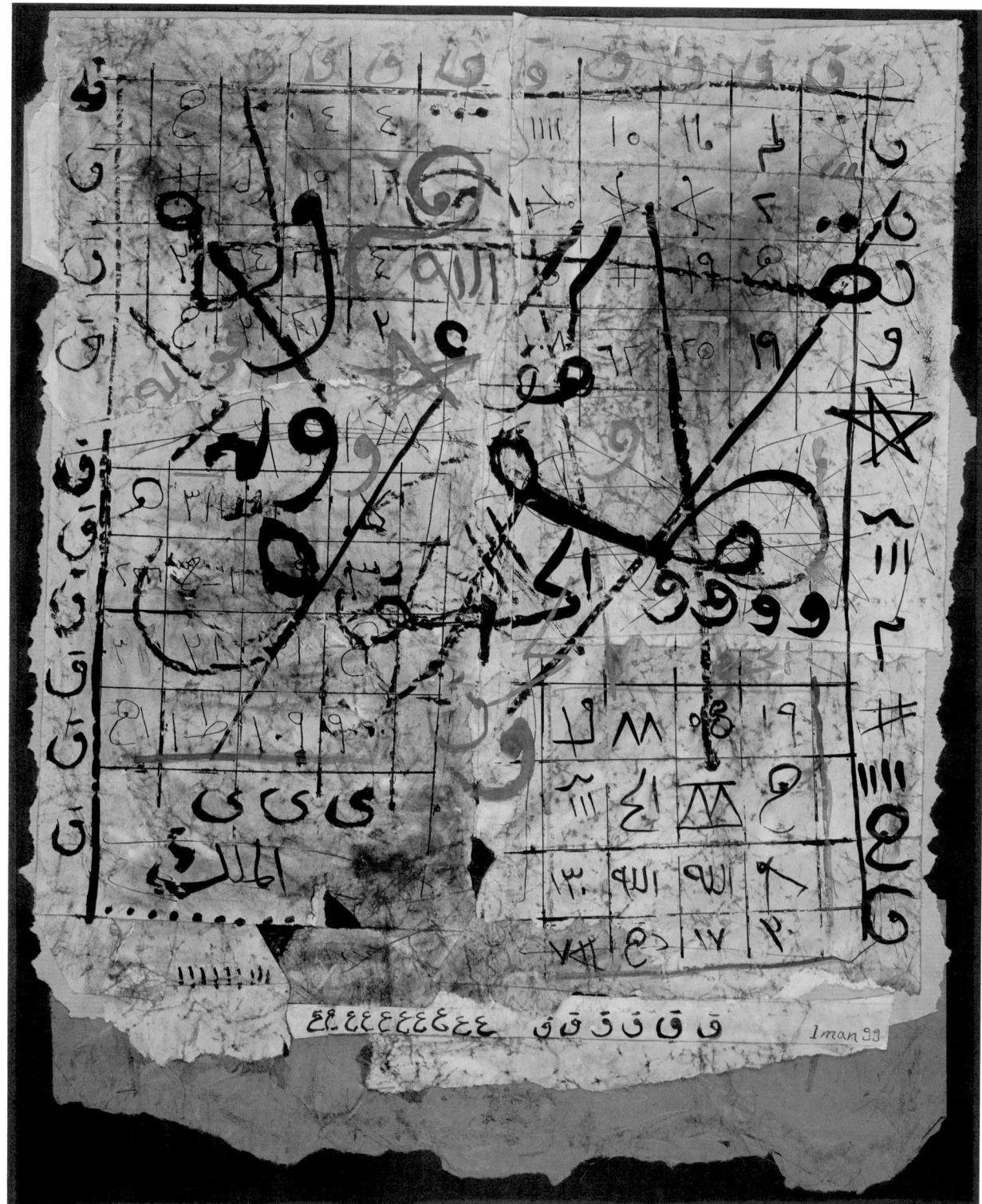

69 Iman Abdullah Mahmud

Ritual signs II

COLOURED PIGMENTS ON PAPER
MOUNTED ON CARD, 1999

H 60.0 cm, W 49.8 cm

IRAQ/GERMANY

2003 10-6 02

BROOKE SEWELL PERMANENT FUND

The composition consists of a fragmentary page with additional scraps of paper attached. It is inscribed with a magical square within which are letters, numbers and symbols, all drawn from the Islamic magical tradition. There are rows of repeated single letters, the use of which was regarded as particularly efficacious in the making of charms and spells.

70 Faisal Samra

Text-body

OIL, PIGMENTS, HENNA AND GOLD LEAF, DRY CLAY
AND WIRE-MESH, 2002
H 80.0 cm, W 40.0 cm, DEPTH 25.0 cm (approx.)
SAUDI ARABIA
LENT BY DR ANWAR GARGASH

Samra has been working in different media
over a number of years. In this sculptural work
he has used text made up of deconstructed
words written in Arabic letters, which he
describes as follows: 'the text hides a subject
or story which we can decode if we wish. It
covers a "body" made of wire-mesh and dry
clay created with an improvised movement,
the two (text and body) become one, like
water taking the shape of the cup.' The
writing also recalls paper charms and amulets
in which strings of incomprehensible letters
are inscribed to heal the sick or ward off evil.
In conformity with certain types of charm,
the Arabic letters are written in their isolated
form, unconnected to other letters. In magical
contexts, letters written in this way were
deemed to have particular power. In talking
about the form of his compositions, Samra
said in a recent interview:

'In 1989 I burned the border between painting and
sculpture by freeing the treated canvas from the
frame and then I cut it to an organic shape and
hang it from one side on the wall or in space. This
act enabled me to open a dialogue between the
artwork and its context.'

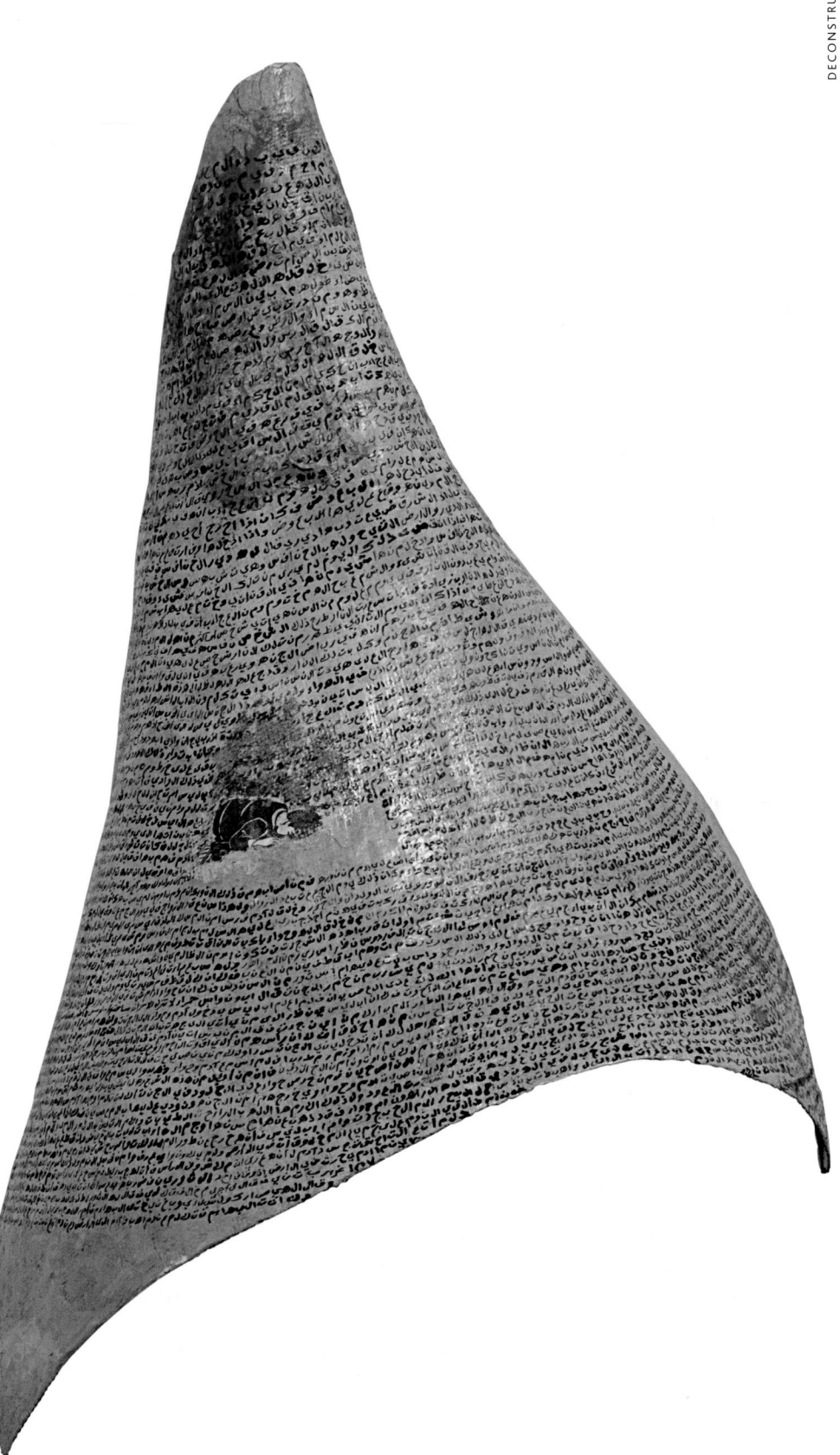

Particularly striking among the work of artists of the Middle East is the way in which their history and the recent crises and wars that have so deeply affected the region are passionately felt and articulated. Using images and the language of the past, through photographs and books, this section has a very different mood, and the works and their words tell particular stories. Included here are snapshots of history – the Qajar era of Iran, for example, is a particular preoccupation of Iranian artists working with photography, whilst the Iran–Iraq war (1980–8) has become the focus of others. For Iraqi artists there are works concerned with the 1991 Gulf war; also with the US-led invasion of Iraq in 2003 and its consequences, such as the destruction of Iraq's libraries. The Egyptian artists included here make reference to historical figures, such as the well-known singer Umm Kulthum (d. 1975), and to social questions; a Palestinian artist touches on issues of identity and conflict, while Lebanese artists speak of the effects of the Lebanese civil war (1975–89).

4 Identity, History and Politics

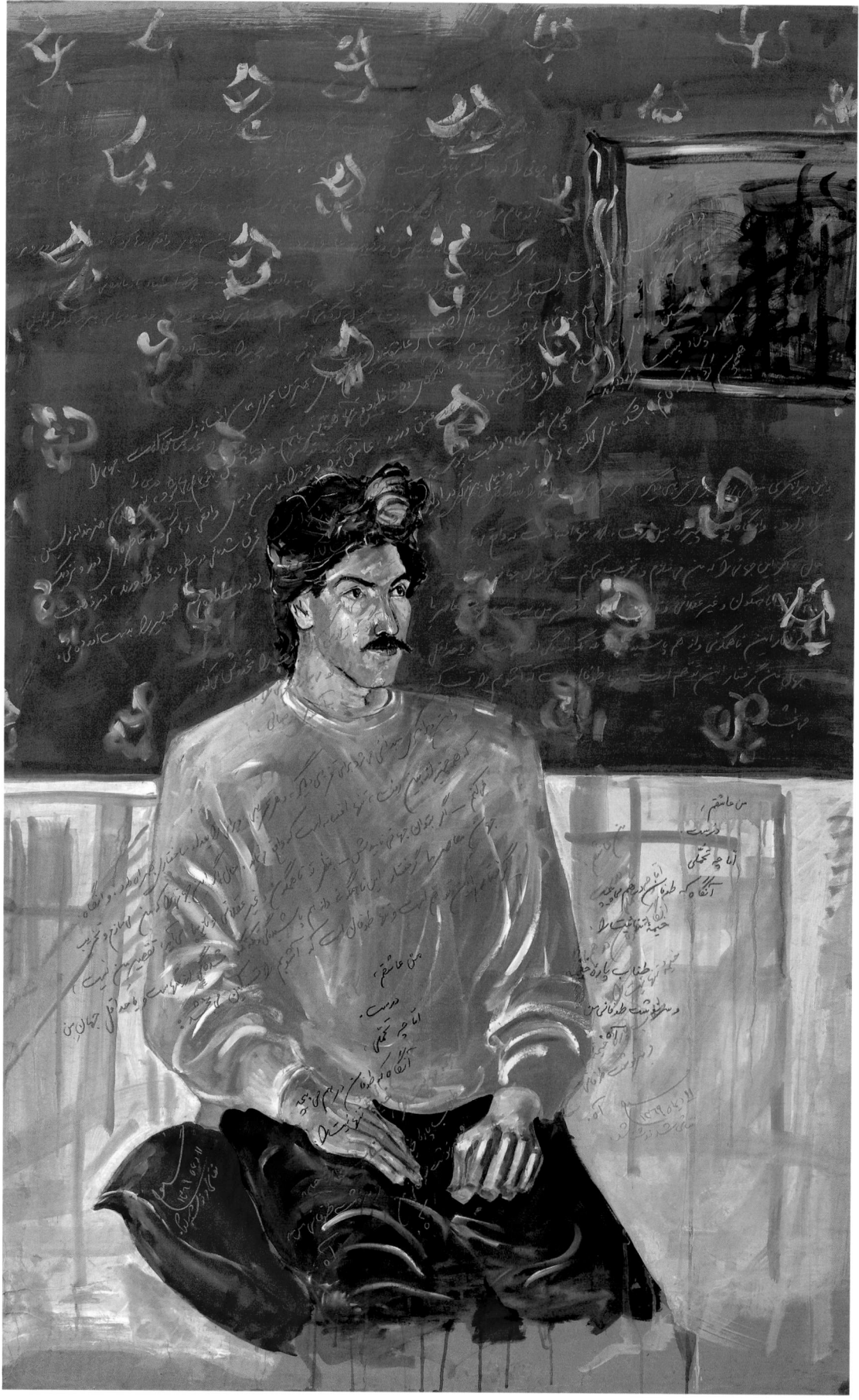

71 Khosrow Hassanzadeh

I'm in love

WATERCOLOUR AND PASTEL ON PAPER, 1990

H 203.0 cm, W 133.0 cm

IRAN

1999 9-28 01

BROOKE SEWELL PERMANENT FUND

Khosrow Hassanzadeh's experiences fighting as a young boy in the Iran–Iraq war (1980–8) have deeply marked his work. The first impression provided by this self-portrait recalls a classical Persian miniature. The text behind the figure tells a different story, however. It consists of philosophical musings on the human condition and starts with a poem:

'I am in love
Right
But what bearing
When the storm twists
The tent of loneliness
The torn rope of the tent
And my stormy destiny
Oh'

It continues:

'And this act of demolishing becomes a basis for another destruction, and each destruction follows a demolition after a construction. And when everything is destroyed, it is only the legend that seems real. Now if this world – which I am making or destroying – can be called a world, looks unfamiliar, irrational and ugly, it is not my fault. Our present world suffers from these unfamiliarities, from being torn apart and breaking into pieces of values, or at least my world suffers from this imagination and only storm can soothe my chaos.'

(Translated Shahrokh Razmjou)

72 Muhammed Aneh Tatari

Husayn, the martyr par excellence

MIXED MEDIA ON PAPER, 1998

H 47.8 cm, W 34.0 cm

IRAN

2000 7-24 01

BROOKE SEWELL PERMANENT FUND

This painting consists of a shadowy portrait of Imam Husayn, the Shi'a martyr killed at the battle of Kerbela in Iraq in AD 680, an event which has powerful resonance for Shi'a Muslims everywhere. Covering his face is a prayer scroll – indecipherable, it recalls script. Much of Tatari's work refers to aspects of past and present traditions of Iran and Central Asia.

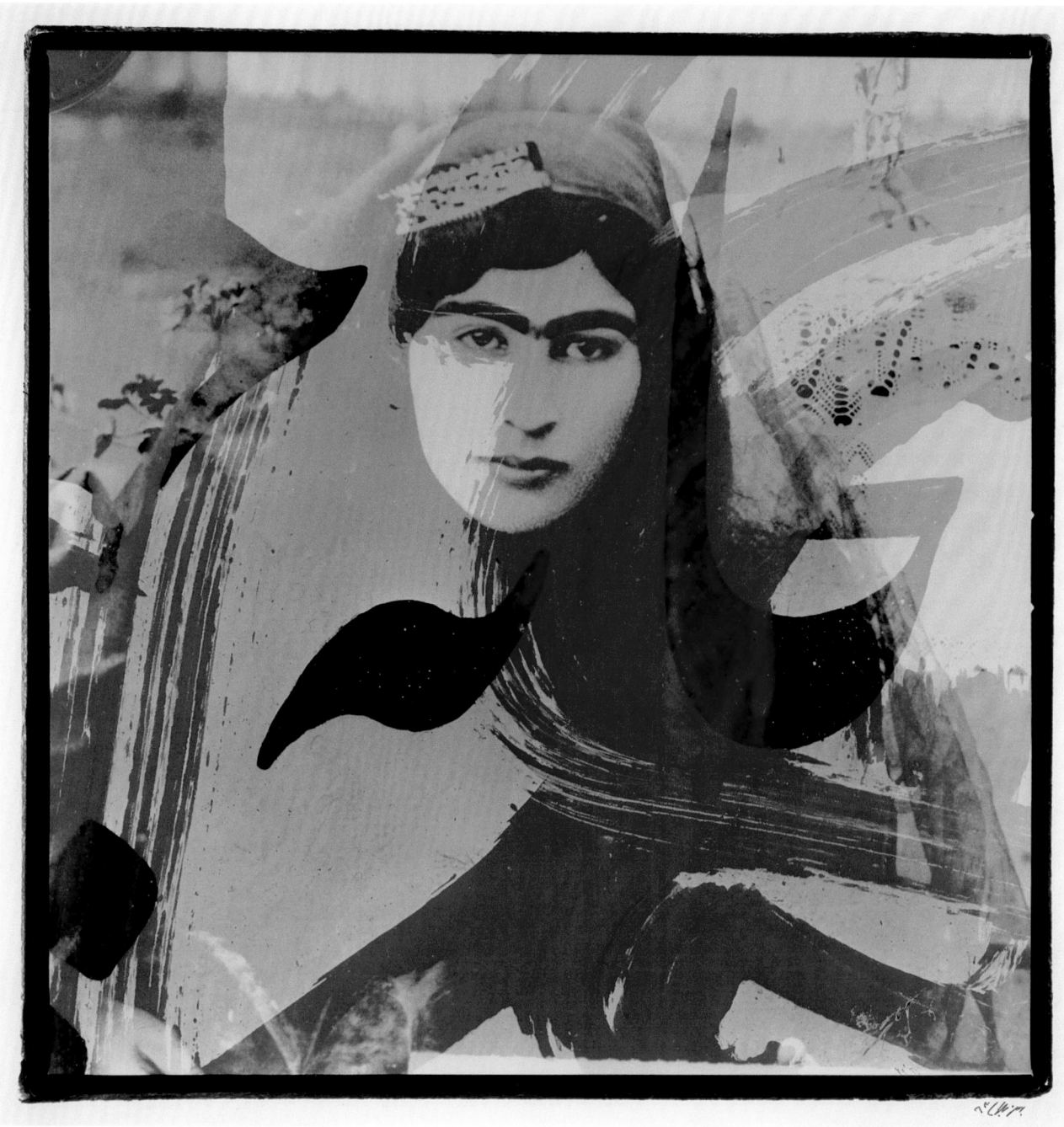

73 Bahman Jalali

Image of imaginations

PHOTOGRAPH, 2002
H 42.5 cm, W 42.5 cm (image)
IRAN
PRIVATE COLLECTION

Jalali described this image as follows:

'94 years ago a photo studio was opened in Isfahan called Chehrehnama. This studio was one of the most important studios in the history of photography in Iran. After the revolution I came across the sign for the Chehrehnama studio (in Persian *akaskhaneh chehrehnam*) which had been closed years ago. Someone had drawn with red paint on it in order to ruin it. From what I have heard women's pictures without the veil were taken in that studio and maybe this was in reaction

to that. Because of my interest in the history of photography in Iran I collect anything concerning photography. After finding this sign, and having portraits of women taken in those days' studios in my archive, I came up with the idea of mixing these two – the sign and the portraits. I mixed two eras, the present and the past, and their reaction to the pictures of women.'

(Personal communication)

74a–b Malekeh
Nayiny
*Three uncles; and
Mom and Hamoush*
2 DIGITAL IMAGES (3/25),
1997–8
H 42.0 cm, W 29.5 cm (each)
IRAN/FRANCE
2001 1-31 01 AND 02
BROOKE SEWELL PERMANENT
FUND

Nayiny writes as follows:

'Here they are to start with in black and white staring rather self consciously into the camera: My mother not yet in her teens but already sporting a *chador,* with her little cousin in a frilly little dress. Grandfather and friends seated around a table against a panoramic backdrop.'

Using computer technology as a 'time machine', she has altered the images in this series which she calls *Updating a Family Album* to take them out of their original setting. The garments have been overlaid with early twentieth-

century Iranian postage stamps of exotic birds. These were among the items in her father's cabinet of curiosities, which she kept in order to establish links with her parents and her past.

'I had the feeling that what I was trying to accomplish was a prolongation of my separation with the past. It became evident to me that if I was to go forward with my life I had to somehow assimilate all these bits and pieces of my life before.'

(Artist's statement)

74a

74b

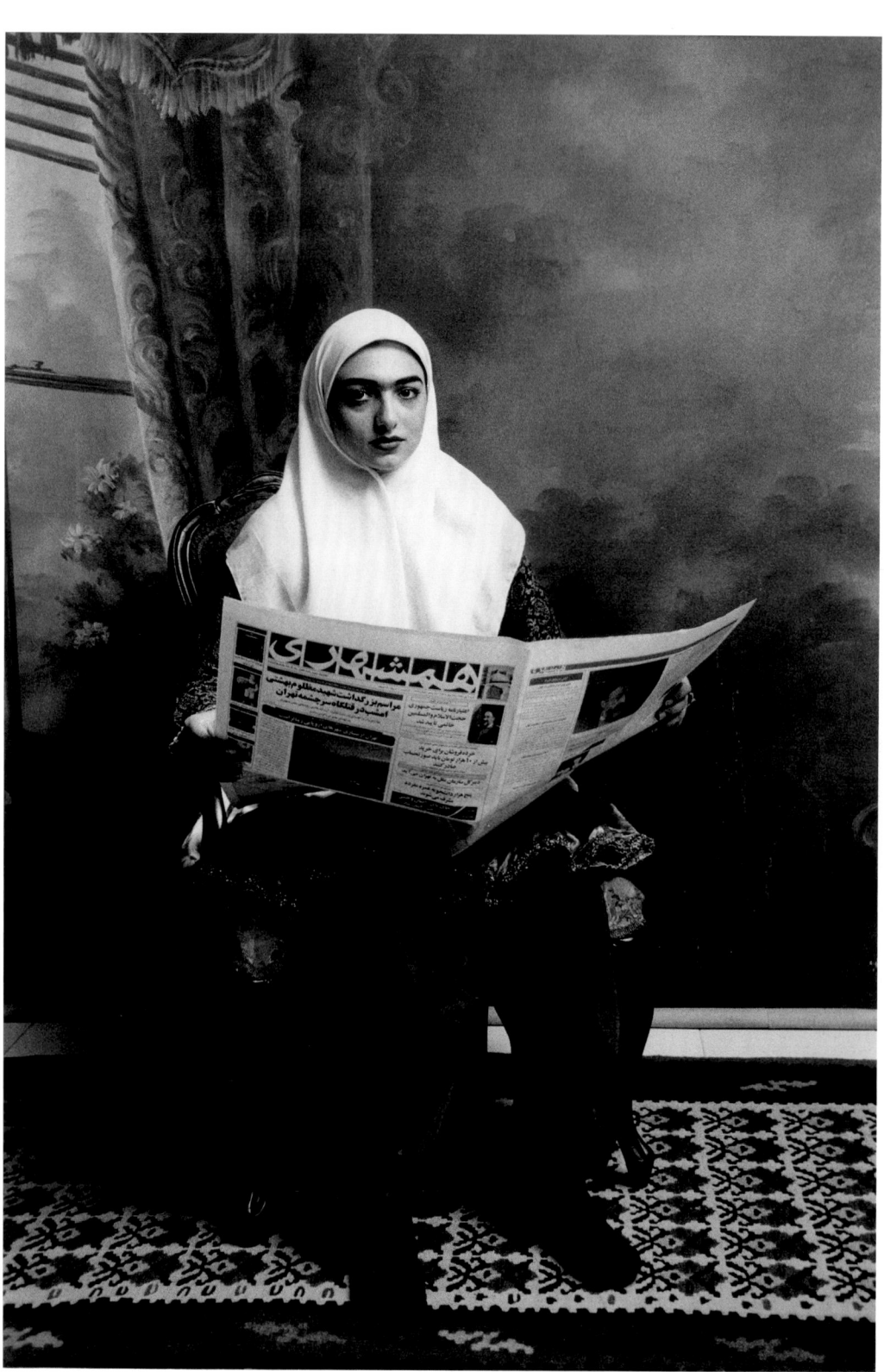

75 Shadi Ghadirian

Untitled

PHOTOGRAPH, SILVER
BROMIDE PRINT, 1998
H 75.0 cm, W 50.0 cm
IRAN
PRIVATE COLLECTION

This is one of a series of
'portraits' inspired by
Qajar-period photographs.
These were regarded with
awe and fascination when
they were first produced
as portraiture had been
forbidden in Iran hitherto.
In Ghadirian's words:

'For the project I had
everything reconstructed,
I had a friend who was a
painter prepare the backdrop,
I borrowed the dresses ... I
also had models re-enact the
poses that you see in the
Qajar pictures, and I tried to
reconstruct the stance the
models would take.'

In a deliberate
juxtaposition of tradition
with modernity, however,
the model is reading the
newspaper *Hamshahri*,
started by the mayor of
Tehran, Qolamhosein
Karbaschi during the
1990s. With a wide
distribution and printed
in colour, it was known
at that time as being
avant-garde.

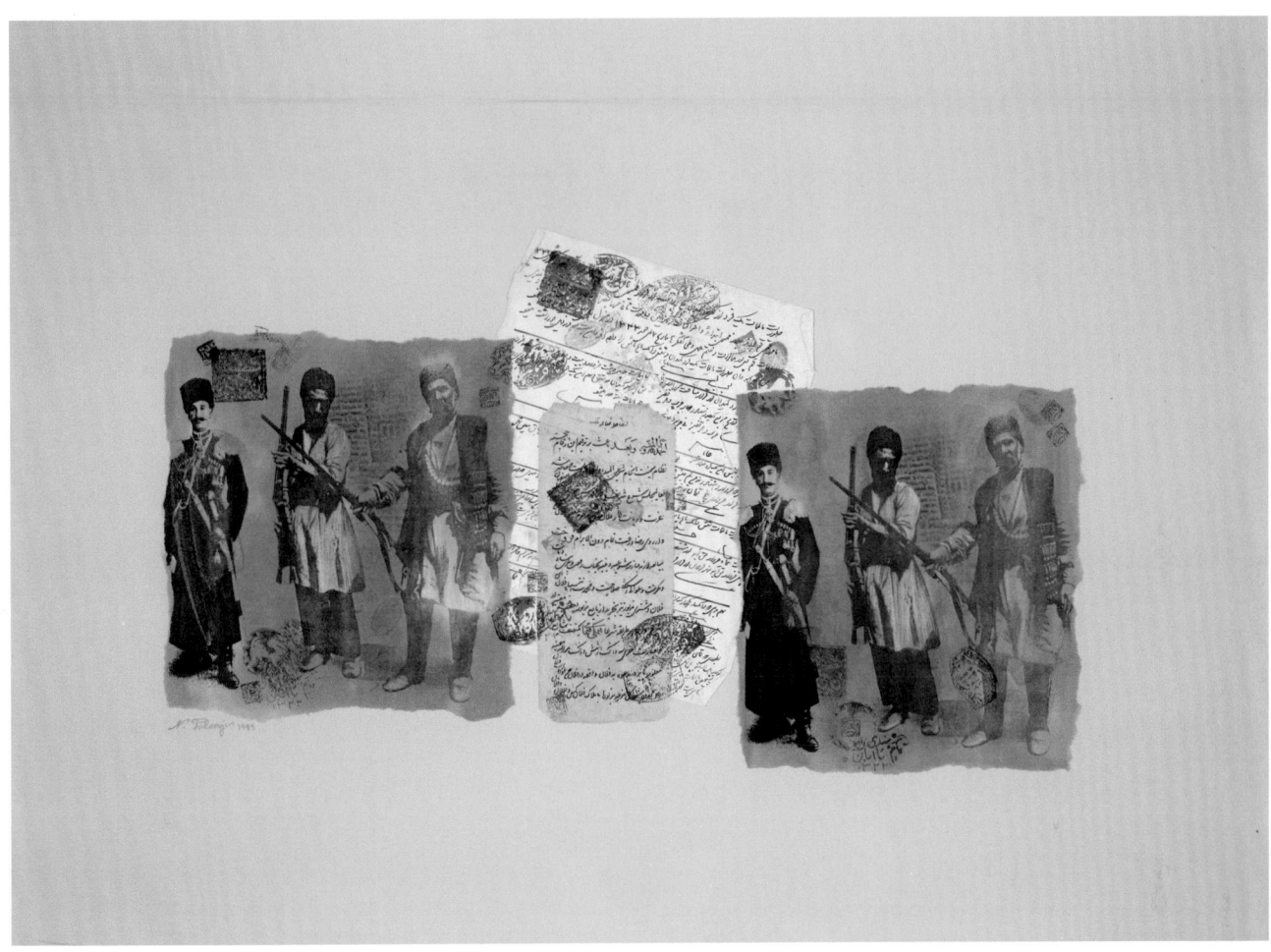

76 Nasser Palangi

Untitled

COLLAGE, 1999

H 50.0 cm, W 70.0 cm

IRAN/AUSTRALIA

2000 7-24 08

BROOKE SEWELL PERMANENT
FUND

In a snapshot of Iranian history, Palangi has combined
in this collage an old photograph of the Qajar era of Iran
(1779–1925), printed twice with legal documents in
between, which include property deeds. These are
stamped with the seals of officials and serve to
authenticate the documents. More seals have been added
across the collage.

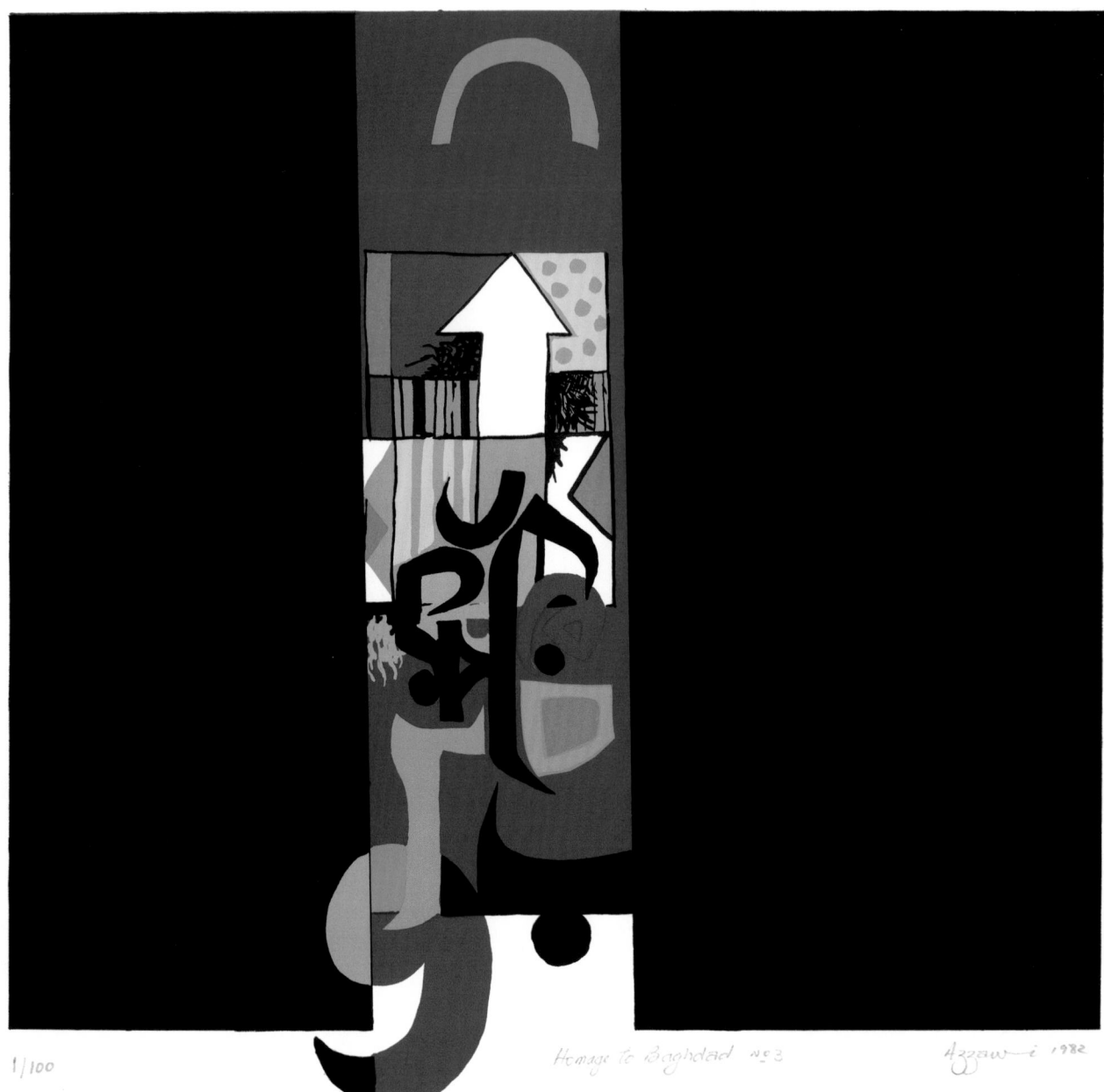

1/100 Homage to Baghdad №3 Azzawi 1982

77 Dia al-Azzawi

Homage to Baghdad

BOXED SET OF 10
LITHOGRAPHS (1/100), 1982

H 55.0 cm, W 50.0 cm

IRAQ/UK

1988 2-3 02

Al-Azzawi trained as an archaeologist, and his constant source of inspiration is Iraq's history and ancient civilizations – in particular that of the Sumerians. This powerful link with the ancient cultures of Mesopotamia creates in al-Azzawi's work a particular identity. In this series, in which he pays tribute to his native city of Baghdad, the vibrantly coloured sculptural abstract shapes echo the forms of those ancient sculptures. These are overlaid with individual Arabic letters, which in some of the lithographs make up the words '*Dijla*' ('Tigris') or 'Baghdad'. Illustrated is lithograph no. 3.

78 Maysaloun Faraj

History in ruins

EARTHSTONE AND OXIDES WITH RAFFIA, 2005
H 30.0 cm, W 60.0 cm (approx.)
IRAQ/UK
2006 2-2 1
BROOKE SEWELL PERMANENT FUND

The texts consist of a repetition of the words *Bism Allah al Rahman al Rahim* ('In the name of God the Merciful the Compassionate') and prayers (*du'a*). On the back is the word *limadha* ('why'). In the artist's words:

'From the land between the two rivers, I pick up in my mind's eye the remnants of pages from an ancient past scripted on clay tablets, where man first recorded his deeds and victories and recreate my own. I 'sew' them together in an act of healing and hope. I stand them tall and proud, like an open gate, defiant and dignified like our precious date palms, like our people, like our spirit.'

(Personal communication)

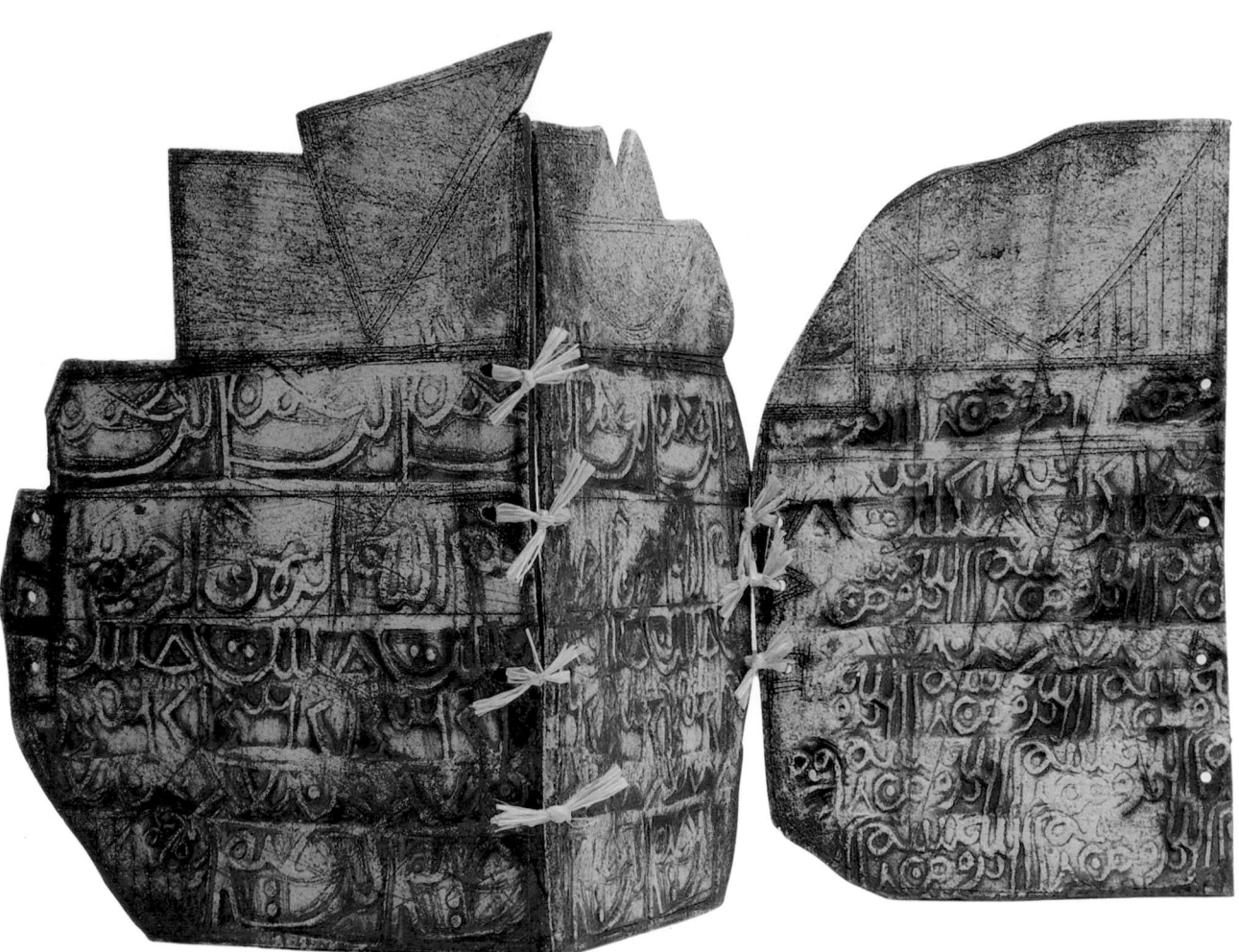

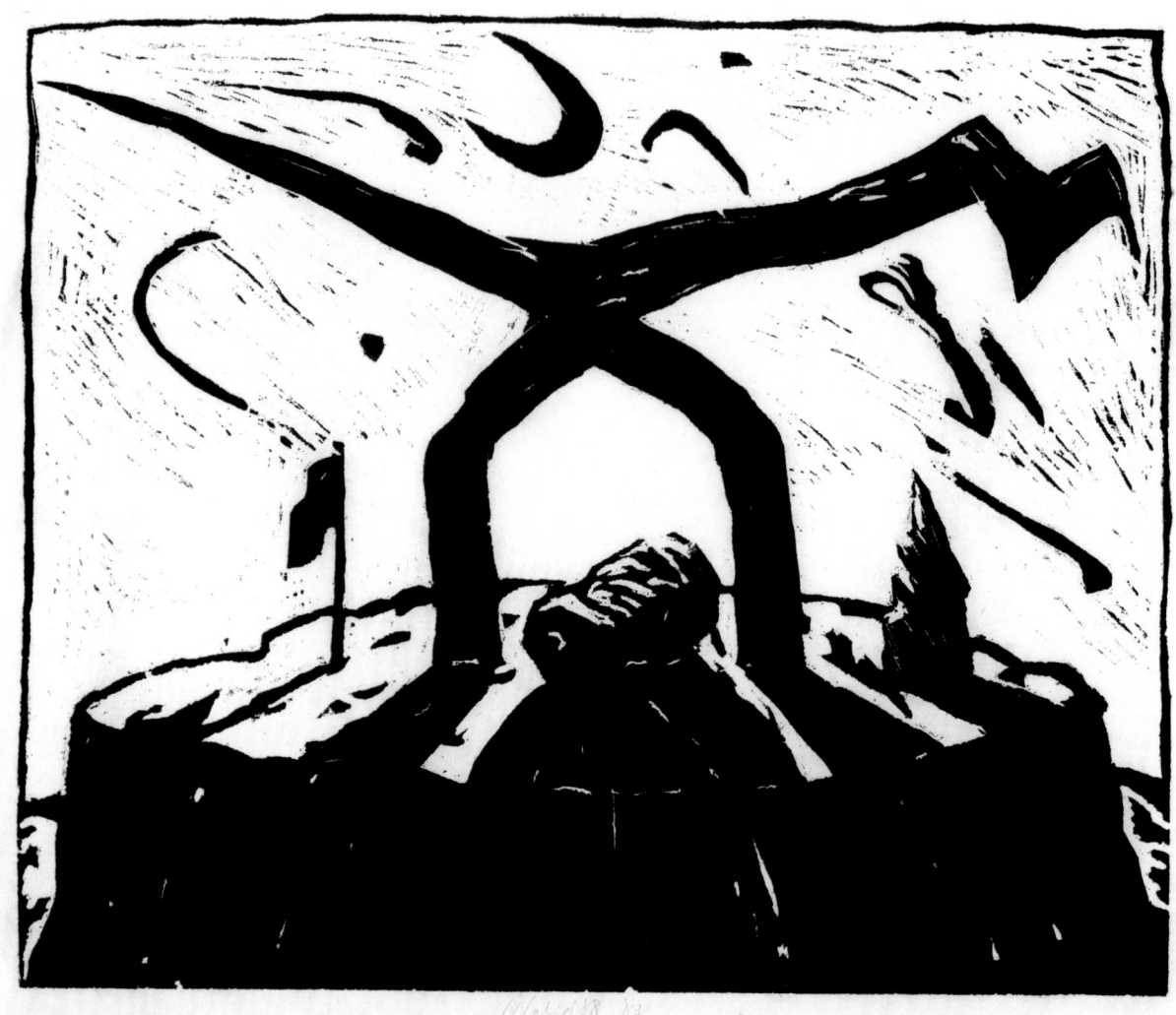

79 Walid Siti

Moonlight

WOODCUT ON JAPANESE RICE
PAPER, ARTIST'S PROOF, 1988

H 49.5 cm, W 63.0 cm

IRAQ/UK

1991 5-16 01

BROOKE SEWELL PERMANENT
FUND

This work is Walid Siti's response to the Iran–Iraq war (1980–8). It is reproduced in a book called *Dark Interludes*, which consists of thirteen lithographs that accompany a powerfully worded printed text by Iraqi writer Kanaan Makia. He comments: 'While I was writing about those fictitious nationalist and religious goals of the 1980s, and whose cost is to this day still being paid for by the people of Iraq, Walid Siti was drawing them. In a little studio in Hackney, London, he was combining broken symbols in stark, fiercely energetic black and white compositions.' Writing about the images as a whole, he says:

'There are no people in *Dark Interludes*: Flags, crescents, broken monuments, sculpted heads fallen off their pedestals, sharp arches that cut and pierce, and the dreadful all-too-familiar machinery of 20th century warfare are the Literal subject matter of these thirteen images. Barely recognizable corpses are reduced to tombstones, broken and littered about the landscape like bits of scattered rubble. These transfigured symbols of power, tradition and death, are set against a backdrop of eery stillness, or else they are caught up in torrent of swirling black and white lines depicting the turbulence and motion of war.'

80 Satta Hashem
Gulf war diary

BOOK, INK ON PAPER, 1991
H 30.0 cm, W 20.0 cm
IRAQ/UK
LENT BY THE ARTIST

Satta Hashem, while living in Sweden, kept this diary throughout the 1991 Gulf war. The page illustrated here marks the beginning of the aerial bombardment of Iraq on 17 January 1991, which continued for six weeks. The flying creatures evoke both ancient mythical beasts and the American planes. He writes on this day:

'17 – January – 1991 ... A quarter past two after mid-night. The war against Iraq erupted three hours ago or more; the air-strikes continue, Baghdad has been destroyed, the Iraqi forces in Kuwait destroyed. By the morning there will be just earth. This is what they say.

Half past eleven in the morning.
I didn't sleep all night. I saw all the news reports, I phoned all the Iraqis I know. None of them knew that the war had started ... All the news so far has come from the West: America and the Coalition ... There is nothing from Iraq about any military action ... but the war will continue for more days ... and there will be new preparations for a new American air-strike ... today.'

(Translated Satta Hashem)

81a

81a–b Kareem Risan

Uranium civilization

UNBOUND BOOK, MIXED MEDIA ON PAPER,
16 FOLDED PAGES, COVER AND SLIP CASE, 2001
H 29.5 cm, W 59.5 cm (each image)
H 31.0 cm, W 30.4 cm (slip case)
IRAQ
LENT BY DIA AL-AZZAWI

This book expresses the widespread concern in Iraq
and beyond that the use of depleted uranium in
anti-tank shells by US and British forces during the
fighting in Iraq in 1991 has left a hazardous legacy
for the inhabitants of Iraq. Risan's work, whether in
his paintings or his extraordinary hand-made
books, is strongly rooted in concern for his own
culture and its destruction. He creates in this series
of paintings images that are powerful and
disturbing.

81b slip case

82 Salam Khedher

Intahat al-harb
(*The war is over*)

SILKSCREEN ON PAPER, 1992
H 72.0 cm, W 57.0 cm
IRAQ/SWITZERLAND
2003 10-6 04
BROOKE SEWELL PERMANENT
FUND

Death, destruction and
desolation are powerfully
evoked in this work, which
is one of a series of seven
prints marking the end of
the Gulf war of 1991. As a
result of direct experience
of war by the artist, he
speaks about it as follows:

'This particular one says that
war is continuously going on,
whether in Halabja* or in
another place in Iraq. I
wanted to ask if really war
has ended. My prediction is
war will go on, it is a
negative conclusion, but it is
a fact cutting my heart and
making my future a grim
one.'

(Personal communication)

*The town in Iraqi Kurdistan
that famously suffered a
devastating chemical gas attack
in March 1988, causing an
estimated 4,000 deaths (Tripp
2000: 245).

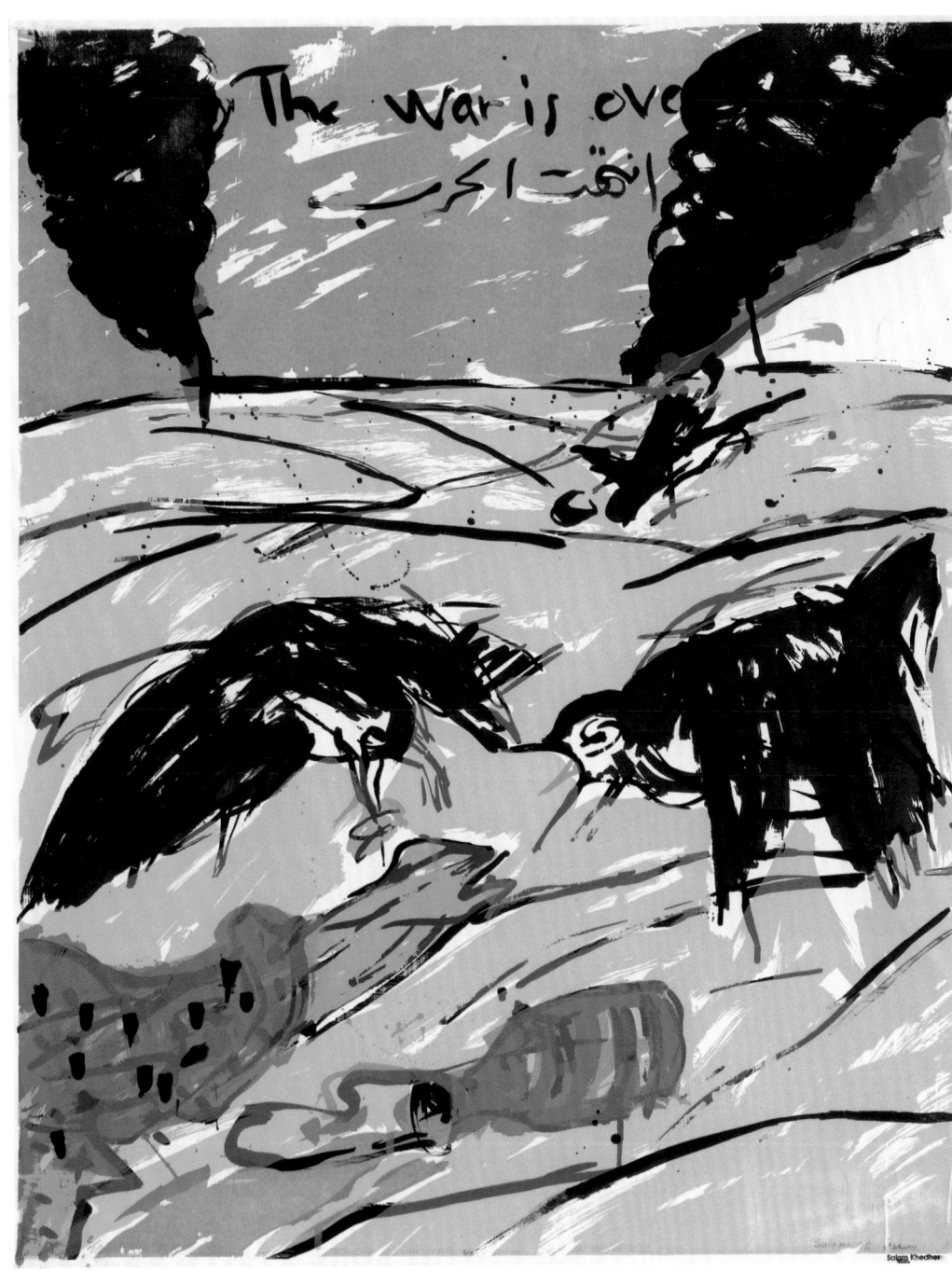

83 Saïd Farhan

Uncle Najib's suitcase

MIXED MEDIA ON CANVAS,
1999

H 39.0 cm, W 52.0 cm

IRAQ/SWITZERLAND

2003 10-6 01

BROOKE SEWELL PERMANENT
FUND

On leaving Iraq Farhan took only a single suitcase
containing his most treasured possessions, which years
later inspired him to create a series of 'suitcases', many of
them named after particular people. These symbolize for
Farhan the state of exile – his own and that of countless
others who have left their homeland. They contain those
familiar, often mundane, objects that provide comfort
when there is nothing else:

'homes don't travel. People hang on to their homes like snails
to their shells. When people have to leave their home, there
remains a scar at that very place were people and walls met so
closely ... The signs I use are inspired by writing, but they have
no more alphabetical meaning. They're still signs, signs made
of memories.'

(Farhan 1999: 18 and 50)

84a cover

84a–b Kareem Risan

Untitled

FOLDING BOOK, MIXED MEDIA ON PAPER, 30 PAGES, 2002
H 20.5 cm, W 20.5 cm
IRAQ
LENT BY DIA AL-AZZAWI

As with *Uranium civilization* (cat. 81), Risan is
focusing on specific aspects of the effects of the
recent wars in Iraq. This work in particular is a
response to the burning and destruction of a
number of important libraries in Baghdad and
elsewhere, which took place soon after American
forces captured Baghdad in April 2003. For many
people the burning of the books symbolized the
annihilation of their history.

84b

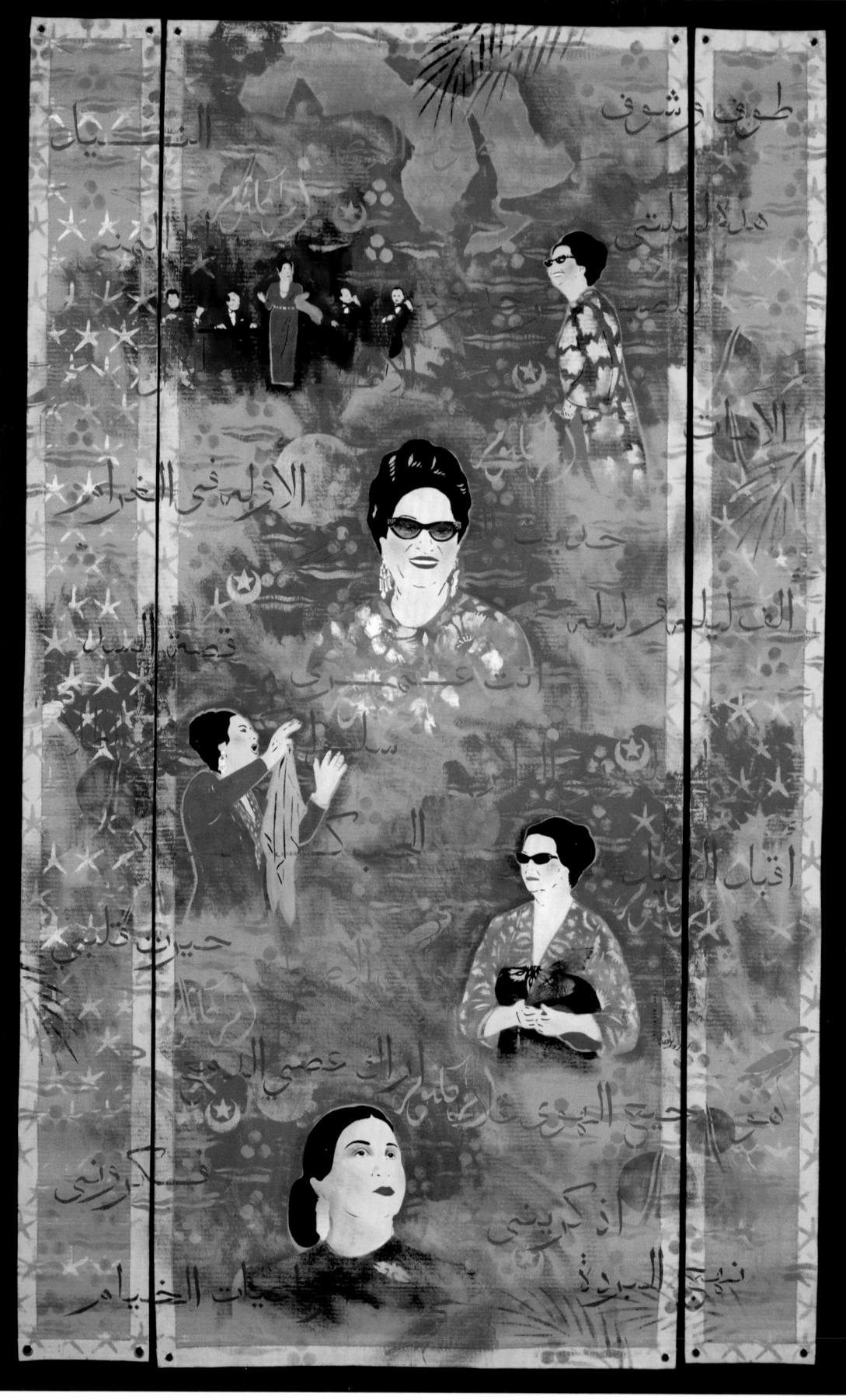

85 Chant Avedissian
*Umm Kulthum's
greatest hits*

RECYCLED BOARD, PIGMENTS
AND GUM ARABIC, 1990s
H 250.0 cm, W 150.0 cm
EGYPT
PRIVATE COLLECTION

The main theme of Avedissian's striking images is the bygone and glamorous era of Egypt of the 1940s and 1950s. Umm Kulthum, known as *Kawkab al-sharq*, 'the star of the east', is one of the most iconic figures of the Arab world. When she died in 1975, over 1 million people joined her funeral procession through the streets of Cairo. Thirty years after her death her songs, of which there are about 280, are still heard throughout the region. The titles of her most famous songs are listed in the picture; for

example, 'You are my life' (1965), 'I see you refusing to cry' by the poet Abu Firas Hamadani (932–68), 'A thousand and one nights' and others. Sung in both classical and colloquial Arabic, some were concerned with specific events, others were about love, patriotism and religion. In this painting, using his characteristic stencils, Avedissian pictures the great diva in various poses and at different stages of her life, often wearing her trademark dark glasses.

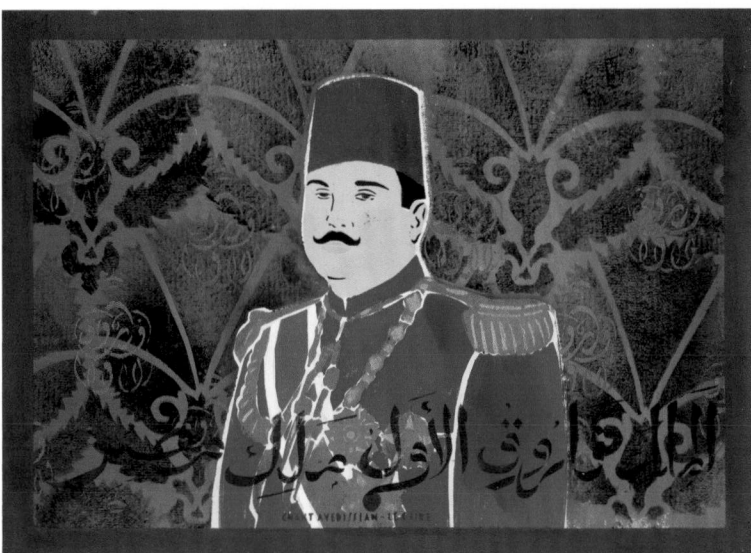

86a

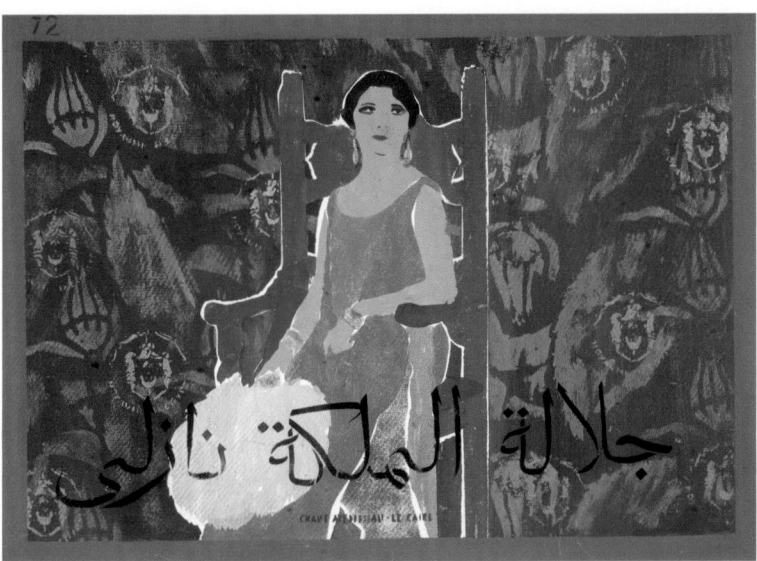

86b

86a–b Chant Avedissian
King Farouk and Queen Nazli

2 STENCILS, PIGMENTS AND GUM ARABIC ON RECYCLED
CARDBOARD, 1990s
H 49.5 cm, W 70.0 cm (each)
EGYPT
2000 8-5 01; 1995 4-11 05
BROOKE SEWELL FUND

In these two paintings Avedissian features King Farouk of Egypt (d. 1965) and his mother Queen Nazli (d. 1978). He became king in 1936, assuming full constitutional authority the following year when he came of age. Queen Nazli was the glamorous wife of King Fouad, Farouk's father. Upon the death of the old king, she became a centre of glamorous intrigue and a byword for the louche morals of the palace set. King Farouk, once the great hope of Egyptian nationalists and Islamists, had turned many against him by the 1940s because of his political ineptitude and increasingly dissolute behaviour. He remained at the centre of a dazzling social scene – Cairo at that time attracted statesmen, spies and film stars who were to make Egypt the intellectual and cultural capital of the Middle East. The portrait of King Farouk shows him in full regalia, but already with something of a cynical and dissipated air about him, perhaps presaging his overthrow in the revolution of 1952. In the background is an Ottoman textile design with the insignia of King Farouk superimposed upon it.

87 Sabah Naim

Cairo Faces

PAINTED PHOTOGRAPH ON
CANVAS AND NEWSPAPER,
2005

H 175.0 cm, W 150.0 cm

EGYPT

2006 2-4 01

BROOKE SEWELL PERMANENT
FUND

Sabah Naim's intention in her pictures, which include
rolled-up newspaper such as this combined with
photographs of people going about their daily lives, is
to draw attention to, and visualize in a concrete way,

'the widening gap between two often incommensurate worlds:
the international arena of the media and global politics and
the everyday world of ordinary Egyptians and their daily effort
to survive. Everyday struggles have taken the place of the
nationalist struggles in this postcolonial world order while
waiting has replaced action.'

('Faultlines', 50th Venice Biennale 2003, press release)

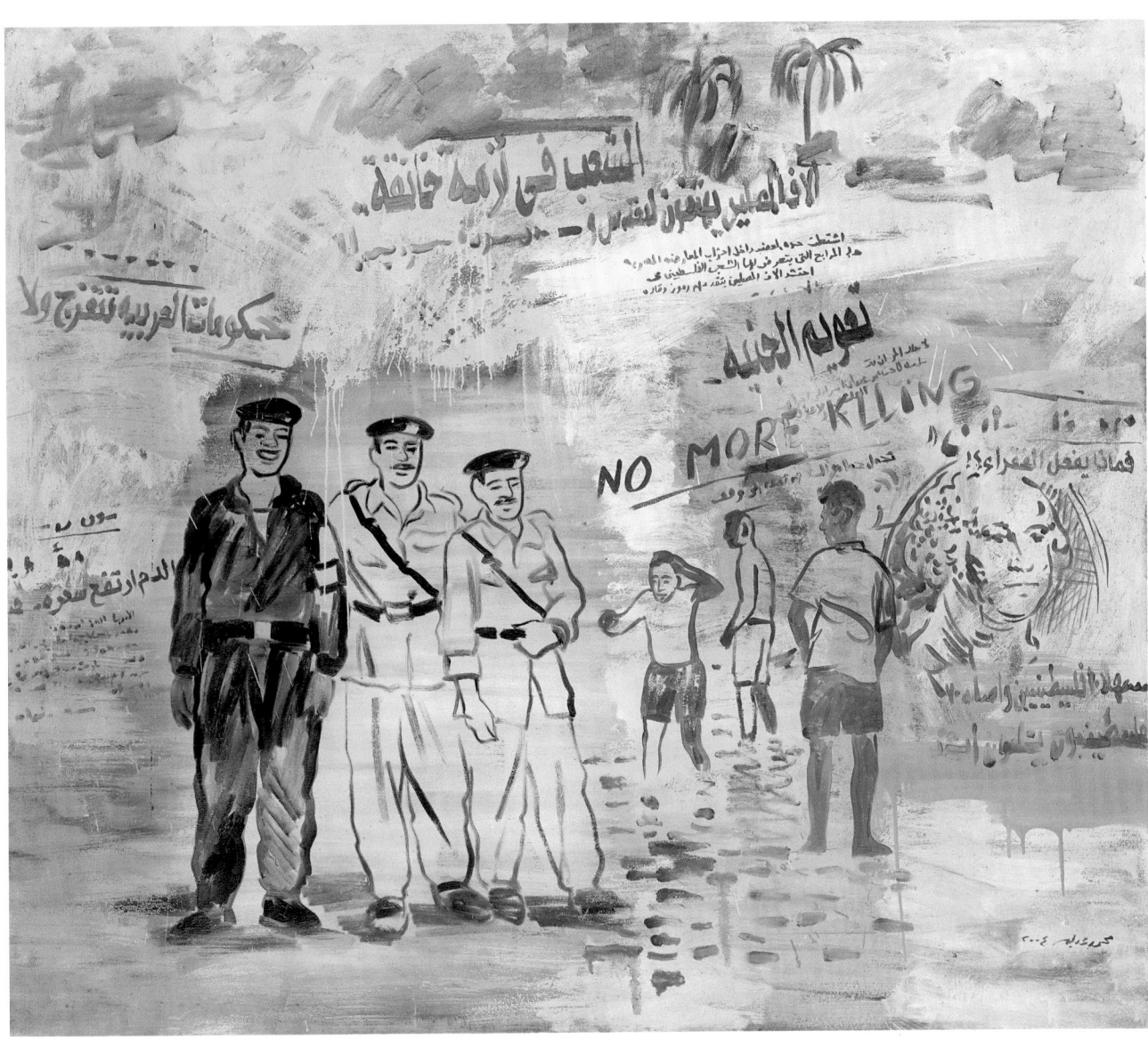

88 Mohammed Abla

No more killing

OIL ON CANVAS, 2004
H 120.0 cm, W 140.0 cm
EGYPT
2005 1-19 01
BROOKE SEWELL PERMANENT FUND

A commentary on the futility of war and the passivity of
Arab governments, this painting depicts three Egyptian
policemen, two in summer and one in winter uniform in
the foreground, a picture of George Washington from a
US dollar, and Arabic and English anti-war slogans
resembling newspaper headlines. These include Arabic
phrases such as 'Arab governments look on but ...', 'Our
people are in a suffocating crisis' and 'The price of blood
has risen.'

89 Youssef Nabil

Self-portrait, Madrid

PHOTOGRAPH: HAND-COLOURED
GELATINE SILVER PRINT, 2002
H 26.0 cm, W 39.0 cm
EGYPT
PRIVATE COLLECTION

Youssef Nabil has become increasingly known for his hand-coloured black-and-white portraits of well-known Western and Middle Eastern stars and artists. The intimate *Self-portrait* series, which he started to produce in 2000, reflects the artist's relationship to situations and the different cities he visited and worked in, including his home town of Cairo, where he always feels an outsider. The evocative words in the picture clearly conjure the

aspirations and dreams of Youssef Nabil as a rising artist. In an answer to a question about the cinematic aspect of his work, Nabil answered 'they all tell stories. I always liked to tell stories through my work, the more simple the photo is, the more complicated the story becomes. What is the point of making a photo if it does not have something to say?'

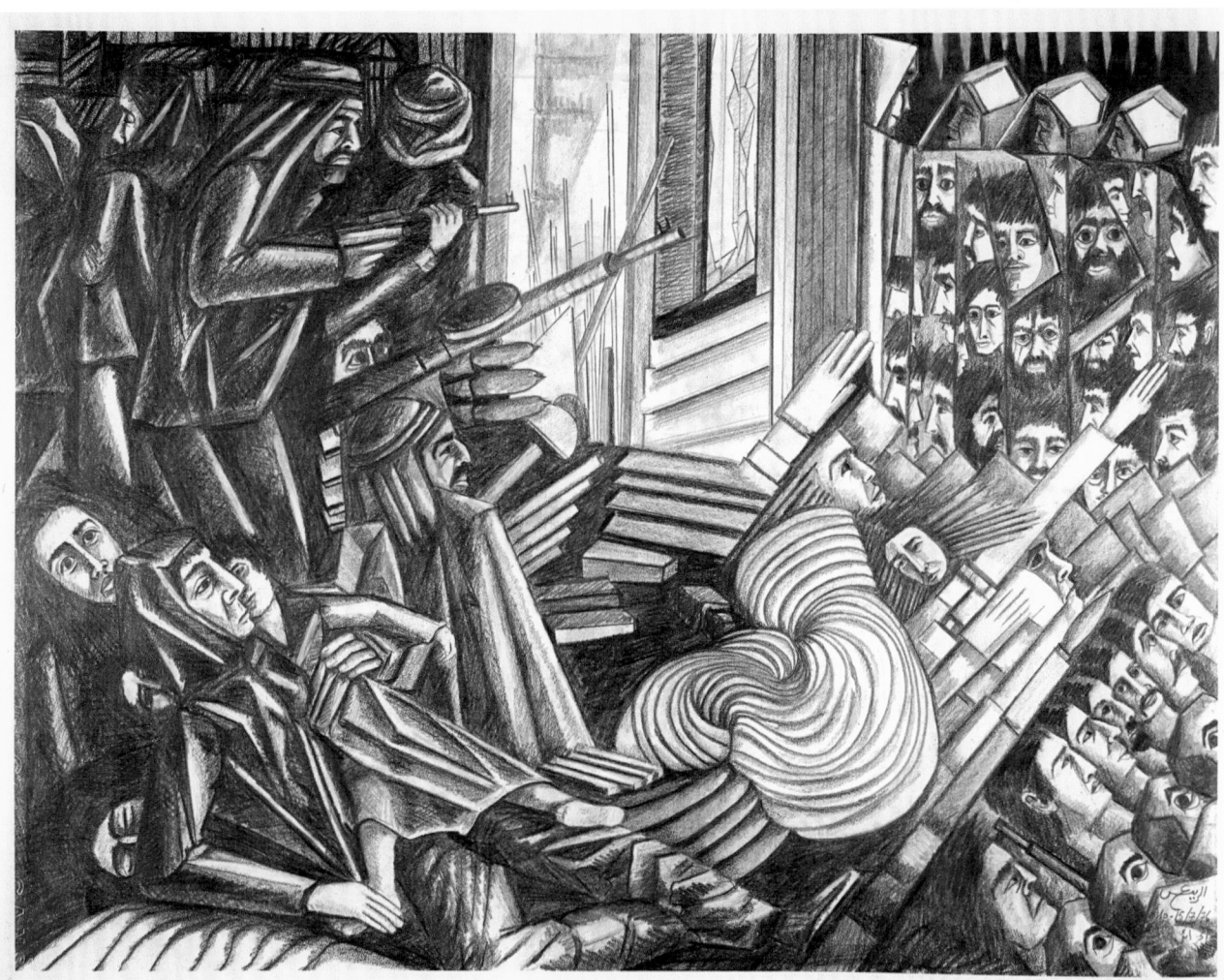

90 Aref el-Rayyess

The road to peace: images of the Lebanese civil war

BOUND BOOK, 1979
H 34.2 cm, W 48.5 cm
LEBANON
PRIVATE COLLECTION

This book contains a series of images that highlight the Lebanese civil war, the terrible conflict that tore Lebanon apart between 1975 and 1989 and set communities against each other. The powerful images are reproduced from charcoal drawings in grey and black. The stark picture illustrated here is called *In anticipation of a settlement*. People are stacked together, soldiers aim at a fractured wall of faces, mothers and children are frightened, and all are grim and unsmiling.

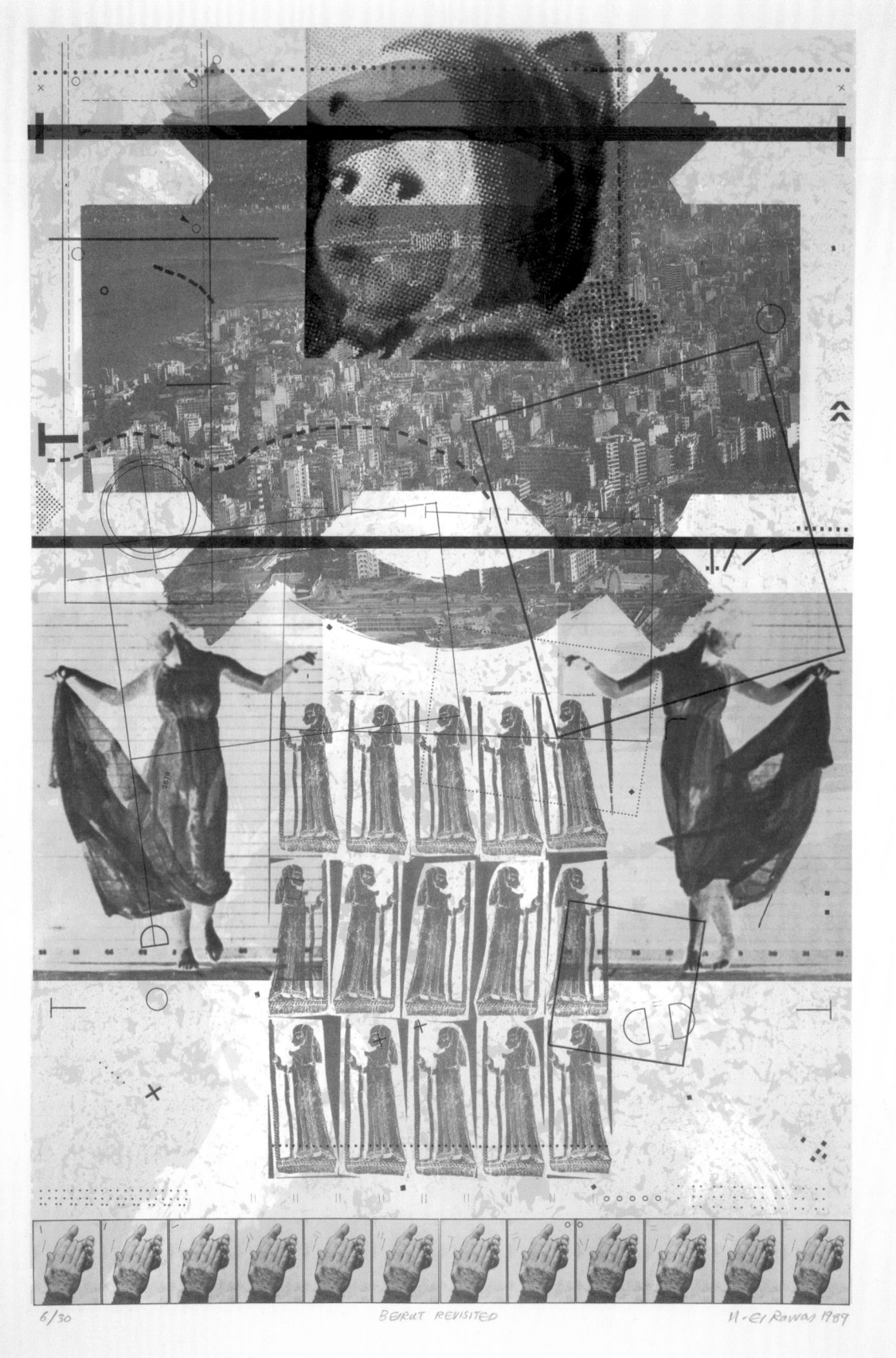

6/30 BEIRUT REVISITED H. El Rawas 1989

91 Muhammad Rawas

Beirut revisited

LITHOGRAPH ON PAPER (6/30), 1989
H 69.8 cm, W 49.7 cm
LEBANON
1990 8-8 01

This work, which received honourable mention at the
Norwegian International Print Biennial in 1989, was
made at one of the worst points of the Lebanese civil
war, just before it ended. It is full of codes. The
snapshot of the city of Beirut at the top of the
picture has a cross over it for 'cancelled' and a zero
meaning 'target'. The face of the child represents
panic. The rows of figures based on ancient ivories
stand for the foreign armies. An image of the
absurdity of war, the whole is turned into a stage
set; hands are clapping with the world looking on.
A strong source of influence for Rawas has been
the sequential photographs of figures in motion by
Eadweard Muybridge (d. 1904). They represent the
idea of moments of time that, as exemplified here,
is a key element of Rawas's work.

92

92 Walid Raad

*The truth will be known when the last witness
is dead*

PRINTED BOOK, ATLAS GROUP, VOL. 1, THE FAKHOURI FILE,
2004
H 29.0 cm, W 23.5 cm (closed)
LEBANON
PRIVATE COLLECTION

Walid Raad established his 'Atlas group' in Beirut in 1999 as a commentary on the recent
history of Lebanon. The artist documents the history around fictitious characters such as
Dr Fadl Fakhouri, after whom the present file is named. In this work Dr Fakhouri, until his
death in 1993, is the foremost historian of the civil war in Lebanon. He bequeathed
numerous documents to the Atlas group, many of which consist of notebooks in which
he documented his gambling on horses – the pastime of many Lebanese historians. These
extraordinary fictitious records appear in the first part of the book. The second part, from
which the illustration is taken, consists of 145 cut-out photographs of cars. These refer
to all the makes and colours of cars used as car bombs during the Lebanese civil war
(1975–91). This is no. 62, Silver Volvo, which on 20 August 1985 killed 56 and injured
120 with 100 kg of TNT. Cars, buildings and shops were also burned.

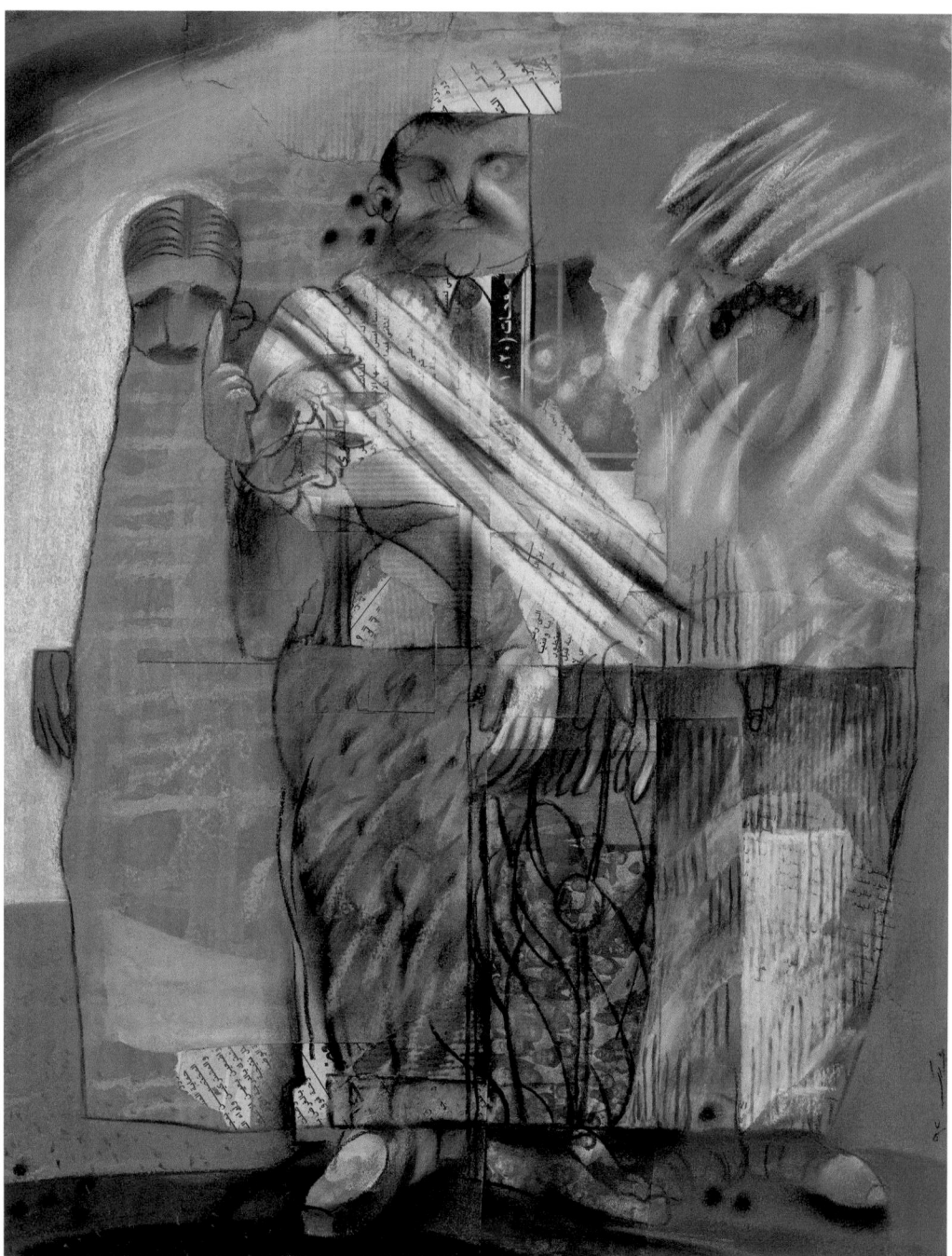

93 Youssef Abdelké

Untitled

PASTELS AND COLLAGE
ON PAPER, 1992
H 40.9 cm, W 32.0 cm
SYRIA/FRANCE
1993 3-1 01

As a caricaturist, graphic artist, painter and engraver, Abdelké worked for many years in Syria before leaving in the early 1980s to live in Paris. In his work he constantly criticizes authority, which is defined within social and political standards (for example, male authority and political figures). The juxtaposition of three standing figures has been a constant theme in his work. In delicate pastel shades, they stand in a row, in the centre a portly and sinister man. Those on either side seem to stand back in fear, the one on the right with all facial features erased. Pasted in are fragments of newspapers.

94 Laila Shawa

*Children of war,
children of peace*

SILKSCREEN ON CANVAS IN
TWO PARTS, 1995

H 100.0 cm, W 230.0 cm (each)

PALESTINE/UK

2001 10-10 01-02

MRS MONA AL-KHATIB,
MR GHAZI SHAKER AND THE
BROOKE SEWELL PERMANENT
FUND

In this two-part work Shawa highlights the plight of
Palestinian children. Her subject is a young boy from the
Sheikh Radwan refugee camp in Gaza carrying a stick.
After the Oslo agreement in 1993 it was believed that
the new potential for peace would change the situation of
the Palestinian refugees, particularly the lives of children.

'Unfortunately there has been no change in these children's
lives and the trauma and dispossession has carried on. The only
apparent difference in the streets of Gaza was the change in
the colour of the graffiti which became brighter. However the
misery, poverty and the trauma of violence remained.'

(Artist's statement)

This work follows a series called *Walls of Gaza*, in which
Shawa featured the graffiti in the streets of Gaza. Rival
groups would make their mark and the Israeli occupiers
would spray purple paint to eradicate it. In *Children of war,
children of peace*, the traces of these writings, now
deliberately illegible, have merged into the background,
an evocative reminder of the context in which these
were painted.

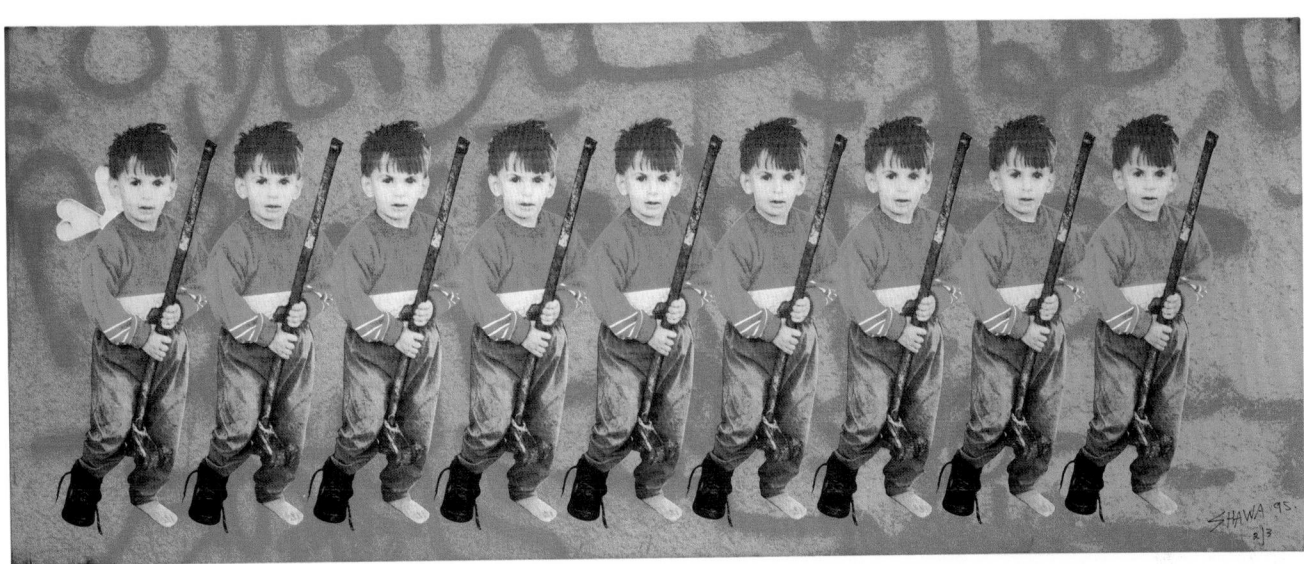

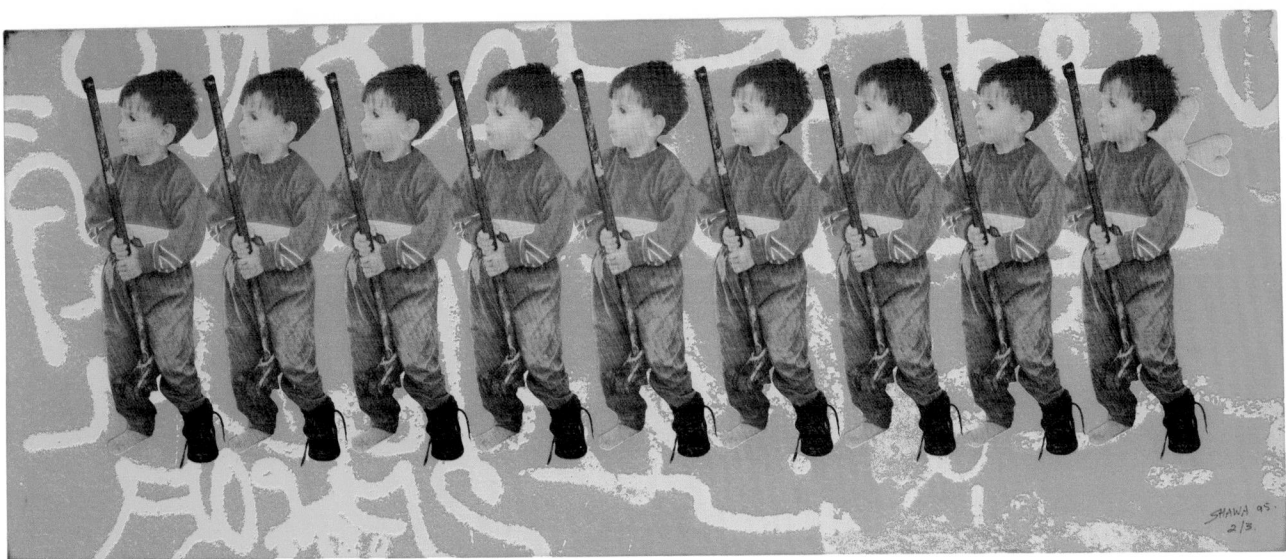

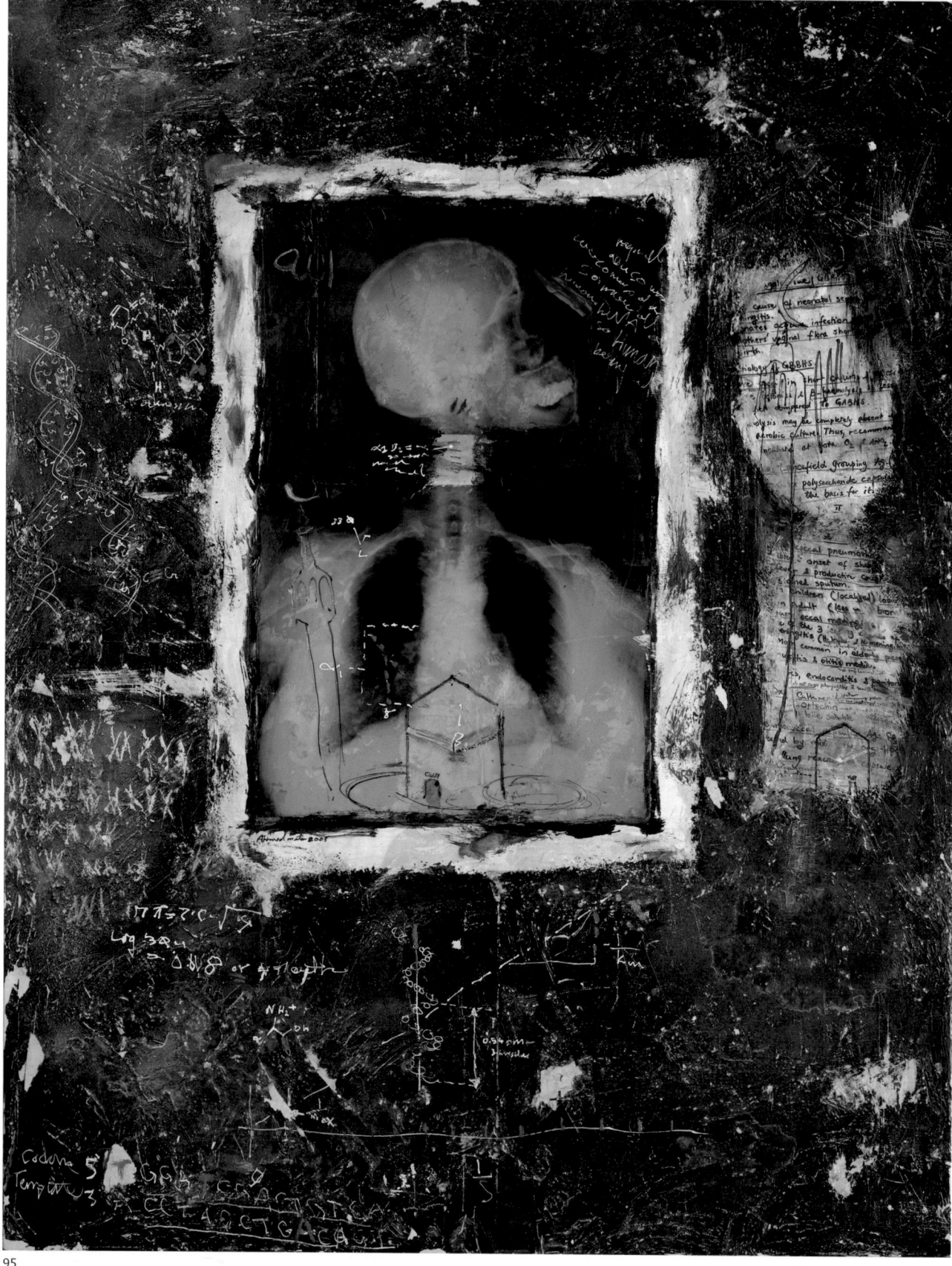

96 Laila Shawa
Hands of Fatima

OIL AND ACRYLIC ON CANVAS,
1989
H 89.0 cm, W 70.0 cm
PALESTINE/UK
1992 4-14 01

During the 1980s Laila Shawa created
a series of paintings focusing on
women and the veil. This painting was
the first of a series entitled *Women
and Magic*. The women with their
blank eyes hold up hennaed hands
that have become banners carrying
the 'Hand of Fatima'. Inscribed in
Arabic are the words *ma sha'a Allah*
('as God wills'). As the daughter of
the Prophet Muhammad, Fatima is a
revered figure in parts of the Islamic
world and a potent symbol against
the 'evil eye'.

'She embodies the power to alter their
lives without their making the effort, since
their misfortunes are the deeds of Satan
... the tradition of magic is so ingrained in
the culture and the psyche of our part of
the world that it transcends religion and
even education.'

(Personal communication)

Shawa's interest in magic comes from
her direct personal experiences of
magical practices when growing up
in the Middle East.

95 Ahmed Mater al-Ziad
X-ray

MIXED MEDIA AND X-RAY FILM,
2003
H 105.0 cm, W 135.0 cm
SAUDI ARABIA
2006 2-14 01
BROOKE SEWELL PERMANENT
FUND

In Mater's words,

'This painting explores the
confusion in the identity of
mankind in the contemporary
world. The x-ray, sitting on top
of a deep, layered background
of medical text and expressive
paint, represents an objective
view of the individual, chosen
to provoke a familiar response
... My approach as a practising
doctor has been evidence based
and influenced by a direct
experience of the world.'

(Artist's statement)

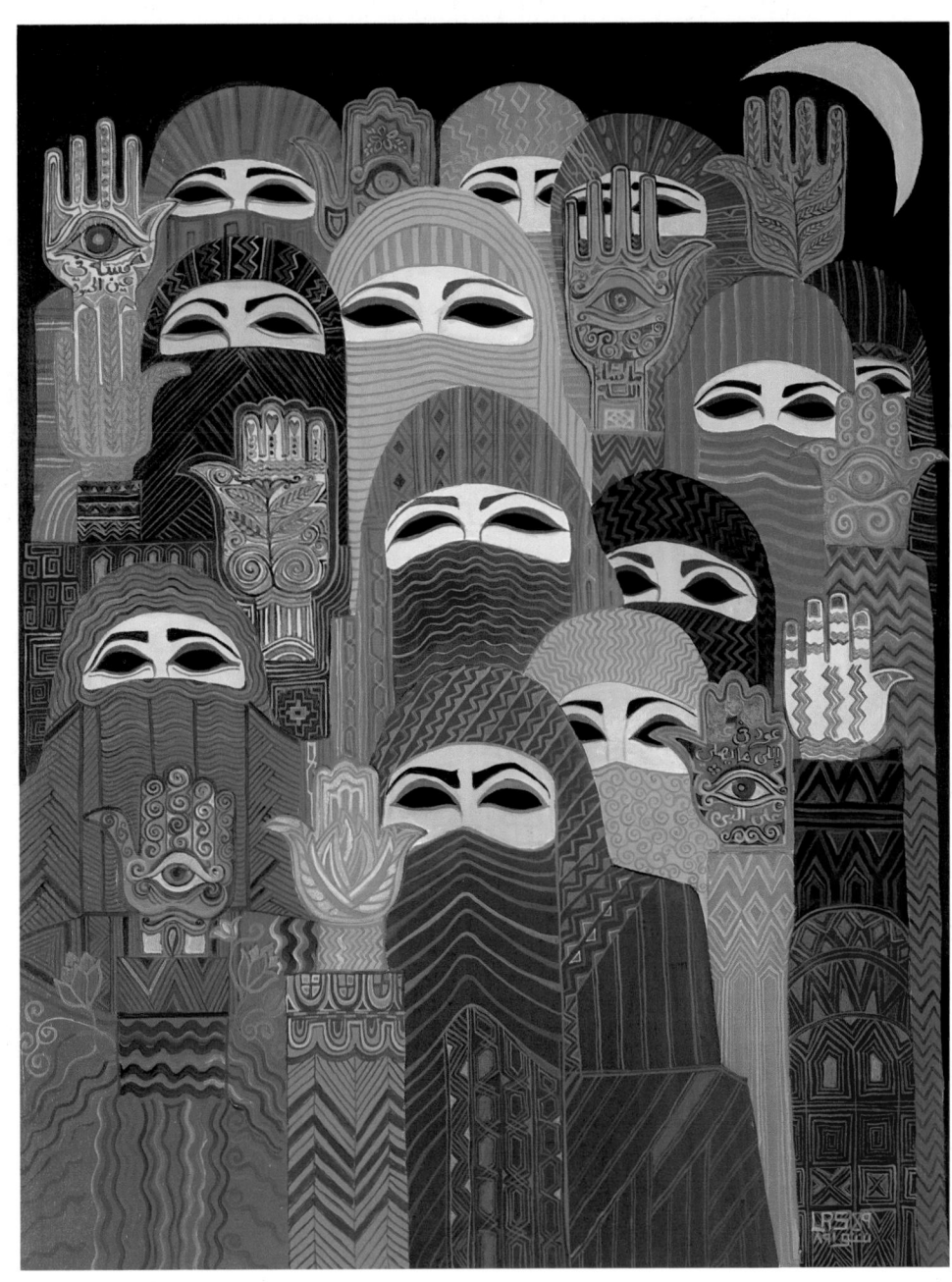

Artist Biographies

Biographies are included for artists whose works are featured in the catalogue section of this book. The information about the artists has been gleaned from a number of sources, including exhibition catalogues, artists' monographs and the internet. Some of these sources are listed in the bibliography. In the catalogue entries the artist's country of origin is cited first and their current place of residence second.

ABBOUD, Shafic

BORN BIKFAYA, LEBANON, 1926 (d. 2004)

Abboud studied art at the Académie Libanaise des Beaux-Arts, Beirut, 1945–7. Among his professors were César Gemayel (Lebanese) and Georges Cyr (French), two prominent artists in the foundation of the modern art movement in Lebanon. The latter introduced him to Western schools of art, and in 1947 Abboud travelled to Paris. He worked in the ateliers of a number of renowned French artists, among them Fernand Léger and André Lhote, and studied at the Ecole Nationale des Beaux Arts. Having settled in Paris, he participated in the Salon des Réalités Nouvelles from 1955 and, in 1962, became a member of its committee. Abboud's work has been exhibited on numerous occasions in France and Lebanon. He has been awarded several prizes, including the Prix Victor Choquet, Paris, 1960, and the Prix du Salon d'Automne at the Sursock Museum, Lebanon, 1964.

ABDELKE, Youssef

BORN QAMECHLI, SYRIA, 1951

Abdelké graduated from the College of Fine Arts, University of Damascus, 1976, and the Ecole Nationale Supérieure des Beaux Arts, Paris, 1986, before obtaining a doctorate in fine arts from the University of Paris VIII, 1989. His work includes posters, book designs, illustrations for periodicals and children's books as well as caricatures. He has researched the history of caricature in Syria, and Arab caricaturists and their techniques. His work has been exhibited in the Middle East, North Africa and Europe, including – in 2005 – the International Biennial *Imagining the Book*, Alexandria Library, Egypt, and solo exhibitions in Kuwait and at the Khan Assad Bacha in Damascus, Syria. Abdelké lives and works in Paris.

ABDULLAH MAHMUD, Iman

BORN BAGHDAD, IRAQ, 1956

Abdullah graduated in graphic arts from the Institute of Fine Arts, Baghdad, 1980, then pursued her studies in painting at the Academy of Fine Arts, Baghdad, 1980–4. In 1998 she moved to Munich, Germany, where she has been living and working ever since. In 2001 she became a member of the German Association of Artists (Bundesverband Bildender Künstler – BBK). Her work has been exhibited in a number of solo and group exhibitions in Europe, the Middle East and the United States, including the touring exhibition *Strokes of Genius: Contemporary Iraqi Art*, which began in the United Kingdom, 2000.

ABLA, Mohammed

BORN BELQAS MANSOURA, EGYPT, 1953

Abla graduated from the Faculty of Fine Arts in Alexandria, 1977. In the 1980s he travelled extensively in Europe, exhibiting and pursuing studies in graphic arts, sculpture and art therapy. Between 1996 and 1998, together with Egyptian artist Adel el-Siwi, Abla worked on a community arts project painting the walls and creating outdoor works in the deprived area of Kom Ghorab in old Cairo. His work, including oils on canvas, limited-edition prints and installations, has been exhibited in the Middle East, Europe and the United States. Abla lives and works in Egypt.

ADNAN, Etel
BORN BEIRUT, LEBANON, 1925

Adnan is a writer and a painter. She studied philosophy at the Sorbonne University, Paris; and at the University of California and Harvard University, USA. She spent a number of years teaching the philosophy of art at the Dominican College of San Rafael, California, as well as giving lectures at several universities. She is the author of several books of poetry and fiction, including her novel about the Lebanese civil war, *Sitt Marie Rose*, 1977. In the 1960s she combined her skills as a writer and a painter when creating her first *livre d'artiste*. She has since continued exploring the relationship between word and image, and has created over two hundred 'artist books'. First, and mostly inspired by Arabic literature, she also gained inspiration from French and American authors. Her work includes paintings, drawings, ceramics and tapestries. She has exhibited extensively in Europe, the Middle East and the United States. Adnan lives in Paris, Beirut and California, USA.

AFNAN, Maliheh
BORN HAIFA, PALESTINE, 1935

Afnan obtained her Master's in fine arts from the Corcoran School of Art, George Washington University, USA, 1962, after having studied sociology at the American University of Beirut, Lebanon. Of Iranian parents, born in Palestine and having studied in the United States and Lebanon, Afnan continued her travels, working in Kuwait, Lebanon, France and England, where she now lives. In 1971 the American artist Mark Tobey, who had been inspired by the influence of Chinese calligraphy as well as Arabic and Persian scripts, arranged and presented her first European exhibition. Since then her works have been shown widely in Europe, the Middle East and the United States, including a solo exhibition at Leighton House, London, 1993, and a retrospective at England & Co., London, 2000.

ALANI, Ghani
BORN BAGHDAD, IRAQ, 1937

Alani studied law in Baghdad and Paris, and art at the Institute of Fine Arts, Baghdad, and the University of Paris VII. He practised calligraphy from an early age and studied under the Iraqi master calligrapher Hashem Muhammad al-Baghdadi, from whom he received a calligraphy diploma (*ijaza*) in 1967. In 1975 he was awarded a second *ijaza* by another celebrated calligrapher, Hamid al-Amidi of the Turkish school. From then on, having completed his law doctorate, Alani dedicated himself fully to calligraphy. Since 1993 he has been in charge of calligraphy at the Ecole Nationale Supérieure, Paris. He has participated in a number of conferences and television programmes on Arabic calligraphy and has authored several works, including *Calligraphie Arabe*, 2001. His calligraphies have been shown widely in Europe, the Middle East and North Africa.

AL-ALI, Salah Faisal
BORN BAGHDAD, IRAQ, 1958

Al-Ali graduated from the Ecole Supérieure d'Art Visuel, Geneva, 1985. He has had a number of solo exhibitions in Iraq, Tunisia and Switzerland. He participated in the first Biennial of contemporary Arab art in Tunisia, 1985, and the British International Print Biennial in Bradford, 1986. Between 1987 and 1988 he worked on the travelling exhibition and accompanying catalogue *Calligraphie Islamique: Textes Sacrés et Profanes – Islamic Calligraphy: Sacred and Secular Writings*, which began at the Musée d'Art et d'Histoire, Geneva, 1988. Al-Ali lives and works in Geneva.

ALI, Wijdan
BORN AMMAN, JORDAN, 1939

Ali is an art historian, painter and art curator. She graduated in history from the Beirut College for Women, 1961, and gained a PhD in the history of Islamic art from the School of Oriental and African Studies, London, 1993. Her art training began in the late 1950s under Muhanna Durra, a leading artist of the modern art movement in Jordan. Ali has written, edited and contributed to a number of publications on contemporary art from the Islamic world and the Arab contribution to Islamic art. She is the founder of the Royal Society of Fine Arts (1979) and the National Gallery of Fine Arts (1980) in Jordan, as well as founder and dean of the Faculty of Arts and Design at the University of Jordan (2001).

ARABSHAHI, Massoud
BORN TEHRAN, IRAN, 1935

Arabshahi held his first solo exhibition at the Iran–India Centre, Tehran, in 1964, four years before graduating from the College of Decorative Arts, Tehran. His work includes oils on canvas, sculptures and architectural reliefs – among the latter commissions for the Office for Industry and Mining, Tehran, 1971, and the California Insurance Building, Santa Rosa, USA, 1985. His sources of inspiration include Achaemenid and Assyrian art as well as Babylonian carvings and inscriptions. Combining tradition and modernity, Arabshahi has been associated with the *Saqqakhaneh* movement, whose prime exponents were Charles-Hossein Zenderoudi and Parviz Tanavoli. His work has been shown in a number of solo and group exhibitions in Iran, Europe and the United States, including *Two Modernist Iranian Pioneers* with Zenderoudi, at the Tehran Museum of Contemporary Art, 2001; and *Iranian Contemporary Art*, Barbican Centre, London, 2001. He lives and works in Tehran and California.

ARMAJANI, Siah

BORN TEHRAN, IRAN, 1939

Armajani moved from Iran to the United States in 1960 to study philosophy at Macalester College, Minneapolis, graduating in 1963. Prior to that, in 1956, he had started practising the traditional art of calligraphy, which he revered alongside poetry and philosophy. Some of his early works, principally two dimensional, are filled with script and lines of Persian poetry. He later turned to sculpture, public art displays and architectural constructions, some of them including quotations from American literature, such as the railings with poetry by Walt Whitman at Battery Park, New York. Armajani received many public commissions worldwide, including the Olympic Tower and Bridge, Atlanta Olympic Games, USA, 1996; the gazebo and garden furniture of the Villa Arson, Nice, France, 1997; and Floating Poetry Room, Amsterdam, Netherlands, 2005. He lives and works in Minneapolis.

ATA, Sina

BORN NEW YORK, USA, 1955

Ata graduated in civil engineering from Baghdad University, 1977, and in building management from London, 1980. He turned to painting in the 1980s. His work has since been shown in a number of solo exhibitions in the Middle East and group exhibitions in the Middle East, Europe and the United States, including the touring exhibition *Strokes of Genius: Contemporary Iraqi Art*, which began in London, 2000. He currently lives in Amman, Jordan, and Dubai, UAE, where he works as a creative consultant.

AL-ATTAR, Suad

BORN BAGHDAD, IRAQ, 1942

Al-Attar graduated in fine arts from the University of Baghdad, where later she taught. In 1975 she moved from Iraq to London and received a postgraduate diploma in printmaking from the Wimbledon School of Art and the London Central School of Art and Design. Throughout her prolific career she has been inspired by her Arab Iraqi heritage, including the *Epic of Gilgamesh* and ancient and contemporary poetry. She has focused on specific subject matters, fantastic landscapes, city views and mystical figures. Al-Attar has had a number of solo exhibitions and gained several awards from international biennials, including London, 1978; Cairo, 1984; Brazil, 1985; and Malta, 1995. Recently, her work has been included in *Bagdad–Paris, Artistes d'Irak*, Musée du Montparnasse, Paris, 2005–6. She lives and works in London.

AVEDISSIAN, Chant

BORN CAIRO, EGYPT, 1951

Avedissian studied fine arts at the School of Art and Design, Montreal, Canada, 1970–3, and printmaking at the Ecole Nationale Supérieure des Arts Décoratifs, Paris, 1974–6. He returned to Cairo in 1980, where he worked with celebrated Egyptian architect Hassan Fathy (1900–89). Inspired by the latter, Avedissian developed a strong interest in traditional arts and local materials, which he uses in many of his works. He has worked in a wide range of media, including photography and textiles. Since 1990 he has been working with stencils on cardboard. Avedissian's work has been shown in several solo exhibitions, including the Institut du Monde Arabe, Paris (1990), the British Council, Cairo (1992), Leighton House, London (1995), the Tropenmuseum, Amsterdam (1998) and the National Museum of African Art, Washington (2000). He lives and works in Cairo.

AL-AZZAWI, Dia

BORN BAGHDAD, IRAQ, 1939

Al-Azzawi graduated in archaeology from Baghdad University, 1962, and in fine arts from the Institute of Fine Arts, Baghdad, 1964. In 1969 he formed the art group 'New Vision' with some of his contemporaries, among them Rafa al-Nasiri, Mohammed Muhriddin, Ismail Fattah, Hashem al-Samarchi and Saleh al-Jumaie. He later joined the 'One Dimension' group started by Shakir Hassan al-Said, while remaining close to 'New Vision' until 1972. Al-Azzawi's work includes paintings, sculptures, prints and drawings as well as books in which visual art interacts with prose and poetry. He has exhibited extensively in the Middle East, North Africa, the United States, India, Brazil and Europe, including a retrospective exhibition *Dia Azzawi* at the Institut du Monde Arabe (IMA), Paris, 2002. He has received several awards, among them first prizes at the International Summer Academy, Salzburg, Austria, 1975, and at the First Arab Contemporary Art Exhibition, Tunis, 1981; as well as the Jury Prize at the International Cairo Biennial, 1992. Al-Azzawi moved to London in 1976, where he worked as an art consultant at the Iraqi Cultural Centre, 1977–80. A prominent artist of the Iraq school, al-Azzawi also plays an important role in the promotion of Iraqi and Arab art to wider audiences, notably through numerous exhibitions of his contemporaries and publications. He lives and works in London.

BELKAHIA, Farid

BORN MARRAKECH, MOROCCO, 1934

Belkahia received several grants to study abroad. He trained at the Ecole des Beaux Arts, Paris, 1954–9; the Institute of Theatre, Prague, Czech Republic, 1959–62; and the Academia Brera, Milan, Italy, 1965–6. In 1962 he was appointed director at the Ecole des Beaux Arts in Casablanca, where he

developed his interest in traditional and popular arts and craft practices. In 1966 he abandoned oils on paper to work on copper, then moved to leather and other local materials. His work also comprises limited-edition prints for books of prose and poetry. He recently had a solo exhibition at the Institut du Monde Arabe, Paris, May/July 2005. In 2004 Belkahia was a member of the jury for the UNESCO Visual Arts Award. He lives and works in Marrakech.

BENANTEUR, Abdallah
BORN MOSTAGANEM, ALGERIA, 1931

Benanteur studied sculpture, painting and drawing at the Ecole des Beaux Arts, Oran. He started printmaking at an early age, creating his first prints on linoleum in 1946. In 1953 he moved to Paris, where his paintings and watercolours were soon noticed. From 1959 he started creating 'artist books', from conception to printing and assembling – many are small editions, some unique. His drawings, engravings, etchings and drypoints have accompanied the texts and poems of many writers from the Middle East, North Africa, Europe, the United States, Japan and China. His body of work now consists of over nine hundred 'artist books' as well as paintings. Benanteur lives and works in France.

BOULLATA, Kamal
BORN JERUSALEM, PALESTINE, 1942

Brought up in Jerusalem, Boullata was awarded a scholarship from the Jordanian government to study at the Accademia di Belle Arti, Rome, 1961–5. After the 1967 war he travelled to Washington DC to pursue his studies at the Corcoran School of Art, 1969–70, later teaching at the Center for Contemporary Arab Studies, Georgetown University, 1982–4. He gained several fellowships to undertake research, working on post-Byzantine icon painting in Palestine

(1740–1940), granted by the Ford Foundation, New York, 2001; and Islamic art in Morocco, a Fulbright senior scholar fellowship, 1993–4. A number of his writings on art have been published, as well as editions and translations of several books of poetry. As a visual artist, Boullata has worked extensively with silkscreen printing, some conceived as 'artist books'. He lives and works in the south of France.

CHORBACHI, Wasma'a
BORN CAIRO, EGYPT, OF IRAQI PARENTS, 1944

Chorbachi received a BA in fine arts and philosophy from the Beirut College for Women, Lebanon, 1966; an MA in studio painting and Renaissance art from Pius XII Institute in Florence, Italy, 1967; and a PhD in the history of Islamic art – which focused on the link between science and the art of design in Islamic architectural design – Harvard University, 1989. She has worked with various media, eventually turning to ceramics – an art she first discovered as a child in Iraq using clay from the banks of the Tigris. Her work includes dishes and mural tiles, many decorated with calligraphy and abstract motifs reflecting her knowledge and interest in traditional techniques and designs. Chorbachi is an artist in residence at the ceramics programme, Harvard University, where she teaches architectural ceramics.

EHSAI, Mohammed
BORN TEHRAN, IRAN, 1939

Ehsai trained at the Faculty of Fine Arts, Tehran University, where he later became a teacher of calligraphy. In 1964 he started using calligraphy in graphic design and painting. He worked on the layout and calligraphy of various publications and was commissioned to create a number of architectural design projects, including the inscriptions of the Alghadir Mosque in Tehran,

1980–3, as well as those at the entrance to the Iran Bastan Museum, Tehran, 1985, and the Iranian Embassy in Abu Dhabi, UAE, 1988–91. A skilled calligrapher, Ehsai achieved a successful synthesis between this traditional art and modern painting. His works have been exhibited worldwide, including at the Iran–America Society, Tehran, 1974; Basle International Art Fair, Switzerland, 1976–8; and the Barbican Centre, London, 2001. In 1976 Ehsai was awarded a prize at the Cagnes-sur-Mer Festival, France, and in 2005 he received Iran's National Award for Art and Culture.

ERMES, Ali Omar
BORN TRIPOLI, LIBYA, 1945

Ermes graduated from Plymouth School of Architecture and Design in 1970. He then returned to Libya where he began writing extensively. In 1974, he was appointed consultant to the London World of Islam Festival which took place in 1976 and, in 1981, he settled in England where he has been living ever since. His work is based on the Arabic letter and he often uses excerpts from Arabic and world literature addressing social and moral issues that have a resonance today. He is involved with numerous cultural and intellectual institutions and is Chairman of the Muslim Cultural Heritage Centre, London. With over sixty solo and group exhibitions worldwide, his works have been acquired by both public institutions and private collectors alike in the Middle East, Europe, the United States and Malaysia.

FARAJ, Maysaloun
BORN CALIFORNIA, USA, 1955

Of Iraqi parents, Faraj studied in Baghdad, where she obtained a BSc in architecture from the College of Architectural Engineering, Baghdad University, 1978. She later pursued her career in arts, training in ceramics with the Inner London Education

Authority (ILEA). In 1995 she founded the International Network of Contemporary Iraqi Artists (INCIA), which culminated in the touring exhibition *Strokes of Genius: Contemporary Iraqi Art*, 2000–3. She edited the exhibition catalogue, in which she also was represented as an artist. Her works, which consist of ceramics and oils and mixed media on canvas, often refer to her concern about Iraq's lost artistic heritage. Faraj has been living in London since 1982.

FARHAN, Saïd
BORN BAGHDAD, IRAQ, 1955

Farhan studied in Switzerland, graduating from the Print Department, Ecole d'Art de Lausanne; and in social sciences and teacher training from the University of Lausanne. He settled in Switzerland, teaching visual arts at Beausobre College, Morges. His work includes paintings and drawings as well as limited-edition prints accompanying poems of the Syrian poet Adonis and the Swiss writer Alain Rochat. More recently he has been working on an installation, *The Library of Baghdad*, reflecting on the destruction of the libraries of Iraq. He is also a writer and has published translations of the works of Iraqi poet Fawzi Karim, children's stories published in the 1970s in Baghdad, and novels in Arabic and French. Much of Farhan's work has been inspired by his experience of exile. His work has been exhibited in Europe, the Middle East and the United States, including the touring exhibition *Strokes of Genius: Contemporary Iraqi Art*, which began in the United Kingdom, 2000. He lives and works in Lausanne.

FATHI, Golnaz
BORN TEHRAN, IRAN, 1972

Fathi received a diploma in calligraphy from Iran's Calligraphy Association, Tehran, 1996, after obtaining a BA in graphic design from the Azad Art University, Tehran, 1995. In 1995 she was awarded a prize as best woman calligrapher, Tehran. In 2003 she travelled to France where, having been awarded a scholarship, she spent three months at the Cité Internationale des Arts, Paris. Her work is inspired by her Iranian cultural heritage, notably architecture and the traditional art of calligraphy. She has exhibited in the Middle East, Europe and the United States, including the first Islamic World Calligraphy Festival at the Museum of Contemporary Art, Tehran, 1997. She lives and works in Iran.

GHADIRIAN, Shadi
BORN TEHRAN, IRAN, 1974

Ghadirian obtained her BA in photography from the Azad University in Tehran, 1998. She has worked at the first museum of photography in Tehran, the Akskhaneh Shahr, and has managed the first Iranian website dedicated solely to photography. Her work has been exhibited in the Middle East, Europe, the United States, Canada and Russia including *Iranian Contemporary Art* at the Barbican Centre, London, 2001; touring exhibitions *Veil*, England and Sweden, 2003–4; *Harem Fantasies and the New Scheherazades*, Spain and France, 2003–4; and *Women in Orient – Women in Occident*, Germany, 2003–4; as well as the Sharjah International Biennial, 2003, and the photo biennial of Moscow, 2004. She lives and works in Tehran.

GHAIB, Ghassan
BORN BAGHDAD, IRAQ, 1964

Ghaib graduated from the Institute of Fine Arts, Baghdad, 1986, and the Academy of Fine Arts, Baghdad, 1997. He has won several awards and participated in numerous exhibitions of contemporary Iraqi art, including the touring exhibition *Strokes of Genius: Contemporary Iraqi Art*, which began in London, 2000. His work includes oils on canvas and mixed media. Together with some of his contemporaries – Dia al-Azzawi, Rafa al-Nasiri and Kareem Risan, among others – Ghaib has been exploring the book art form. His work was shown at the Frankfurt book fair, Germany, 2004; at the touring exhibition *Dafatir: Contemporary Iraqi Book Art*, which opened in Texas, 2005; and at *Bagdad–Paris, Artistes d'Irak*, Musée du Montparnasse, Paris, 2005–6. He lives and works in Baghdad.

HAMADANI, Mahmoud
BORN RASHT, IRAN, 1958

Hamadani graduated in mathematics and public administration from the State University of New York, 1981, and Harvard University, 1992, respectively. He spent some time working in Kabul, Afghanistan, as a political advisor for the United Nations, and planned to write on his return in 1995. Instead he turned to drawing, a medium through which he began expressing his experience of conflict and chaos in Kabul. One of the artists on the Lower Manhattan Cultural Council artist-in-residence programme at the World Trade Center, New York, 2001, Hamadani was affected by the events of 11 September. Following his experience, he created two works: *Ode to Kabul*, a set of abstract ink drawings, and *Ode to New York*, an installation of toppled white cubes, both of which were exhibited at the New Museum of Contemporary Art, New York, 2001–2. Hamadani lives and works in New York.

HAMMAD, Mahmoud

BORN DAMASCUS, SYRIA, 1923 (D. 1988)

Hammad was awarded a scholarship to study at the Accademia di Belle Arti, Rome, 1953–7. Upon his return to Syria, he taught art at secondary schools and, from its establishment in 1959, at the College of Fine Arts, University of Damascus – where, from 1970 to 1980, he was dean. Initially influenced by European academic figurative art and Impressionism, he later established himself as one of the first artists to have used the Arabic script in the abstract art movement in Syria. Hammad also played an important role as a teacher, inviting Italian and French lecturers to the College of Fine Arts and influencing a number of Syrian artists of the following generation. His works are in a number of public and private collections, including the National Museum in Damascus.

El-HANANI, Jacob

BORN CASABLANCA, MOROCCO, 1947

El-Hanani trained at the Avni School of Fine Arts, Tel Aviv, 1965–9, and the Ecole des Beaux Arts, Paris, 1969–70. When he was six he moved from Morocco to Israel, where at an early age he began work as a political cartoonist. In 1972, in Paris, he moved away from figurative art, and in 1974 he travelled to New York, where he came under the influence of Minimalism and the American artist Sol LeWitt (b. 1928). El-Hanani's works, principally on paper, display minute linear elements methodically arranged to culminate in elaborate compositions. He values the process of execution and one drawing may take months to be completed. His works have been exhibited extensively in the United States, Europe and Israel, including the forty-seventh biennial at the Corcoran Art Gallery, Washington DC, 2002, and *Recent Acquisitions, Works on Paper*, Museum of Modern Art, New York, 2003. He lives and works in New York.

HASHEM, Satta

BORN DIALE, BOHREZ, IRAQ, 1959

Hashem studied fine arts at the Ecole Nationale des Beaux Arts, Algeria, 1978–80, and at the Institute of Fine Arts, Moscow, Russia, 1983–4. He continued his studies in Russia, obtaining an MA in fine arts, mural painting and decorative arts from the Leningrad V. Mukhina College of Arts and Design, 1989. He then moved to Sweden and, later, England, where he now lives and works. In 2003 Hashem won the annual Nottingham Castle Open Art Exhibition, following which he had a solo exhibition, Nottingham Castle Museum and Art Gallery, 2004. His work includes paintings and drawings as well as mural paintings.

HASSANZADEH, Khosrow

BORN TEHRAN, IRAN, 1963

Returning from the Iran–Iraq war, Hassanzadeh decided to follow the path he always had dreamed of – art and poetry. He began studies at the Faculty of Painting, Mojtama's-e-Honar University, Tehran, 1989–91 and, later, trained with his mentor, Iranian artist Aydeen Aghdashlou, 1996–8, while studying at the Faculty of Persian Literature, Azad University, Tehran. Many of Hassanzadeh's paintings and drawings can be seen as visual diaries incorporating his own writings, his family, self-portraits and his experience of war. His work also includes installations and photographs. He participated in *Children of the Dark City*, 2000, a multi-media installation of sculptures, videos, photographs and paintings about the harmful effects of air pollution on children. In 2001 his work was included in *Iranian Contemporary Art*, Barbican Centre, London, and in 2002 he participated in the second exhibition of conceptual art, *New Art*, at the Tehran Museum of Contemporary Art. In 2005 he had his first exhibition of photographs only, *Terrorist*, in Tehran. Two

documentaries on Hassanzadeh's work have been made by the journalist and film maker Maziar Bahari, 1997–8. He lives and works in Tehran.

HONDA, Kouichi Fou'ad

BORN TOKYO, JAPAN, 1946

Honda graduated from the Arabic Department of Tokyo University for Foreign Studies, 1969. In 1973 he travelled to Saudi Arabia where, working as an interpreter, he was introduced to Arabic calligraphy. He returned to Tokyo in 1979, becoming a lecturer in Arabic at the Institute for Asian and African Languages and, later, at the University for Foreign Studies, 1986. He studied Arabic calligraphy with Ustadh Hasan Çelebi in Istanbul, receiving his diploma (*ijaza*) in 2000. In 1987 he was appointed instructor in Arabic calligraphy at the cultural centre of the Japan Broadcasting Corporation and in 1991 at the Arab–Japan Association. Honda has been invited to participate in calligraphy festivals and competitions in the Middle East; has had numerous exhibitions in Japan, the Middle East and Europe; and is a key artist behind the growing popularity of Arabic calligraphy in Japan. He is a professor of international relations at Daito Bunka University, Tokyo

HOUSHIARY, Shirazeh

BORN SHIRAZ, IRAN, 1955

Houshiary first trained in theatre, turning to visual arts after her arrival in London in 1973. She studied at the Chelsea School of Art, London, 1976–9; was junior fellow at Cardiff College of Art, Wales, UK, 1979–80; and had her first solo exhibition at Chapter Arts Centre, Cardiff, 1980. By the late 1980s she had established herself as one of the leading artists of her generation. Her works were included in significant group exhibitions, among them *Aperto 82*, the Venice Biennale,

1982; and *Les Magiciens de la Terre* at the Centre Georges Pompidou, Paris, 1989. Initially known for her sculptures, she turned to painting and drawing in 1992. In 2003 she also created a four-screen video installation, *Breath*, in which her drawings come to life. She followed this with *Breath II*, 2004, a sculpture of limestone bricks with audio equipment. Her work is varied but throughout imbued with her interest in abstract forms and a sense of spirituality. The poetry of the thirteenth-century Sufi mystic Jalal al-Din Rumi has been a direct source of inspiration for many of her works. In 1994 Houshiary was short listed for the Turner Prize at the Tate Gallery, London. Her works have been exhibited worldwide and recently included in *Turning Points – 20th Century British Sculpture*, Tehran Museum of Contemporary Art, 2004. She lives and works in London.

JA'FAR, Mustafa
BORN NASARIYA, IRAQ, 1952

Ja'far is a graphic designer and, in his own words, 'a passionate letterer rather than a calligrapher in the traditional sense'. He studied painting and design in Baghdad and Rome at the Accademia di Belle Arti, as well as Arabic calligraphy under the celebrated master Hashem Muhammad al-Baghdadi, Institute of Fine Arts, Baghdad, 1969–71. He lives and works in the United Kingdom, where he conducts workshops and teaches Arabic calligraphy at a number of museums and institutions – among them the British Museum, the British Library and Birkbeck College, University of London. In 2002 he was the author of *Arabic Calligraphy, Naskh Script for Beginners*, published by the British Museum Press.

JALALI, Bahman
BORN TEHRAN, IRAN, 1944

Jalali is a self-taught photographer who graduated in economics. He worked as director of photography at Soroush Press, 1976–91, and since 1985 has been a teacher of photography at a number of universities in Iran. In 1997 he was one of the founding members of the Akskhaneh Shahr, the country's first museum of photography, where he became a curator. In 1999 he was appointed a member of the editorial board of the bi-monthly journal of photography *Aksnameh*. During the Iran–Iraq war Jalali went into photo-journalism and war photography for an agency in Paris. However, not satisfied, he continued independently. Subsequently, his images of war were shown widely, notably in a number of solo exhibitions, 1982–4. Through his work Jalali explored many other subjects, including the 1979 Iranian revolution and the relationship between past and present driven by his fascination with old photographs. His works have been shown worldwide, including the second exhibition of conceptual art, *New Art*, at the Tehran Museum of Contemporary Art, 2002; *12 Photographic Journeys – Iran in the 21st Century*, SOAS, London, 2003; *Contemporary Iranian Photography*, Dubai, UAE, 2004; and *Photo-London*, Royal Academy of Art, London, 2005.

KHALIL, Mohammed Omar
BORN BURNI, SUDAN, 1936

Khalil was educated in Khartoum, where until 1963 he studied and taught at the School of Fine and Applied Arts. He later pursued his studies in fresco painting and printmaking at the Academy of Fine Arts in Florence, Italy. In 1993 he was a resident artist at Darat Al Funun, Amman, Jordan. Khalil's work comprises paintings, prints and 'artist books'. His work has been included in numerous exhibitions worldwide, including *Perspective on Contemporary Art*, the Kinda

Foundation Collection at the Institut du Monde Arabe, Paris, 2002. Khalil has received several awards, among them First Prize at the International Biennial, Cairo, 1993; and First Prize in Printmaking, National Academy Award, New York, 2003. He has been living and working in New York since 1967.

KHEDHER, Salam
BORN AMARA, IRAQ, 1953

Khedher obtained a BA in art and design from the Academy of Fine Arts, Baghdad, 1976; and a BA in fine arts from Concordia University, Montreal, Canada, 1994. In addition, he studied etching and printmaking at the Municipal Institute, Barcelona, Spain, 1981–5; mural painting at the University of Madrid, Spain, 1980–2; and silkscreen at Concordia University, Montreal, 1987–91. He has exhibited in the Middle East, Russia, the United States, Canada and Europe; including the touring exhibition *Strokes of Genius: Contemporary Iraqi Art*, which began in the United Kingdom, 2000. Kheder has given lectures on Iraqi art and has participated in several events supporting contemporary creativity in Iraq, 2004–5. He lives and works in Switzerland.

AL KHEMIR, Sabiha
BORN TUNISIA, 1959

Al Khemir is an art historian, artist and novelist. She obtained her MA from the School of Oriental and African Studies, London, 1986, and her PhD in Islamic art and archaeology from the University of London, 1990. Her work includes a first novel, *Waiting in the Future for the Past to Come* (1993), an essay in *Meetings with Remarkable Muslims* (2005), book illustrations and book covers – among the latter Naguib Mahfouz's novel *Respected Sir*. She has exhibited in Europe and the United States, including the touring exhibition *Dialogue of the Present, the*

Work of 18 Arab Women Artists, United Kingdom, 1999–2000. Al Khemir is currently chief curator of the Islamic Art Museum, Doha, Qatar.

KORAICHI, Rachid
BORN AÏN BEÏDA, ALGERIA, 1947

Koraïchi studied art at the Ecole Nationale Supérieure des Beaux Arts in Algiers and Paris, 1967–71 and 1975–7 respectively; at the Ecole Nationale Supérieure des Arts Décoratifs, Paris, 1971–5; and at the Institut d'Urbanisme at the Académie de Paris, 1973–5. His work includes drawings, weavings, prints, paintings on silk and installations – all most often including Arabic script as well as magical signs and symbols. He has collaborated with a number of poets and authors, among them Mahmoud Darwish, Mohammed Dib, Jamel Eddine Bencheikh, René Char and Michel Butor. In 1995 he was one of six international artists – along with Friedensreich Hundertwasser (Austria), Souleymane Keita (Senegal), Roberto Matta (Chile), Robert Rauschenberg (USA) and Dan You (Vietnam) – chosen for the UNESCO project *Six Flags of Tolerance*. He has exhibited extensively, including at the forty-ninth Venice Biennale, 2001, where his celebrated installation *The path of roses* was shown, and, recently, at the October Gallery, London, 2005. Koraïchi is an honorary member of the Khalil Sakakini Cultural Centre, founded Ramallah, 1996. He lives and works in Paris.

MADI, Hussein
BORN CHEBA'A, LEBANON, 1938

Madi is a painter, sculptor and printmaker. He studied at the Académie Libanaise des Beaux-Arts, Beirut, 1958–62, and in 1963 travelled to Rome to pursue his studies at the Accademia di Belle Arti and the Accademia San Giacomo. He remained in

Italy until 1987, making long and frequent visits to Lebanon. He taught art at the Institute of Fine Arts, University of Beirut, Lebanon, 1973–86, and from 1982 to 1992 was president of the Lebanese association of painters and sculptors. In 1979 he had a retrospective at the Chambre de Commerce et d'Industrie, Beirut. Madi lives and works in Beirut.

MAHDAOUI, Nja
BORN TUNIS, TUNISIA, 1937

Mahdaoui studied at the Academy Santa Andrea, Rome, and the Department of Oriental Antiquities, Ecole du Louvre, Paris. His varied work comprises paintings, prints, tapestries, designs for fashion designer Amel Sghir, book covers and book illustrations. In addition, he was selected by Gulf Air to design the external decoration of one of its fleet, 2000, and in 2005 won a UNESCO Crafts Prize for the Arab States with a stained-glass creation. He has received many awards and has been on the committees for a number of international artistic events. Mahdaoui lives and works in Tunisia while participating in numerous conferences worldwide.

MANSOUR, Nassar
BORN AMMAN, JORDAN, 1967

Mansour obtained a BA in jurisprudence and legislation (Islamic studies), economics and statistics from the University of Jordan, 1988. He later graduated with an MA in Islamic arts, specializing in Arabic calligraphy, from the Al al-Bait University, Jordan, 1997. He was a lecturer in the art of Arabic calligraphy at the University of Jordan, 1991–5, and later at the Faculty of Traditional Islamic Arts, al-Balqa' Applied University, Jordan, 1998–9. Between 1997 and 1999 he was in charge of calligraphy and ornamentation on the project of rebuilding

the twelfth-century Saladin's pulpit (*minbar*) destroyed in 1969, at the al-Aqsa Mosque, Jerusalem. In 2003 Mansour received a calligraphy diploma (*ijaza*) from renowned Turkish master calligrapher Hasan Çelebi (b. 1937). He has participated in numerous calligraphy workshops and exhibitions in the Middle East, Europe, India, Malaysia and Japan. His work includes publications on calligraphy and the *ijaza*. In 2005, with Venetia Porter, he organized an exhibition on the *ijaza*, *The Making of the Master*, at the British Museum. Since 2002 he has been a PhD candidate at the Visual Islamic and Traditional Arts Institute (VITA), London.

MASSOUDY, Hassan
BORN NAJAF, IRAQ, 1944

Massoudy started work in Iraq as an apprentice calligrapher. In 1969 he moved to Paris, where he studied figurative art and painting at the Ecole des Beaux Arts. He continued calligraphy, creating covers for Arabic magazines to earn a living and, in 1972, performing in public, accompanied by the comedian Guy Jacquet and the musician Fawzi al-Aiedy. In 1975, upon finishing his studies, he returned fully to the art of calligraphy. His calligraphies have accompanied a number of texts and poems which have been drawn from world literature – medieval Sufi mystic writer Ibn 'Arabi, philosopher Jean Jacques Rousseau, poet Charles Baudelaire, Chinese Tchouang-Tseu and Virgil among many others. Massoudy has been a key figure in introducing the art of Arabic calligraphy to wider audiences. He lives and works in Paris.

MATER AL-ZIAD, Ahmed
BORN TABOUK, SAUDI ARABIA, 1979

Mater studied medicine and surgery in Abha, Saudi Arabia. In 1995 he followed a course on drawing and photography at the Al-Miftaha Art Village, King Fahad Cultural Centre, Abha, which he joined in 1998. His work, comprising drawings, paintings and photographs, has been exhibited in a number of solo and group exhibitions in Saudi Arabia. He has received several awards, among them the Abha Cultural Prize for Photography, 2001, and first place in the King Khalid University contest in drawing, 2004. Mater is the founder of the *Al-Miftaha* cultural magazine, 2001, and instigator of a large number of art initiatives in Saudi Arabia.

METOUI, Lassaad
BORN GABÈS, TUNISIA, 1963

Metoui is an artist calligrapher. He studied at the Atelier des Beaux Arts, Gabès, 1983–7, then pursued his training in history of art in Nantes, and in Latin calligraphy in Toulouse, France, 1990–2. He teaches calligraphy (Arabic and Latin) in France, Europe and North Africa while organizing workshops and participating in a number of conferences. His work includes publications on the art of calligraphy and books where his calligraphic designs accompany text and poetry by various authors, among them Khalil Gibran, Umar Khayyam and Malek Chebel. Metoui lives in France.

MOSHIRI, Farhad
BORN SHIRAZ, IRAN, 1963

Moshiri travelled from Iran to the United States in the early 1980s to study at the California Institute of Arts, from which he graduated in 1984. He first became known for his series of large oils on canvas showing monumental jars and bowls with richly textured surfaces and flowing calligraphy. His work also includes photographs, sculptures and installations. Among his more conceptual pieces are his vitrine of gilded objects, 2003; the *Rogue* gun installation, 2004; and *The ultimate toy – Legold*, 2004. Moshiri's work has been shown in a number of solo exhibitions, including Leighton House, London, 2003; and galleries in Rome, Geneva, Dubai and New York. He has also shown at the Sharjah Biennial, 2003, and, more recently, with a group of contemporary Iranian artists at *Welcome*, New York, 2005, a show that he also curated. Moshiri lives and works in Tehran.

AL-MOUDARRES, Fateh
BORN ALEPPO, SYRIA, 1922 (D. 1999)

Al-Moudarres, a poet, novelist, painter and sculptor, is considered a leader of the Syrian modern art movement. After an early period of Realism and Surrealism, he went to study at the Accademia di Belle Arti in Rome, 1954–60. He returned to Damascus, having developed a very personal style that he described as 'surrealistic and figurative with a strong element of abstraction'. His subjects are varied, often inspired by ancient traditions, icon painting, symbols and mythology as well as contemporary politics with which, since 1967, he became increasingly preoccupied. Between 1969 and 1972 he pursued his education in Paris, studying at the Ecole des Beaux Arts. He then returned to Syria where, as a professor at the College of Fine Arts (established 1959), University of Damascus,

he trained and influenced generations of younger artists. Al-Moudarres had numerous exhibitions, including a retrospective at the Institut du Monde d'Arabe, Paris, 1995–6. A number of his poems and short stories have been published and translated.

MOUSTAFA, Ahmed
BORN ALEXANDRIA, EGYPT, 1943

In 1966 Moustafa was awarded the highest national distinction as an accomplished figurative artist in the Faculty of Fine Arts, University of Alexandria. He later taught there and, in 1974, was awarded a scholarship to the United Kingdom. He joined the printmaking department of the Central School of Art and Design, London, where he developed his interest in Arabic calligraphy and the theories of celebrated Abbasid calligrapher Ibn Muqla (886–940). In 1978, after graduating, he received a grant from the British Council to pursue his research on the scientific foundation of the Arabic letter shapes, and in 1989 was awarded a PhD by the Council for National Academic Awards. Moustafa has since 1974 lived in London where, in 1983, he set up the Fe-Noon Ahmed Moustafa Research Centre for Arab Art and Design. His work includes lectures and workshops worldwide as well as numerous commissions, among them a composition presented by Her Majesty Queen Elizabeth II to Pakistan on the occasion of that country's fiftieth anniversary, 1997. In 1998 he was invited by the Vatican to exhibit at the Pontifical Gregorian University, Rome. That exhibition, entitled *Where the Two Oceans Meet*, was heralded in the world media as the first achievement of its kind in the history of Muslim–Christian relations.

MUHRIDDIN, Mohammed

BORN BASRA, IRAQ, 1938

Muhriddin studied painting and graphic arts at the Institute of Fine Arts, Baghdad, 1956–9, and at the Warsaw Academy of Fine Arts, Poland, 1966. Back in Iraq, he conveyed his experience of Polish art to his contemporaries and contributed to the development of graphic arts which had come into focus with the arrival at the Institute of Fine Arts in the late 1950s and mid-1960s of the Polish teacher, artist and printmaker Roman Artymowski. In 1965 Muhriddin participated in the first exhibition in Baghdad dedicated solely to graphic arts. He has exhibited in the Middle East, the United States and Europe, including the touring exhibition *Strokes of Genius: Contemporary Iraqi Art*, which began in London, 2000, and *Bagdad–Paris, Artistes d'Irak*, Musée du Montparnasse, Paris, 2005–6. He lives and works in Baghdad.

NABIL, Youssef

BORN EGYPT, 1972

Nabil turned to photography in 1986. He was influenced by Armenian–Egyptian photographer Van Leo, who specialized in studio portraits – notably of celebrated Egyptian actresses, artists and literary figures of the 1950s and 1960s. Later, he worked as assistant photographer to David Lachapelle, New York, 1992–3, and fashion photographer Mario Testino, Paris, 1997–8. In 2003 he was appointed artist-in-residence at the Cité Internationale des Arts, Paris, and received the Seydou Keita Prize for Portraiture, Rencontres Africaines de la Photographie, Bamako, Mali. In 2005 he received a prize at the International Photography Awards (IPA), Los Angeles. Nabil has exhibited extensively in solo and group exhibitions, including the 2005–6 *Regards des Photographes Arabes Contemporains* at the Institut du Monde Arabe (IMA), Paris.

NAIM, Sabah

BORN CAIRO, EGYPT, 1967

Naim obtained her BFA, MFA and PhD focusing on the human body in contemporary art from the College of Art Education, Cairo, 1990, 1996 and 2003 respectively. Her work has been exhibited in a number of solo exhibitions in Egypt, Italy and The Netherlands, as well as in group exhibitions – among them the fiftieth Venice Biennale, 2003; the Havana Biennial, Cuba, 2003; and the touring exhibition *Africa Remix: Contemporary Art of a Continent*, Düsseldorf, Germany (2004), Hayward Gallery, London (2005), the Centre Georges Pompidou, Paris (2005) and the Mori Art Museum, Tokyo (planned May 2006). Naim lives and works in Cairo.

AL-NASIRI, Rafa

BORN TIKRIT, IRAQ, 1940

Al-Nasiri studied painting at the Institute of Fine Arts, Baghdad, 1956–9, and printmaking at the Central Academy of Fine Arts, Beijing, China, 1959–63. He later obtained a scholarship from the Gulbenkian Foundation, at Gravura Lisbon, Portugal, 1967–9. He worked in several printmaking studios in Europe and the Middle East and taught in Baghdad, where he founded and became head of the Department of Graphics at the Institute of Fine Arts. Between 1969 and 1972 he was a member of the 'New Vision' group, 1969–72, which included Dia al-Azzawi, Mohammed Muhriddin, Ismail Fattah, Hachem al-Samarchi and Saleh al-Jumaie. Recently his work was included in touring exhibitions *Strokes of Genius: Contemporary Iraqi Art*, opened in London, 2000, and *Dafatir: Contemporary Iraqi Book Art*, opened University of North Texas, USA, October–November 2005. Al-Nasiri now lives and works in Amman, Jordan.

NAYINY, Malekeh

BORN TEHRAN, IRAN, 1955

Nayiny obtained a BA in fine arts and photography from Syracuse University, New York, USA, in 1978. She pursued her studies in cinematography at the Parsons School of Design, New York, 1979–80, and in advanced photography at the International Center of Photography, New York, 1980–2. She participated in touring exhibitions, including *La Photographie entre Histoire et Poésie – photographie de la collection Fnac*, France, Italy and Spain, 2004–5; and *Détournements de l'Intime* with Shadi Ghadirian, France, Spain, Portugal and Russia, 2001–5. Her works have also been shown at *Photo-London*, Royal Academy of Art, London, 2005; and at *Iran under the Skin*, Barcelona Centre of Contemporary Art, Spain, 2004 – where she displayed her installation *Vasile: Hansel and Gretel*. Nayiny's work also comprises designs for porcelains and textiles. She lives and works in Paris.

NESHAT, Shirin

BORN QAZVIN, IRAN, 1957

In 1974, at the age of seventeen, Neshat moved from Iran to the United States to study art at the University of California, Berkeley. As a result of the 1979 revolution in Iran, she did not travel back to her homeland until 1990. It was then, profoundly affected by her visit and the changes she noticed and experienced, that Neshat resumed work as a practising artist. She began with photographs, many heightened with words in ink, and in the late 1990s started experimenting with video. In 1999 her video installation *Turbulent* won the Golden Lion Award at the Venice Biennale. She has since received a number of prizes, including the Grand Prix of the Kwangju Biennial in Korea, 2000, and the Visual Art Award of the Edinburgh Festival, 2000. Neshat's work has been shown worldwide in numerous solo and group exhibitions. She lives and works in New York.

HAJI NOOR DEEN MI GUANJIANG

BORN SHANDONG PROVINCE, CHINA, 1963

Haji Noor Deen is a prominent calligrapher who in 1997 became the first Chinese Muslim to be awarded the Egyptian Certificate of Arabic Calligraphy, and subsequently became a member of the Association of Egyptian Calligraphy. He teaches Arabic calligraphy at the Islamic College in Zhen Zhou, China, and is also a researcher into Islamic cultures at the Henan Academy of Science, Zhen Zhou. He has given several lectures on Islam in China and has participated in a number of workshops and talks on Arabic calligraphy worldwide, including at Harvard University, USA; the University of Cambridge, UK; and, in 2005, the Globe Theatre, London. Between 2000 and 2003 he received a grant to tour and display his work at several universities in the United States.

OMAR, Madiha

BORN ALEPPO, SYRIA, 1908 (D. 2005)

Omar graduated from the Maria Grey Training College, London, 1933. In 1937 she taught painting at the Teachers Training School for Women, Baghdad, where, later, she was appointed head of the Arts and Painting Department. In 1942 she moved to Washington DC, studying art education at George Washington University and graduating in fine arts from the Corcoran School of Art, 1950. She began exploring the possibilities of using Arabic script in modern painting in the mid-1940s and became known as the first artist to have done so. She was encouraged by the celebrated art historian Richard Ettinghausen, who in 1949 organized an exhibition of her works at the Georgetown Public Library, Washington. That same year she wrote a manifesto entitled *Arabic Calligraphy: An Element of Inspiration in Abstract Art*. Later, Omar, together with Jamil Hammoudi and others, was part of the 'One Dimension Group' formed in 1971 by Shakir Hassan al-Said.

PALANGI, Nasser

BORN HAMADAN, IRAN

Palangi graduated in visual arts from Tehran University, 1984. He pursued his education in painting and art education in Tehran until 1989, while lecturing at different universities until 1998. At the beginning of the Iran–Iraq war (1980–88), he spent three years working as a war artist, creating drawings, paintings and photographs. In addition, he created a series of mural paintings entitled *My Memory of the War* for the congregational mosque of Khorramshahr, Iran, 1981. He has had many commissions throughout his career, including installations and two mural reliefs for the War Memorial Museum in Khorramshahr, 1997–8; a mural painting for the Treasure Gallery, Seattle, USA, 2000; a painting for the *Medicines without Border Project*, Dubai, UAE; and ten sculptures, *Migrants in Australia*, for the National Multicultural Festival, Canberra, Australia, 2004. He has exhibited widely including at the Tehran Museum of Contemporary Art, 2000, and the Seyhoun Gallery, Tehran, 2001. Palangi lives in Australia, where an exhibition of a selection of his works dating from 1999 to 2005 took place at the East & West Gallery, Victoria, Australia, 2005.

PEACOCK, Jila

BORN TEHRAN, IRAN, 1948

Having moved to Britain in 1959, Peacock studied medicine at London University, 1968–73, and worked as a doctor before gaining her BA in fine art from St Martin's School of Art, London, in 1984. In 1990 she moved to Scotland, where she is a member of the Glasgow Print Studio and was a visiting lecturer at the Glasgow School of Art from 1995 to 2002. In 2003–4 she was a visiting scholar at New Hall, Cambridge, researching Islamic figural calligraphy with an award from the Arts and Humanities Research Board. Her paintings and monoprints have been exhibited in the United Kingdom, and her interest in music and the poetic image has resulted in a multi-media collaboration, *The seafarer*, with composer Sally Beamish.

RAAD, Walid

BORN CHBANIEH, LEBANON, 1967

Raad is a media artist. His work comprises photography, video and literary essays, all sometimes combined in installations, as well as performances and lectures. He is a member of the Arab Image Foundation set up in Beirut, 1996. In 1999 he established the 'Atlas group', Beirut and New York, aimed at researching and documenting the contemporary history of Lebanon, through archival material produced by the group and attributed to named imaginary or anonymous individuals and organizations as well as to the group itself. Raad lives and works in New York, where he teaches film, photography and video at the Cooper Union for the Advancement of Science and Art.

AL-RAES, Abdul Qadir

BORN DUBAI, UNITED ARAB EMIRATES, 1951

Al-Raes had his first solo exhibition in Dubai, 1974, shortly after completing his studies. His work, deeply inspired by his homeland, has since been exhibited on numerous occasions in the United Arab Emirates and the rest of the Gulf region, as well as in North Africa, Europe, South and North America, China and Australia. Al-Raes has received a number of prizes, including the Jury Award at the Sharjah Biennial, 1993, and the Golden Palm Leaf (*al-sa'afa al-dhahabia*) at the Gulf Cooperation Council (GCC) exhibition, 1999.

RAWAS, Mohammad

BORN BEIRUT, LEBANON, 1951

Rawas studied painting at the Institute of Fine Arts, Lebanese University of Beirut, 1971–5. Among the artists who taught him were Aref el-Rayess, Jean Khalifé, Shafic Abboud (then a visiting professor) and Halim Jurdak, who introduced him to etching. Following the civil war in Lebanon, Rawas moved to Syria and later to Morocco, where he taught in Rabat, 1977–9. He then travelled to London and studied printmaking at the Slade School of Fine Art, University College, 1979–81. Upon his return to Lebanon, Rawas taught at the Institute of Fine Arts, 1982, and the American University of Beirut, 1992–2004, where he set up a printmaking studio at the Department of Architecture and Design. Between 1983 and 1992 he was secretary general of the Lebanese association of painters and sculptors. His work – including prints, mixed media and assemblage on canvas, panel or cardboard – often incorporates photographs, words and three-dimensional elements. He has exhibited on numerous occasions in the Middle East, Europe, the United States, Japan and, more recently, in 2003, at the first Beijing International Art Biennial, China. Rawas lives and works in Beirut.

EL-RAYESS, Aref

BORN ALEY, LEBANON, 1928 (D. 2005)

El-Rayess started his career as a self-taught artist. Between 1950 and 1957 he moved to Paris, where he worked in the ateliers of Fernand Léger, André Lhote and Ossip Zadkine, while taking classes at the Académie de la Grande Chaumière in Montmartre. He travelled extensively between Paris and Senegal, where he learnt stone and wood carving. He returned to Lebanon in 1957 and, having received a scholarship from the Italian government, pursued his training at the Accademia di Belle Arti in Rome, 1960–3.

Back in Lebanon, he taught at the Institute of Fine Arts, University of Beirut, and in 1973 was appointed president of the Lebanese association of painters and sculptors. His work includes paintings and drawings as well as commissions from the Lebanese government, among them a tapestry for UNESCO, Paris, and two sculptures to represent Lebanon at a world fair in New York. Following the civil war in Lebanon, he moved to Jeddah, where he became an art consultant and received further commissions from the Saudi government, including a 27-metre-high sculpture for Palestine Square, Jeddah.

RISAN, Kareem

BORN BAGHDAD, IRAQ, 1960

Risan graduated from the Academy of Fine Arts, Baghdad, 1988. Shortly afterwards he joined the army, a period which he documented through a series of drawings. His work includes a variety of media. Along with some of his contemporaries – Dia al-Azzawi, Rafa al-Nasiri and Ghassan Ghaib, among others – he uses the book form, as displayed in *Baghdad burning*, 2003, a boxed book of twelve folios with collage, drawing and printing. He has exhibited extensively in the Middle East and Europe: recently, in the touring exhibition *Dafatir: Contemporary Iraqi Book Art*, which opened in Texas, USA, 2005; and *Baghdad–Paris, Artistes d'Irak*, Musée du Montparnasse, Paris, 2005–6. He lives and works in Baghdad.

ROVNER, Michal

BORN ISRAEL, 1957

Rovner obtained a BA in cinema/television and philosophy from Tel Aviv University, 1981, and a Bachelor of Fine Arts degree from the Bezalel Academy of Art and Design, Jerusalem, 1985. In 1978 she co-founded the Camera Obscura School of Art,

Tel Aviv, which has since developed into a prominent institution in Israel for the study of photography, video and cinema. She began as a photographer, then moved to films, video installations – some conceived for specific sites – as well as works on paper and canvas. Among her installations are series of notebooks and stones whose surfaces are animated by video projections. Rovner has had over forty solo exhibitions, including a mid career retrospective at the Whitney Museum of Art, New York, 2002; her acclaimed exhibition *Against Order? Against Disorder?* at the fiftieth International Art Exhibition, Venice Biennale, 2003; and, more recently, *Fields*, co-produced by the Festival d'Automne, at the Galerie du Jeu de Paume, Paris, 2005. Rovner lives and works in New York and Israel.

AL-SAID, Shakir Hassan

BORN SAMAWA, IRAQ, 1925 (D. 2004)

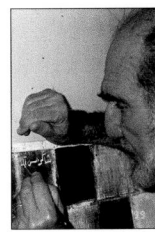

Al-Said graduated in social sciences from the Higher Institute of Teachers, Baghdad, 1948, and in art from the Institute of Fine Arts, 1954. He was taught art history by the artist Jewad Selim, and with him co-founded the 'Baghdad Modern Art' group, 1951. Between 1955 and 1959, after obtaining a scholarship, al-Said studied in Paris at the Académie Julien, the Ecole des Arts Décoratifs and the Ecole Supérieure des Beaux Arts. He then returned to Baghdad, where he taught art history at the Institute of Fine Arts, 1970–80, and began his writings on art, including the *Contemplative Art Manifesto*, 1966. By 1971, following the theoretical framework he had developed, al-Said formed the 'One Dimension' group, which focused on the exploration of the different values of the Arabic script – graphic, plastic, linguistic and symbolic – in modern art. A celebrated artist, al-Said received several awards and his work has been shown in numerous solo and group exhibitions worldwide.

SAMRA, Faisal
BORN BAHRAIN, 1956

Samra graduated from the Ecole Nationale Supérieure des Beaux Arts, Paris. Of Saudi parentage, he began work in Saudi Arabia as a stage designer and a graphic designer before founding his own design company in Dammam. Between 1987 and 1992 he lived in Paris, where he worked as a fine arts and graphics consultant at the Institut du Monde Arabe. He later taught drawing and painting at the College of Fine Arts in Amman, Jordan, and at his studio in Bahrain. In 2005 he was appointed artist-in-residence at the Cité Internationale des Arts, Paris, and was a member of the jury at the Alexandria Biennial, Egypt. Samra has exhibited in a number of solo and group exhibitions in the Middle East, the United States and Europe, among them his 1991 solo exhibition at the Institut du Monde Arabe; the eighth International Cairo Biennial, 2001; the Kinda Collection at the Institut du Monde Arabe, 2002; the Kunst Museum and the Frankfurt Book Fair, Germany, 2005. He has received several awards, including the invitation to participate in the United Nations fiftieth anniversary exhibition *Dialogues of Peace, 50 Artists Worldwide*, Geneva, Switzerland, 1995; and, in 1998, to take part in *Liberté 98*, celebrating the fiftieth anniversary of the Universal Declaration of Human Rights, United Nations, New York.

AL-SAYEGH, Samir
BORN LEBANON, 1945

Al-Sayegh was educated at Saint Savior Convent, Joun, Lebanon. He studied history of art at the Ecole Nationale des Beaux Arts, Paris and, in 1993, became a lecturer at the Graphic Arts Department, American University of Beirut, Lebanon. His interest in the traditional art of Arabic calligraphy as well as in contemporary art and design led him to the creation of new calligraphic typefaces. He has fashioned several logos and worked on the calligraphy of a number of publications. Al-Sayegh also writes, including poetry and numerous articles and essays on art and aesthetics. He lives and works in Lebanon.

SELIM, Rashad
BORN KHARTOUM, SUDAN, 1957

Of a German mother and a diplomat Iraqi father, Selim travelled extensively before moving to Iraq in 1971. He specialized in graphic arts at the Institute of Fine Arts, Baghdad, 1980, later pursuing his studies in audio visuals at St Martin's School of Art, London, 1983. Between 1977 and 1978 he was the Iraqi crew member on the Norwegian Thor Heyerdahl's reed-boat expedition from the river Tigris to Djibouti, which developed his interest in history, indigenous cultures and traditional arts. His career is marked by a number of travels and residencies, including those in Tunisia, Morocco, Yemen and Great Britain. He has taught extensively and has been an art advisor for the United Nations and a number of cultural institutions. His work includes film and photography, printmaking, sculpture, illustration, and stage design. Selim is from a renowned artistic family – notably his uncle, Jewad Selim, pioneer of modern art in Iraq. Rashad Selim lives and works in England.

AL-SHAARANI, Mouneer
BORN SYRIA, 1952

Al-Shaarani graduated from the Faculty of Fine Arts at the University of Damascus, Syria. He began calligraphy at an early age under the celebrated Syrian calligrapher Badawi al-Dirani (d. 1967), himself a student of Turkish master calligrapher Hamid al-Amidi. Shaarani's work includes designs for books and typeface characters as well as publications and articles on calligraphy. He has exhibited on several occasions in the Middle East, North Africa and Europe, including his display of calligraphies inspired by ancient Arabic poetry in Oxford, 2005. Al-Shaarani lives and works in Syria.

Al-SHAMMAREY, Mohammed
BORN BAGHDAD, IRAQ, 1962

Al-Shammarey is a self-taught artist. He is a member of the UNESCO International Association for Plastic Arts (AIAP), the Iraqi Artist Association and the Iraqi Plastic Artists Society. His works have been exhibited in the Middle East, North Africa and Europe – including the ninth Cairo International Biennial, 2003–4; the Frankfurt book fair, 2004 and 2005; *Imagining the Book* International Biennial, Alexandria Library, Egypt, 2005. In 2004 he received an award from the Festival of Mediterranean People, Bisceglie, Italy; and in 2003 the prize of Arab Pioneers from the Arab Pioneers Festival under the patronage of the Arab League. His work comprises book art, paintings and sculptures.

SHAWA, Laila
BORN GAZA, PALESTINE, 1940

Shawa studied at the Leonardo School of Art, Cairo, before graduating in fine arts from the Accademia de Belle Arti, Rome, 1957–64, and in plastic and decorative arts from the Accademia St Giaccomo, Rome, 1960–4. Between 1960 and 1963 she followed additional classes under Italian professor and Expressionist artist Renato Guttuso, at the Academy of Fine Arts in Rome and, in the summer, under Austrian Expressionist Oskar Kokoschka at the Oskar Kokoschka School of Seeing in Salzburg, Austria. Her work comprises oils on canvas, photographs and silkscreens as well as designs for stained-glass windows at the Cultural Centre in Gaza. Shawa has also worked as an illustrator of books for children,

a lecturer and an art education advisor. She has had a number of solo exhibitions in the Middle East and Europe and participated in the touring exhibition *Dialogue of the Present, the Work of 18 Arab Women Artists*, United Kingdom, 1999–2000. She lives and works in London.

SITI, Walid

BORN DUHOK, IRAQI KURDISTAN, 1954

Siti graduated from the Institute of Fine Arts, Baghdad, 1976. He then travelled to Slovenia, where he obtained a BA and MA from the Academy of Fine Arts in Ljubljana, 1977–82. In 1984 he moved to London, where he has been living ever since. Siti is a painter and a printmaker. He has drawn most of his subject matter from his experience of war, pain and loss. He has exhibited in Europe, the Middle East, Russia and Asia, including several solo exhibitions in the United Kingdom – among them Leighton House Museum, London, 1996 – and, more recently, at Salman's Gallery, in his home town Duhok, 2004. His group exhibitions have included a number of print biennials; the fifth Sharjah International Arts Biennial, UAE, 2001; the tenth Asian Art Biennial, Dhaka, Bangladesh, 2002; and the Contemporary Art Society, London, 2004.

BEN SLIMANE, Khaled

BORN SOUSSE, TUNISIA, 1951

Ben Slimane graduated in ceramics from the Institut Technologique d'Art, d'Architecture et d'Urbanisme, Tunis, 1977, then pursued his studies in Spain at the Escuela Massana de Barcelona. In 1979 he returned to Tunis, where he set up his own ceramics atelier. In 1982 he travelled to Tokyo. He remained in Japan until 1983, working with a number of celebrated Japanese ceramists ('living national treasures'). Ben Slimane had his first solo exhibition in 1982 and since then has exhibited extensively, including at the Craft Council gallery, London, in 2005. His work is varied, comprising ceramics of all forms and scale, including commissions for large ceramic murals in collaboration with Rachid Koraïchi, as well as works on paper and oils on canvas. He lives and works in Tunisia.

TANAVOLI, Parviz

BORN TEHRAN, IRAN, 1937

Tanavoli graduated from Tehran's High School of Fine Arts in 1956. He then travelled to Italy, where he studied at the Accademia di Belle Arti, Carrara, until 1957. The following year, after an exhibition of his works at the Fahrang Hall, Tehran, he was awarded a scholarship to pursue his studies in Italy. He went to the Accademia di Belle Arti di Brera, Milan, 1958–60, where he worked under the Italian sculptor Marino Marini. Between 1962 and 1963 he taught at the Minneapolis College of Arts and Design, USA, returning to Iran in 1964 to become head of sculpture at Tehran University until 1979. Tanavoli has been at the origin of many art initiatives. He created the Atelier Kaboud, Tehran, 1960 – where many of his contemporaries subsequently exhibited – organized a touring exhibition of Iranian artists in the United States, starting in Minnesota, 1961; and, in the 1960s, was a key member of the *Saqqakhaneh* movement with Charles-Hossein Zenderoudi. He is a celebrated artist, often described as the pioneer of modern sculpture in Iran, as well as a collector, teacher, scholar and author. He founded the Tehran Rug Society, 1973, and organized a number of exhibitions of tribal rugs from Iran. His collections of Iranian locks and Islamic metalwork have been exhibited and were published in 1976 and 2000 respectively. His career throughout is infused with a deep passion, knowledge and understanding of Iran's rich visual and literary heritage as well as crafts traditions. Tanavoli lives and works in Tehran and Vancouver, Canada. His works have been exhibited regularly in Iran, Europe and the United States including a retrospective at the Tehran Museum of Contemporary Art, 2003, as well as at the Elliott Louis Gallery, Vancouver, 2006.

TATARI, Mohammed Aneh

BORN TURKMEN SAHARA, IRAN, 1957

Tatari teaches fine arts at Tehran University, Iran. He often travels back to his homeland, the Turkmen region in the north-east of Iran, where he gains much of his inspiration. He is particularly fond of warm colours, notably orange and red, and their parallels in the desert landscapes he is familiar with. His works have been exhibited on a number of occasions, including a solo exhibition at Leighton House, London, 2002; *Gardens of Iran – Ancient Wisdom, New Vision* alongside works by Parviz Tanavoli, Behrooz Daresh and Siah Armajani among others at the Tehran Museum of Contemporary Art, 2004; and a show with his pupils at the Barg Art Gallery, Tehran, 2005.

WAQIALLA, Osman

BORN RUFA'A, SUDAN, 1925

Waqialla graduated from the Gordon Memorial College, Khartoum, Sudan, 1945; the School of Design, Khartoum, 1946; and, having received a scholarship, Camberwell School of Arts and Crafts, London, 1949. He later travelled to Egypt, where he trained as a calligrapher under the master Sayyid Muhammed Ibrahim (d. 1994) at the School of Arabic Calligraphy, Cairo. He taught at the College of Fine and Applied Arts in Khartoum, 1949–54, and in 1954 founded Studio Osman, a meeting place for artists and intellectuals in Sudan until 1964. He received several commissions, including calligraphic designs for the first Sudanese currency, and is considered one of the first artists of the modern art movement in Sudan to have

explored calligraphy. He moved to England in 1967 and worked as a consultant calligrapher to the firm of banknote makers, De La Rue. His work has been exhibited in Africa, the Middle East, the United States and Europe, including the touring exhibition *Seven Stories about Modern Art in Africa*, which began at the Whitechapel Art Gallery, London, 1995. He has recently returned to Sudan.

YAHYA, Nazar

BORN BAGHDAD, IRAQ, 1963

Yahya obtained his BA in fine arts from the Academy of Fine Arts, Baghdad, 1986. His work has been included in a number of solo and group exhibitions in the Middle East, Europe and the United States, among them the touring exhibitions *Strokes of Genius: Contemporary Iraqi Art*, which opened in London, 2000, and *Dafatir: Contemporary Iraqi Book Art*, opened University of North Texas, USA, October–November 2005 – where the artist also gave a lecture on Iraqi 'artist books'; as well as *Baghdad–Paris, Artistes d'Irak*, Musée du Montparnasse, Paris, 2005–6. He currently lives and works in Amman, Jordan.

ZENDEROUDI, Charles-Hossein

BORN TEHRAN, IRAN, 1937

Zenderoudi graduated from Tehran's High School of Fine Arts in 1958. He became a chief exponent of the *Saqqakhaneh* movement, 1960s, integrating Iran's heritage to the modern art movement. After a selection of his work was sent to and received awards at the Paris biennials of 1959 and 1961, he moved to Paris, where he has been living ever since. In 1971 he was included in the French magazine *Connaissances des Arts* list of the ten best living artists, alongside Frank Stella, Mark Tobey, Andy Warhol and Zao Wou-Ki. Commissioned works include the

monumental tapestries and paintings for Riyadh and Jeddah airports, Saudi Arabia; the cover and serigraphy accompanying the text of the Holy Qur'an, published Ph. Lebaud 1972 and 1980, which received the international prize of The Most Beautiful Book of the Year from UNESCO; and illustrations for the Divan of Hafez, *The Dance of Life*, published 1988. In 2002 Zenderoudi had a retrospective exhibition at the Tehran Museum of Contemporary Art. More recently his paintings and photographs were shown in Europe, including the FNAC galleries, Paris, 2005, and in the United States at the Grey Gallery, University of New York, 2003.

Bibliography

This list includes works cited in the text as well as a selection of general works and exhibition catalogues. These are relevant to the subject of contemporary Middle Eastern art as a whole or to the artists included in this book. Many more references can be found through the internet by looking up individual artists. There are also extensive bibliographies in Wijdan Ali's *Modern Islamic Art*, in Sylvia Naef's *A la recherche d'une modernité arabe* and *L'art de l'écriture arabe: passé et présent* and in the University of Oslo Library website on contemporary Arab art: http://folk.uio.no/sveinen/ara-art.pdf.

All translations from the Qur'an are from A.J. Arberry, 1955, *The Koran Interpreted*. George Allen & Unwin Ltd

Abboud, S., 2006. *Shafic Abboud Monographie*. Gallerie Claude Lemand, Editions Clea, Paris

Adler, J. and U. Ernst, 1987. *Text als Figur: Visuelle Poesie von der Antike bis zu Moderne.* Herzog August Bibliethek Wolfenbüttel, Weinheim

Adnan, E., 1982. *Sitt Marie Rose*. Post Apollo Press, Sausalito, California

Adonis, 2000. *Un poète dans le monde d'aujourd'hui 1950–2000*. Institut du Monde Arabe, Paris

Afnan, M., 2000. *Maliheh Afnan Retrospective*. England & Co., London

Africa Remix – Contemporary Art of a Continent, 2005. Hayward Gallery, London

Akyavaş, E., 2000. *Erol Akyavaş his Life and Works* (retrospective exhibition, catalogue ed. B. Madra and H. Dostoğlu), Istanbul Bilgi Üniversitesi Yayinlari, Istanbul

Alani, G., 2001. *Calligraphie Arabe, Initiation*. Editions Fleurus, Paris

Alani, G. and Joële-Claude Meffre, 2002. *Une geste des signes*, Fata Morgana, Paris

Ali, Wijdan, 1987. *Contemporary Art from the Islamic World*. Scorpion Press, Essex, on behalf of the Royal Society of Fine Arts, Amman, Jordan

Ali, Wijdan, 1997. *Modern Islamic Art*. University Press of Florida, Gainesville

Art contemporain arabe, 1988. Collection du Musée. Institut du Monde Arabe, Paris (French, Arabic)

Ateliers Syriens, 1999. Oeuvres Contemporaines. Palais de L'Unesco, Paris

al-Attar, S., 2004. *Suad al-Attar*. Al-Madad Foundation, London

al-Azzawi, D., 2001. *Dia Azzawi*. Institut du Monde Arabe, Paris

Balaghi, S. and L. Gumpert (eds), 2002. *Picturing Iran, Art, Society and Revolution*. I.B. Taurus, London

Belkahia, F., 1995. *Procession*. Galerie Climats, Paris

Belkahia, F., 2005. *Farid Belkahia*. Institut du Monde Arabe, Paris

Bell, G., 1995. *The Hafez poems of Gertrude Bell*. Ibex Publishers, Bethesda, Maryland

Ben Slimane, K., 2004, *Khaled Ben Slimane Céramique de Tunisie*. Editions Simpact, Tunis

Benanteur, A., 2005. *Oeuvres Graphiques*. Galerie Claude Lemand, Paris

Blair, S., 2006. *Islamic calligraphy*. Edinburgh University Press, Edinburgh

Boullata, K., 1983. *Solo Exhibition Catalogue*, Alif Gallery, Washington DC

Boulus, S., 2000. *Judariya [Mural]*. Riad El-Rayyes Books, Beirut

British Art in Print, 1995. The Publications of Charles Booth-Clibborn. Paragon Press, London

Butor, M., 1969. *Les Mots dans la Peinture*. Albert Skira, Geneva

Carey, F. (ed.), 1991. *Collecting the 20th Century*. British Museum Press, London

Carey, F. and A. Griffiths, 1980. *American Prints 1879–1979*. British Museum Press, London

Contemporary Art in Syria, 1998. Gallery Atassi, Damascus

Coppel, S., 1989. *Word as Image*. Australia National Gallery, Canberra

Croisement des Signes, 1989. Institut du Monde Arabe, Paris

Curtis, V.S. and S. Canby, 2005. *Persian Love Poetry*. British Museum Press, London

Daftari, F., 2002. 'Another modernism: an Iranian perspective', in S. Balaghi and L. Gumpert (eds), *Picturing Iran, Art, Society and Revolution*. I.B. Taurus, London

Daghir, S., 1990. *Al-Hurufiyya al-'arabiyya, fann wa hurufiyya*. Sharikat al-matbuat li'l tawzi ' wa al-nashr, Beirut

De Young, T., 1998. *Placing the Poet, Badr Shakir al-Sayyab and post-colonial Iraq*. State University of New York Press

Dib, M., 1998. *L'enfant Jazz: Poèmes*. Editions de la Difference, Paris

Ermes, A.O., 1991. *Art and Ideas*. Saffron Books/ Eastern Art Report, London

Fani, M., 1998. *Dictionnaire de la Peinture au Liban*. Editions de L'Escalier, Paris

Faraj, M. (ed.), 2001. *Strokes of Genius, Contemporary Iraqi Art*. Saqi Books, London

Farhan, S., 1999. *Saïd Farhan*, Lausanne (Arabic, English, French, German)

Gardens of Iran, 2004. Ancient Wisdom New Visions. Tehran Museum of Contemporary Art, Tehran

Guesdon, M.-G. and Annie Vernay-Nouri (eds), 2001. *L'Art du livre arabe du manuscript au livre d'artiste*. Bibliothèque Nationale de France, Paris

al-Haidari, B., 1981. 'The influence of Arab culture on contemporary Arab artists', *UR*, in special issue on contemporary Arab art, pp. 10–27

al-Hallaj, Husayn ibn Mansur, 1955. *Le Diwan d'al-Hallaj* (transl. and ed. L. Massignon). Geuthner, Paris

Honda, K., 1994. *An Exhibition of Islamic Calligraphy*. Bashir Mohamed Ltd, Kuala Lumpur

Ibn al-'Arabi, Muhyiddin, 1911. *The Tarjumán al-Ashwáq. A Collection of Mystical Odes* (ed. R.A. Nicholson). Royal Asiatic Society, London

Irwin, R., 1999. *Night and Horses and the Desert*. Penguin, London

Issa, R., 2003. 'Les noves Xahrazads', in *Fantasies de harem I noves Xahrazads* 136–65, Centre de Cultura Contemporània, Barcelona

Issa, R. (ed.), 2006. *Chant Avedissian – Cairo Stencils*. Saqi Books, London

Issa, R., C. Brown and M. Sutcliffe, 2001. *Iranian Contemporary Art – Barbican Centre*. Booth-Clibborn Editions, London

Jayyusi, S.K. (ed.), 1987. *Modern Arabic Poetry. An Anthology*. Columbia University Press, New York

Jayyusi, S.K. (ed.), 1992. *Anthology of Modern Palestinian Literature*. Columbia University Press, New York

Johnson-Davies, D., 1994. *The Island of the Animals* (illustr. Sabiha al Khemir). Quartet Books, London

Jones, W., 1782. *The Moallakat, or Seven Arabian Poems which were Suspended on the Temple at Mecca*. London

Kabbani, R., 1986. *'Sand' and Other Poems, Mahmoud Darweesh*. Kegan Paul International, London

Kabbani, R., 1993. *Maliheh Afnan, Paysages, Personnages, Ecritures*. England & Co., London

Karnouk, L., 1995. *Contemporary Egyptian Art*. American University in Cairo Press, Cairo

al-Khalil, S., 1991. *The Monument – Art, Vulgarity and Responsibility in Iraq*. André Deutsch, London

Khatibi, A., 2001. *L'art contemporain arabe*. Editions Al Manar. Institut du Monde Arabe, Paris

Kinda Foundation, 2002. *Perspective on Contemporary Art*, Institut du Monde Arabe, Paris

Koraïchi, R., 1991. *Cris Ecrits*. Editions de Lassa, Brussels

Koraïchi, R. and M. Butor, 1990. *Salomé*. Centre Georges Pompidou, Paris

Legrand, F., 1962. 'Peinture et écriture', in *Quadrum: Revue Internationale d'art moderne XIII*, pp. 5–48

Lloyd, F. (ed.), 1999. *Displacement and Difference, Contemporary Arab Culture in the Diaspora*. Saffron Books, London

Madi, H., 2005. *The Art of Madi*. Saqi Books, London

Mahdaoui, N., 2001. *L'Art-Calligraphie*. L'or du temps, Tunis

Mansour, N., 2000. *The Ijaza in Arabic Calligraphy* (in Arabic). Dar Majdalaoui Publishers, Amman

Massoudy, H., 1991. *Le chemin d'un calligraphe*. Phébus, Paris

Massoudy, H., 2001a. *Le poète du désert*. Editions Alternatives, Paris

Massoudy, H., 2001b. *L'Harmonie Parfaite d'Ibn Arabi. Calligraphies de Hassan Massoudy*. Albin Michel, Paris

Maunick, E., 1990. *Nja Mahdaoui*. Ceres Productions, Tunis

Mejcher-Atassi, S., 2002–3. 'Re-inscribing oneself into the Middle East: Etel Adnan and her "livres d'artiste" in the context of *al-hurufiyya al-'arabiyya*', in *Beiruter Blätter Mitteilungen des Orient-Instituts Beirut* 10–11, pp. 90–5

Metoui, L., 1994. *Les signes de sables*. Editions Opera, Nantes

Metoui, L. 1999. *Les Orientales en Calligraphie Victor Hugo*. Editions Alternatives, Paris

al-Moudarres, F., 1995. *Fateh al-Moudarres*. Galerie Atassi, Syria; Institut du Monde Arabe, Paris

Moustafa, A., 1998. *Where the Two Oceans Meet – The Art of Ahmed Moustafa* (text by Henzell-Thomas), Fe-noon Ahmed Moustafa. UK Ltd, London

Naef, S., 1992. *L'art de l'écriture arabe: Passé et présent*. Editions Slatkine, Geneva

Naef, S., 1996. *A la Recherche d'une Modernité Arabe*. Editions Slatkine, Geneva

Neshat, S., 2000. *Shirin Neshat*. Kunsthalle, Vienna; Serpentine Gallery, London

al-Niffari, Muhammad Abd al-Jabbar, 1935. *The Mawaqif and Mukhatabat of Muhammad ibn Abd al-Jabbar al-Niffari* (ed. and transl. J.W. Arberry). Gibb Memorial. Luzac & Co., London

Omar, M., 1946. *Arab Calligraphy in Art*. Corcoran Institute, Washington

Pakbaz, R. and Y. Emdadian (eds), 2001. *Charles-Hossein Zenderoudi*. Pioneers of Iranian Modern Art, Tehran

Pakbaz, R. and Y. Emdadian (eds), 2003. *Parviz Tanavoli*. Pioneers of Iranian Modern Art, Tehran

Qotbi, M., 1999. *Qotbi dédié à la lettre*. Editions Le Fennec, Casablanca

al-Raes, A., 2005. *Abdul Qader Al Raes*. Al Owais Cultural Foundation, Dubai

Rawas, M., 2004, *The Art of Rawas*. Saqi Books, London

Rotterdam, 2002. *Contemporary Arab Art*, Wereldmuseum

Rovner, M., 2005, *Fields* (exhibition at the Jeu de Paume and the Tel Aviv Museum of Art). Steidl Publications, Göttingen

al-Said, S.H., 1981. 'The unconscious structure of the Arabic letter, in *Funun Arabiyah* (*Arab Arts*) (London) 1, pp. 64–8

el-Said, E., 1989. *Issam el-Said: Artist and Scholar*. Issam El-Said Foundation, London

Samra, F., 2000. *Faisal Samra*. Al-Mansouria Foundation, Riyadh

Seven Stories about Modern Art in Africa, 1995. Whitechapel, London; Flammarion, Paris/New York

al-Shaarani, M., 2005. *The Traces of Song – Calligraphic Paintings by Mouneer al-Shaarani*. St John's College Research Centre, Oxford

Shabout, N.M., 1999. Modern Arab art and the metamorphosis of the Arabic letter. PhD, University of Texas at Arlington; forthcoming publication with this title anticipated 2006–7

Shawa, Wijdan, 1994. Laila Shawa, *The Walls of Gaza*; Wijdan, *Calligraphic Abstractions*. October Gallery, London

Singh-Bartlett, W., 2005. 'Farhad Moshiri – when ancient becomes modern', in *Canvas* 1.5, pp. 72–9

Theophilus, J., 1993. *An Alchemy of Letters – The Art of Ahmed Moustafa*. Artizana, Prestbury, Cheshire

Tripp, C., 2000. *A History of Iraq*. Cambridge University Press, Cambridge

al-Udhari, A., 1999. *Classical Poems by Arab Women*. Saqi Books, London

Adrian von Roques, K. (ed.), 2005. *Languages of the Desert, Contemporary Art from the Gulf States* (exhibition catalogue). Kunstmuseum, Bonn

PHOTOGRAPHIC AND TEXT ACKNOWLEDGEMENTS

fig. 2: photograph courtesy of Stephen Stapleton

fig. 3: © ARS, NY and DACS, London, 2006

fig. 4: photograph courtesy of Maysaloun Faraj

fig. 5: © Photo RMN/© Jean-Gilles Berizzi

fig. 6: © 2005, Digital Image, The Museum of Modern Art, New York/Scala Firenze

fig. 7: courtesy of the artist and Gagosian Gallery, photo Rob McKeever

cat. 8: photo Prudence Cuming Associates Ltd

cat. 41: © Institut du monde arabe, Paris/Philippe Maillard

cat. 61: Ellen Labenski, courtesy of Pace Wildenstein

Artist portraits:

Youssef Abdelké: photo Ammar Albeik

Ghani Alani: © Groupe Fleurus, 2001: Ghani Alani, *La Calligraphie Arabe*, p. 72

Abdallah Benanteur: photo Dahmane Benanteur

Kamal Boullata: photo Serge Bergeon

Maysaloun Faraj: photo Gary Swann (Swann Photography)

Jacob El-Hanani: photo Nicole Klagsbrun Gallery

Khosrow Hassanzadeh: photo Eugenie Dolberg

Shirazeh Houshiary: photo Shannon Oksanen

Sabiha al Khemir: photo © Horacio Monteverde

Rachid Koraïchi: photo The October Gallery

Sabah Naim: photo Muhammad Abla

Shirin Neshat: photo courtesy of Gladstone Gallery, New York

Mohammed Rawas: photo Gilbert Hage

Michal Rovner: photo Dan Porges, 2005

Laila Shawa: photo H. Schneebell

Parviz Tanavoli: photo Tandees Tanavoli

Osman Waqialla: photo Awad El Zein

Wijdan: photo October Gallery

cats 2, 3 and 8: Extracts from the Qur'an from *The Koran Interpreted* by A.J. Arberry. Copyright © 1955 George Allen & Unwin Ltd.

cat. 13: Extract from verse by Layla bint Lukayz, translated by Suheil Bushrui, from *Suad al-Attar* by S. al-Attar. Copyright © 2004 Al-Madad Foundation.

cat. 24: Extract from 'A tomb for New York' by Adonis, translated by J.K. Jayyusi and Alan Brownjohn, from *Modern Arabic Poetry. An Anthology*, edited by J.K. Jayyusi. Copyright © 1987 Columbia University Press. Reprinted with permission of the publisher.

cat. 25: Extract from 'The blind whore' by Badr Shaker al-Sayyab, translated by T. De Young, from *Placing the Poet, Badr Shakir al-Sayyab and post-colonial Iraq* by T. De Young. Copyright © 1998 State University of New York Press.

cat. 27: Extract from *Birds Die in Galilee* by Mahmoud Darwish, translated by R. Kabbani, from *'Sand' and Other Poems, Mahmoud Darweesh* by R. Kabbani. Copyright © 1986 Kegan Paul International.

cat. 28: Extract from *Mural* by Mahmoud Darwish, translated by S. Boulus, from *Judariya [Mural]* by S. Boulus. Copyright © 2000 Riad El-Rayyes Books.

cat. 29: Extract from 'Qasida K' by Tawfiz Sayegh, translated by Adnan Haydar and Jeremy Reed, from *Anthology of Modern Palestinian Literature*, edited by J.K. Jayyusi. Copyright © 1992 Columbia University Press. Reprinted with permission of the publisher.